The Amphoto Photography Workshop Series

FILM

Making the most of films and filters

The Amphoto Photography Workshop Series

FILM

Making the most of films and filters

Michael Freeman

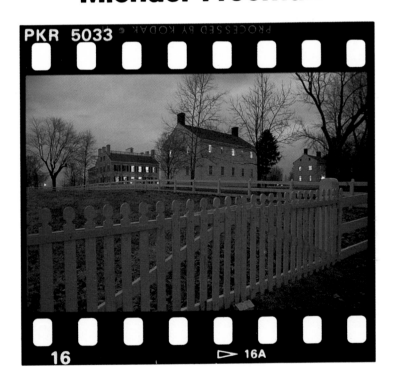

amphoto

First published in 1988 in the United States by Amphoto, an imprint of Watson Guptill Publications, a division of Billboard Publications Inc., 1515 Broadway, New York, New York 10036

Library of Congress Cataloging-in-Publication Data

Freeman, Michael, 1945–
 Film.
 (The Amphoto photography workshop series; 3)
 Includes index.
 1. Photography – Films I. Title. II. Series.
 TR283.F68 1986 771′.5324 88–6288
 ISBN 0–8174–3868–8

Editor Sydney Francis
Art Director Christine Wood
Designer Paul Morgan
Illustrations Rick Blakely

Phototypeset by Qualitext, Abingdon
Originated by Bright Arts (HK) Ltd, Hong Kong
Printed and bound in Italy by Amilcare Pizzi S.p.A., Milan

All the pictures in this book are by Michael Freeman with the exception of those on page 19 (top) which are reproduced by courtesy of Kodak Ltd, and the camera on page 95 (left) which is reproduced by courtesy of Polaroid (UK) Ltd.

The author and publishers also gratefully acknowledge the assistance of Cowbell Processing, Keith Johnson Ltd, Kodak (UK) Ltd and Neyla Freeman.

Michael Freeman, an established photographer for nearly twenty years, has emerged as one of the most important authors of books on photography. He specializes in studio, reportage and wildlife photography. His work has appeared on posters and record sleeves and in numerous books and magazines. Michael Freeman's other publications include *The Photographer's Studio Manual, The 35mm Handbook, Collins Concise Guide to Photography and Wildlife and Nature Photography*.

CONTENTS

INTRODUCTION

Within the last few years there have been some remarkable advances in film technology which have set the scene for a continuing programme of development. This has resulted in a greater choice of film types than ever before, quite apart from all the competitive brands, and the variety is increasing all the time. The major film manufacturers are engaged in both improving the performance of existing basic films and producing new emulsions that open up new fields of photography.

Improved performance has been achieved through such methods as the use of flat grains of silver halide (see page 10) instead of the traditional compact shape of crystal. As long as these grains are aligned in the emulsion so that they face the incoming light, they respond more efficiently; for the size of grain, the silver halide is more sensitive to light. Another basic improvement in colour film is a new type of colour coupler (see Glossary) in which the molecules are packed more tightly than usual. This makes it possible to have a thinner emulsion, which in turn reduces the amount of light scattering. The result is a sharper image.

Among the second group of improvements – making new types of film – one outstanding example is pushable colour film. Photographers, particularly professionals, have always been accustomed to pushing the processing of films (see page 11) as one method of gaining more speed. Usually, though, this has been something of an emergency measure, used when a faster film was not at hand. The price was loss of image quality, the more so with colour film than with black-and-white. The new films, fast to begin with, are actually designed in such a way that the photographer can choose the film speed setting, from ISO 400 up to ISO 3200. This flexibility means that low-light photography can be approached in exciting new ways.

The excitement of the new film technology lies in how it affects the practice of taking pictures. The chemistry may be daunting, but this sophisticated technology is actually altering the way in which photographers shoot. The relationship between film and the taking of photographs will never be the same again; you can expect the choices of film to be changing constantly, and you will have to keep an eye on what is new and what is on the horizon.

FILM BASICS

The cutting edge of modern film technology bears no resemblance whatsoever to the early days of the camera, when photographers like Mathew Brady (who photographed the American Civil War in the 1860s) and Roger Fenton (he recorded the Crimean War in 1855) had to prepare and sensitize their plates immediately before exposing them. The standards of image quality and film performance are well beyond the ability of individual photographers to make for themselves, and the involvement that most people have in the film that they use is now extremely small. Few photographers process their own film, even though modern processes and kits are simple and reliable; the efficiency of commercial laboratories and the speed at which they now regularly turn film round has made home-processing seem a chore.

On the surface, this modernization of film manufacture and processing only seems good. The quality of the image has never been so high, and photographers are free to shoot – which is what most are happiest doing – instead of having to spend time in a darkroom. The drawback, however, is less understanding about what different films can and cannot do. To get the best out of an emulsion – in fact, in order to choose the right film for the job – nothing can take the place of a good knowledge of how it works. Not only this, but developing the film oneself offers the greatest possibilities of fine control. In black-and-white photography, different developers give a choice of effect, over graininess, film speed and contrast. With all films, control over the amount of development, through the temperature, time or the strength of the solution, can be used to set the contrast of the image, and can also compensate for under or overexposure.

The specifics of how the latest films improve image quality are rather involved, but we leave these until later in the book. For now, we look at the fundamentals of film. These are, for the most part, the fundamentals of black-and-white photography, because the early parts of the process, in which the image is recorded and developed, are the same as those used in colour film. Whether transparency or negative, a colour emulsion is essentially a series of three layers of the same kind of light-sensitive crystals; the colour appears later, during development. Modern film chemistry is highly sophisticated, but the basics have barely changed from the days when photography was in its infancy.

Basic Film Technology

The details of modern film chemistry are certainly complex, but all of the emulsions used in normal photography work on the same basic principle. A matrix of light-sensitive crystals reacts to the brightness of an image projected onto the surface of the film. This alone is not enough to cause any visible change to the film, but when a developing solution is added the sensitivity of each crystal is increased millions of times, and in a chemical reaction the crystals that were struck by the light are altered into silver for a virtually permanent record of the image.

This sequence, unadorned, produces the familiar black-and-white negative. The two major advances in the history of film – colour and reversal technology – take this simple process further, as we shall see in more detail later in the book. It helps to remember, however, that colour negative and colour transparency films contain black-and-white emulsions, and the first stages of processing them are essentially the same as for a black-and-white development. To help understand basic film technology, we confine our attention here to black-and-white negatives.

The film

The heart of any film is the light-sensitive crystal. The detail that can be recorded depends very much on how small and how tightly packed these crystals are, and as we will see on the following pages, some of the most basic distinctions between film types are in the size, layering and shape of the crystals. The crystals are silver halides, colourless compounds of silver mixed with potassium chloride, potassium bromide or potassium iodide. For these halides to be useable, they need to be held in a thin layer in a fixed position, and film manufacturers use gelatin for this. Look at the leader of film protruding from a 35mm cassette, and you will see that the side that faces the lens when the film is loaded in the camera is grey or yellowish, with a semi-matt texture. This is the layer of gelatin in which large numbers of silver halide crystals are embedded – in other words, the emulsion.

Gelatin is used because when dry it is quite stable and holds the crystals firmly in position, but when wet it swells and absorbs liquid. If you wet the end of the leader slightly and then touch it, you will notice that it becomes tacky. This quality is useful

during processing, as it allows the developer and other liquid chemicals to penetrate the gelatin layer easily and act on each crystal without disturbing its position, but makes it necessary to have another layer to the film: a strong supporting base that is flexible enough to allow the film to be rolled around spools, but which will not stretch out of shape. Turn the leader over and you will see that the surface there is dark and shiny. This is the cellulose triacetate base, and when developed, the image can be viewed through this transparent layer. Sheet film needs a stiffer backing, normally a thicker type of plastic called polyethylene.

Two other, thinner layers are added to these two basic components: a scratch-resistant supercoat above the emulsion, and an anticurl layer that includes an anti-halation dye. The sandwich of gelatin and acetate has a tendency to curl inwards towards the emulsion side, so that a gelatin coating on the back of the film serves to counteract this slightly. The anti-halation dye reduces the scattering of light back into the emulsion; without it there would be a higher level of fogging on the exposed film.

Forming the image

With the later help of the developer, a single crystal of silver halide that is struck by light is converted into black metallic silver. In a sheet of film containing millions of these crystals, the image is built up through the pattern of sensitized and non-sensitized crystals. In the processed negative, the view through a microscope shows a texture of black grains and clear film – the clear areas are where the unexposed crystals originally were, before being dissolved and removed during processing.

When an individual silver halide grain is struck by light, metallic silver is formed, but in such a tiny speck that it remains invisible. At this stage, therefore, all the information is recorded in the pattern of crystals, but remains hidden as a latent image. The film remains in this state until development, and as it is wound on to the next frame in the

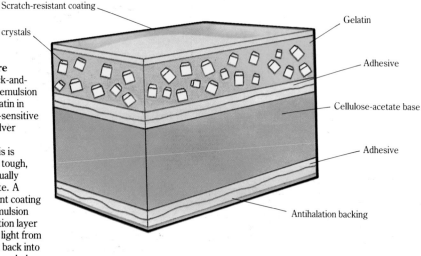

Scratch-resistant coating

Light sensitive crystals

Gelatin

Adhesive

Cellulose-acetate base

Adhesive

Antihalation backing

Film structure
In a typical black-and-white film, the emulsion is a layer of gelatin in which the light-sensitive crystals – of silver bromide – are embedded. This is supported on a tough, stable base, usually cellulose acetate. A scratch-resistant coating protects the emulsion and an antihalation layer prevents stray light from being reflected back into the emulsion from below.

camera, all the exposed frames carry their latent, unchanging pictures.

Developing the image

During the processing of the film there are two important stages: the original minute reaction to light is enhanced to the point where it can be seen, and any further reaction is halted so that the image becomes permanent. For the first stage, developer solution is added. This permeates through the gelatin, which swells to accept the liquid. The developer acts only on those silver halide crystals that have already been exposed to light: the silver traces in each grain that have collected together grow until the entire crystal is reduced to black silver metal. In areas of the film that have been strongly exposed to light, the mass of black grains also tends to coalesce, producing what appears to be a solid black.

If the developer were allowed to act on the film without a time limit, even the unexposed crystals would eventually be affected in the same way, so that the development must be halted at the point where the image is fully formed. The number of minutes that this takes depends on the type of developer solution, the type of film and the temperature. To stop the development, the solution is poured away and the emulsion bathed in either clean water or acetic acid (the latter acts more quickly, but because fixing – the second stage in the processing – usually follows immediately, it is often not necessary).

The processing must still take place in complete darkness because of the remaining unexposed silver halide crystals. These must now be removed entirely to make the image stable. This is done with a fixing solution. The principal ingredient in this is sodium thiosulphate (hypo), and it dissolves the silver halides, which can then be flushed out of the gelatin by the final wash. All that then remains is for the film to be dried so that the gelatin emulsion, now swollen and easily damaged, can contract and harden.

Formation of the image

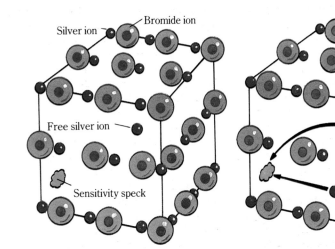

1 In a schematic version of one grain of silver bromide, pairs of silver and bromine ions are held together by an electrical charge. The silver ions lack one electron, and so have a positive charge; the bromine ions have an extra electron and are negatively charged. Specks of silver sulphide and occasional free ions complete the structure.

2 When a photon of light strikes the crystal, it gives extra energy to the electron of a bromine ion, allowing it to move around the crystal. The bromine ion then attracts and bonds to a positively charged free silver ion. Specks of impurity, such as silver sulphide, tend to attract this new bonding and so are known as sensitivity specks.

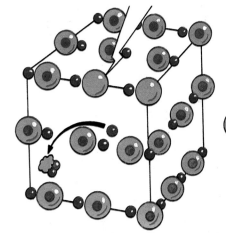

3 As more photons of light strike the crystal, more electrons are released. These and more silver ions migrate to the same site as the others – towards the sensitivity speck. The combination of ions and electrons creates silver metal, although this is invisible at this stage.

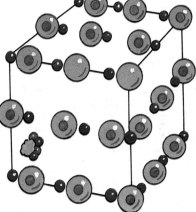

4 After the full exposure to light, the chemical change has occurred, but is latent – that is, it still awaits the action of a developer to magnify it several million times and make it visible.

Film Speed

Whether we look at black-and-white or colour films, the most obvious distinction between the different types is their speed ratings. Until recently, there were two main speed rating systems in use, ASA and DIN. ASA, standing for American Standards Association, is arithmetical, meaning that doubling the number denotes doubling the speed. An ASA 100 film, therefore, is twice as fast as one with an ASA rating of 50. The DIN system of Germany and some other European countries (it stands for Deutsche Industrie Normen, or German Industrial Standards) is logarithmic, and under this system doubling the film speed is denoted by adding three. The DIN equivalent of ASA 50 is 18; twice as fast is 21.

Of the two systems, ASA was always much more widely used, but now they have been replaced by the ISO system (International Standards Organization). In practice, however, the ISO rating is simply a combination of the two, with the old ASA number appearing first and the DIN number distinguished by a degree sign. Not surprisingly, the majority of photographers refer only to the first number, as the entire ISO figure is rather cumbersome. For this reason, we also use the abbreviated rating here. Hence, ASA 100 becomes ISO 100.

Popularly referred to as "fast", "medium" or "slow", the speed of a film is a measure of how sensitive it is to light. Other considerations apart, the more sensitive an emulsion is, the easier it is to use; shutter speeds can be high enough to overcome problems of camera shake or the blurring of a moving subject, and aperture settings can be small enough to give good depth of field. Front-to-back sharpness and frozen movement are not always desirable in a picture, but for most photographers in most situations they are important enough to make good film speed vital.

Broadly speaking, the way to make a film very sensitive to light is to use larger grains and more of them. Then, provided that the right developer is used, a relatively small exposure can produce a visible black silver

Film Speed Ratings			
ISO	**ASA**	**DIN**	
16/13°	16	13	
25/15°	25	15	SLOW
32/16°	32	16	
50/18°	50	18	
64/19°	64	19	
80/20°	80	20	MEDIUM
100/21°	100	21	
125/22°	125	22	
160/23°	160	23	
200/24°	200	24	FAST
400/27°	400	27	
800/30°	800	30	
1000/31°	1000	31	ULTRA-FAST
1600/33°	1600	33	

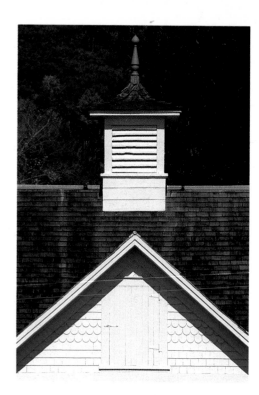

▶ The exemplar of fine-grained colour reversal films is Kodachrome 25, used here on an architectural detail of a New England barn. While the low sensitivity – 2 stops less than a typical medium-speed film – restricts its use, its image qualities are virtually unsurpassed.

image. Here lies the problem, for while a high speed is high on the list of priorities, so is a sharply detailed image, and grain, as we will see in a few pages, reduces detail. Modern film technology has made great improvements in gaining extra sensitivity with only small increases in graininess, but the link between speed and grain remains. You cannot have one without the other, and so there must be a trade-off. Which is sacrificed depends on the use that a particular film is intended for, but the normal choice is on a scale from slow and fine-grained to fast but grainy. When we look at specific films later in this book, we will see some of the methods used by manufacturers to reduce graininess as far as possible and improve this choice.

A few other things also affect the speed of a film. One is the colour of the lighting. Not all films are equally sensitive to all colours; most black-and-white emulsions, for example, are less sensitive to red than they are to blue. As a result, a film may have a lower effective speed if you are shooting under domestic tungsten lamps, which are more reddish than daylight.

Another factor is the developer. The film speed given by the manufacturer assumes normal development in a standard developer. A fine-grain developer will bring up less of the latent image, and so effectively reduce the film speed. Similarly, a high-energy developer will make a film behave as if it were faster.

Finally, something we will deal with in more detail on pages 36–9, the actual amount of time that a film is exposed to light will affect the speed. At both very long and very short exposures most films are less sensitive. The limits vary with the make of film, but for most they are around $\frac{1}{1000}$ second at the short end of the scale and about 1 second at the long end.

Characteristic curves

Throughout this book, the kinds of description that we mainly use are practical rather than technical. Expressions such as "fast" and "slow" are popular and generally well understood, and are an accessible way of referring to the sensitivity of a film. They are, however, also vague; while they are fine for making broad distinctions, something else is needed when it is important to make detailed comparisons.

One of the standard technical descriptions of a film is in the form of a graph, plotting the amount of exposure against the density of the developed image. With a negative, the more exposure to light, the darker the image – that is, the greater the density of silver in the film. The rate at which this happens produces a curved slope on the graph. This is the characteristic curve, and its shape is specific to each film. Once you are familiar with these, it is easy to see at a glance how well a film performs: in particular, its contrast and sensitivity to light.

The vertical component of the graph shows the density, from nearly clear at the bottom (the shadow areas in the picture negative) to almost black at the top (the highlights). If you examine a normal, developed negative, you will see that even the brightest, unexposed areas are covered with a very pale grey veil; this is the "fog level", and sets the lower limit to the curve. The "toe" of the curve starts just above this. At the top of the curve is the "shoulder", just below the maximum density. The importance of the toe and shoulder is that they set the limits for recording detail in the negative. A normal exposure is one in which all the different levels of brightness in a scene are contained within the straight-line portion of the graph. If some of the picture densities fall on the toe, the result is underexposure; if some fall on the shoulder, they appear overexposed.

There are three such curves with colour films, one for each layer of emulsion. Problems of colour balance and rendition often appear as crossed or separated lines.

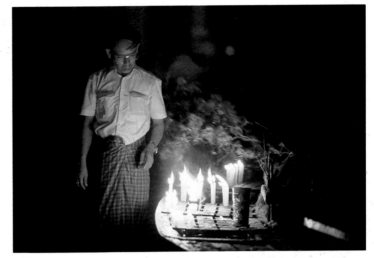

High-speed film like ISO 400 Ektachrome has quite prominent grain, and tends to be used in lighting conditions that would be impractical for slow or medium emulsions. In this example, its speed was sufficient to record a candlelit scene with a telephoto lens: using a tripod, a 180mm lens was used at ¼ second and f 2.8.

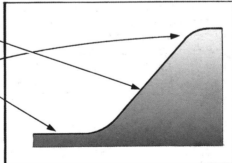

Characteristic curve
This curve plots exposure against density, and maps out the tones on film and print. Little or no exposure marks the bottom of the slope or "toe", and represents the deepest shadows. The maximum exposure that gives highlights marks the top or "shoulder". Mid-tones in the print fall in the middle of the straight-line portion.

Colour Sensitivity

Visible light covers a range of wavelengths, which our eyes see as colours. One of the major tasks that a film manufacturer has with any emulsion used for normal photography is to make the film respond to all of these colours in the same way. This is just as important for black-and-white emulsions as for colour: ideally, the shades of grey in a monochrome photograph should resemble the eye's impression of brightness. However, silver halides, which are the basis of almost all films, have the disadvantage of responding quite differently. Used without special treatment they would produce black-and-white images in which the blues were too bright and the reds too dark.

The eye is sensitive to the range of colours between violet at one end of the spectrum and red at the other. The wavelengths that continue beyond these two colours – ultraviolet and infra-red – cannot be seen by the human eye. As you might expect, at these limits at either end of the scale the colours appear to us to be dark, while the colours that appear brightest are in the middle. As you can see from the diagram, this is just what happens. The eye is most sensitive to yellow-green; it seems to us to be the brightest colour. The situation changes a little when the lighting becomes dim. Then, the eye's response peaks in a different place, at blue-green rather than yellow-green. (This is covered in more detail in volume III, *Light.*)

If we start by considering just black-and-white photography, it is a fairly straightforward matter to assign tones of grey to these colours. A normal film ought to have the same response, but unfortunately this is not so simple. Basic silver halides are sensitive only to blue – up to about 500 nanometers (nm) on the scale. This was the type of emulsion that all early photographers had to work with, with the result that blue skies appeared white in a print, greens appeared dark, and reds came out as virtually black.

The manufacturing answer has been to use dyes that help the emulsion respond to

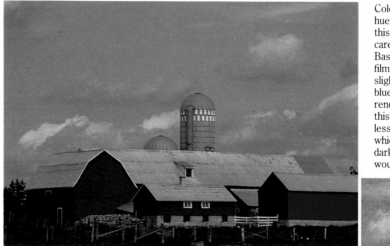

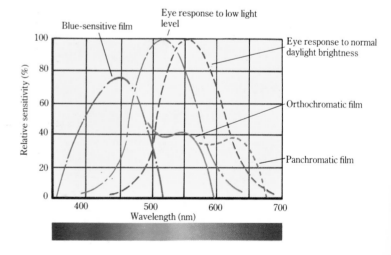

Colour film responds to hues accurately, although this is the result of carefully selected dyes. Basic black-and-white film, even today, is slightly over-sensitive to blue – hence the pale rendering of the sky in this example. It is also less sensitive to reds, which here become darker than the eye would imagine.

The red curves represent the way the eye sees in bright and in low light: in bright light we see yellow as the lightest colour. Film, even regular panchromatic film, responds differently. These differences account for many of the filters that are needed to make slight corrections when using film with different light sources.

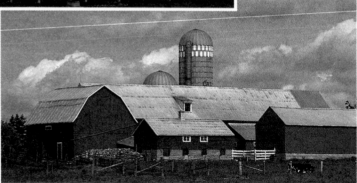

the red end of the spectrum. Orthochromatic films (usually abbreviated to "ortho") have dyes that extend their sensitivity to include greens, but not as far as red. They survive today in the form of lithographic (usually abbreviated to lith or litho) films (see pages 54–9) and are useful because they can be developed under a red safelight by inspection: in various kinds of special effects and masking, it is important to be able to see what you are doing.

Normal black-and-white emulsions, however, are called panchromatic, and are sensitive up to red, at about 660nm or 680nm. Nevertheless, even the dyes used for this are not capable of giving black-and-white films exactly the same sensitivity as the eye. If you look at the diagram you can see that, compared with what we see, a normal black-and-white film is too sensitive to blue, violet and ultraviolet, fairly insensitive to greens, and too responsive again to red. As a result, unless you use filters (see pages 154–7), blues will appear too light, greens a little dark and reds pale.

With colour film, the standards of accuracy have to be more critical, particularly with what some manufacturers call "memory" colours. These are the colours that people are extremely familiar with, and expect to see reproduced very accurately. Flesh tones and greys are prime examples of memory colours. Even a slight shift towards a different colour, of as little as 5 or 10 per cent, immediately looks "wrong" to most viewers. The difficulty here, as we shall see on pages 88–9 when we examine the making of colour emulsions, is that the colour is built up from three different layers of dye in the film. To begin with, the silver halides in each layer must have just the right sensitivity. Then, the dyes that the manufacturer uses must be accurate. Finally, the thickness of each layer must be exact to within a tolerance of no more than 4 or 5 per cent. As each of these layers is no thicker than about $3/10,000$ inch ($1/20$ mm), the manufacturing problems are formidable.

These Polaroid prints show the difference in response between panchromatic and orthochromatic film. The colour version *below*, of pen and inks in the three primary colours, is for comparison.

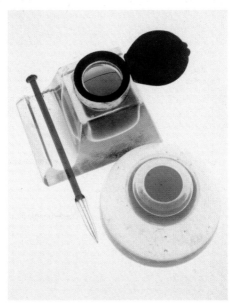

A low-contrast panchromatic film (Polaroid Type 52) gives a recognizable black-and-white interpretation of the three colours, with the blue slightly paler than the eye would anticipate. This is typical of regular black-and-white emulsions.

A high-contrast orthochromatic film (in this instance, Polaroid Type 51) is extremely sensitive to red, which appears black, and so insensitive to blue that the ink is invisible.

Sharpness

First in our list of essential film qualities is sharpness. It may seem surprising, but sharpness is not a measurable quality; in fact, it is very much a subjective impression of the amount of fine detail in an image. No wonder, then, that photographers and manufacturers regularly disagree as to which films are the sharpest. The factors that combine to give the impression of sharpness can, however, be measured – they are acutance, contrast, resolution and grain. What weight you give to each is open to question.

First, we should establish exactly what these factors are. Acutance is a measure of how abruptly one tone changes into another. Imagine the edge of a silhouette in a photograph, magnified. Ideally, there should be no zone of transition between the white and the black areas, just an abrupt edge. In reality, there nearly always is. The more abrupt the edge, the higher the acutance. The contrast in the picture also has an effect: imagine two edges as just described, one between white and black, the other between white and grey. Even though the edges may be both equally abrupt, the white-to-black transition will look sharper. In other words, the more contrast there is, the greater the impression of sharpness.

Resolution, or resolving power, is a measure of how much closely-spaced detail the film can record. It also, however, depends very much on the performance of the lens you are using. Even Fujichrome's fine-grain ISO 50 emulsion, for example, will fail to produce a sharp image if you use it with a lens of only average quality. (It almost goes without saying that the focus must be accurate and the camera steady.) Resolution can be measured by photographing a test target under known laboratory conditions, and there are published figures for all films prepared by the manufacturers.

One caution, however: as with many film qualities, including the speed rating, the

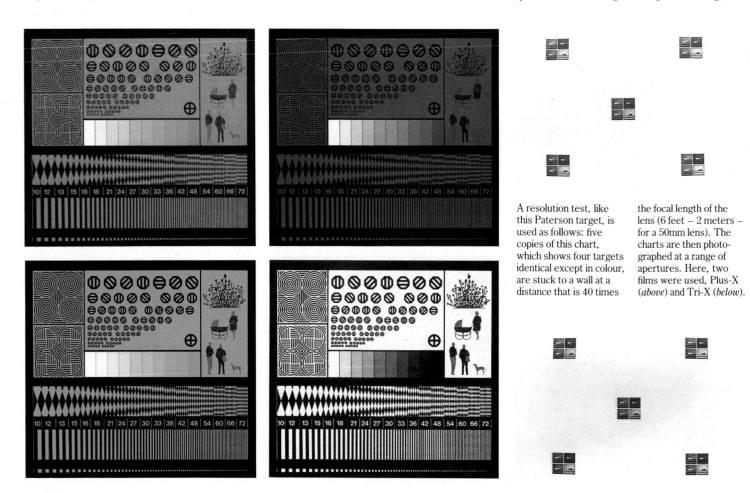

A resolution test, like this Paterson target, is used as follows: five copies of this chart, which shows four targets identical except in colour, are stuck to a wall at a distance that is 40 times the focal length of the lens (6 feet – 2 meters – for a 50mm lens). The charts are then photographed at a range of apertures. Here, two films were used, Plus-X (*above*) and Tri-X (*below*).

manufacturer's claims may not always bear out precisely in normal use. *Modern Photography* magazine in particular makes its own independent tests of film and equipment, and its results make instructive reading. Be careful about reading too much into small differences in the published technical specifications: for example, if the resolving power of one film is claimed to be 125 line pairs per millimeter and for another 100 line pairs per millimeter, this tells you that they are similar but not necessarily that the first is noticeably sharper. The normal method of measuring resolving power is to take a photograph of a target of alternating black and white lines, as shown *opposite*.

Finally, grain contributes to the impression of how sharp the image appears. We deal with graininess and granularity (not quite the same!) on pages 18–19, but for sharpness, their effects are not straightforward. Graininess breaks up the image, thereby destroying some of the detail, and so reduces the impression of sharpness. At the same time, however, there may well be an opposite effect, because if the grain texture is precise and crisp, it can actually help the sharpness. You should judge the impression for yourself by shooting with a grainy film, such as Kodak's 2475 Recording Film, or Tri-X processed in a high-energy developer.

The importance of sharpness in film depends on the degree of enlargement. The 2× enlargement *right* of a full 6×6cm negative shows, naturally, no limitations to the sharp detail. *Above* is a 30× magnification of a small area in sharp focus – the equivalent of a print measuring 5 feet (1.5 meters) square, and here the limits of resolution on this medium-speed film can be seen.

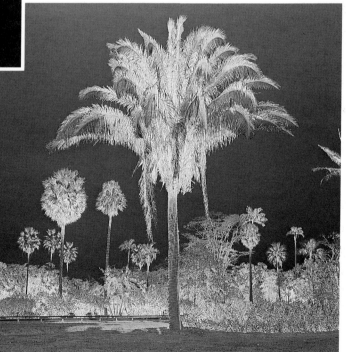

Measuring resolution

The resolving power of film is measured by using an extremely sharp lens just on the axis to give the highest possible image quality. The target is in the form of black and white lines that decrease in thickness and spacing, as in the example shown here. The results are examined microscopically. The simplest way of expressing the resolving power is to quote the narrowest spacing of lines that remain distinct, and measure them as line pairs per millimeter. Usually, two figures are given: one for a low-contrast target (1.6:1) and one for a high-contrast target (1000:1). For the latter, a good resolution would be in the region of 100 or 125 line pairs per millimeter. A more sophisticated measurement used by some manufacturers is Modulation Transfer Function (MTF), which shows how the differences in brightness between the dark and light bars become less as the spacing becomes finer. The ideal would be an MTF of 1.0; in practice, most black-and-white films have an MTF of between 0.25 and 0.35, while most colour films fall between 0.05 and 0.1.

Getting the best possible sharpness

However good the film is, the way you use it makes a considerable difference to the sharpness of the picture. The following is a list of ways to make sure that this is as high as it can be:

- Use a sharp lens with clean surfaces, and an efficient lens shade.
- Focus accurately and use a shutter speed fast enough to avoid the possibility of camera shake.
- Do not overexpose, as this causes halation and irradiation to occur inside the emulsion.
- Use a high-acutance developer with black-and-white films, and in any case do not push-process.
- When making a print, think of the enlargement process as a second photographic stage, and take the equivalent precautions (choice and care of lens, and so on).

Grain

While graininess seems an obvious quality, and easy to recognize when we look at a print or slide, the terminology often causes some confusion. A film's emulsion, as we have already seen, consists of millions of tiny particles that start as silver halide and are developed to become silver (or, in the case of colour images, dyes that replace them). These particles are known as either crystals or grains, but they are too small to be seen. The largest individual grains are about 1/500 mm across, and the smallest about ten times less than this. When you look at an obviously grainy picture, what you are seeing is the effect of large numbers of grains clumping together. They clump not only because concentrations of developed silver tend to merge together, but because even a thin layer of emulsion contains great numbers of grains stacked in depth – when you view them, they appear to overlap. A point to remember, incidentally, is that if you view a print, the dark parts of the graininess are actually the gaps between the clumps of silver.

So, there is graininess, which is the impression you get when looking at a photograph, and there is granularity, which is the objective measurement. Graininess is subjective, and cannot be measured, but granularity is exact: it is the amount that the density fluctuates randomly in an area of the film that appears uniform. The two are not the same, but tend to go hand in hand. The main categories of graininess are suitably vague – fine, medium and coarse – but granularity can be measured, with an instrument called a densitometer. This detects very small variations in density in the film, and the standard measurement is of how much this deviates from an average value. The figure, normally between 5 (small deviation) and 50 (large deviation) is called the RMS Granularity; RMS (root-mean-square) means the variation.

In colour film, the same silver halide crystals are used to record the image, and these are developed in the usual way into silver. However, the colour is formed by dyes in the same places as the silver grains, and to complete the processing, the silver is removed from the film. The graininess that remains is caused by small spots of dyes (in three colours, each in a different layer) where the silver grains used to be. Being transparent, they do not appear as sharply as black-and-white grain. As our eyes have difficulty seeing colour in very small detail, the overall impression of graininess from a colour film is actually less, despite the fact that there are three layers of emulsion to look through. In fact, it is the magenta layer that makes the most impression: it absorbs green light and, as we just saw on page 14, the eye is most sensitive to green.

Practically, though, how should graininess affect your choice of film? Graininess is something that film manufacturers do their best to reduce, and most photographers try to avoid, because it interferes with detail. However, as it is intimately linked to the speed of the film, this is not always possible. If the grain has to be fine, the film must be slow, even though there are ways of improving this state of affairs. Usually, photographers have to make a compromise, and the most common one is to use the slowest film that the lighting conditions allow. In a lot of photography, there is no way of being certain about the lighting in advance, and for this reason most photographers carry more than one type of film.

What the film manufacturer can do to lessen the graininess without sacrificing too much speed is to vary the size and shape of the crystals. In what are popularly called T-grain films the crystals are shaped like tablets rather than the usual chunky form. If these tablets are then aligned so that they lie flat in the emulsion, they receive light over a larger area. Another improvement is to alter the composition of the silver halides so that they are more efficient.

Project: Using grain
Having said all this, there is not necessarily anything wrong with a grainy picture – in fact far from it; some images can actually work better because of an obviously grainy texture. This is worth experimenting with yourself: choose a fast, grainy film (see pages 46-9 and 112–15), use a high-energy developer if it is a black-and-white, and shoot in such a way that you enlarge just a part of the frame. When the grain texture is very prominent, the effect on the picture is rather like the pointillist technique used by French Neo-Impressionist painters. Whether you like the results or not is, of course, only a matter of taste.

If you experiment with different films for grain texture, you may notice a difference in the pattern. Generally, the tighter and more consistent the pattern, the more successful graininess is in its graphic effec

Avoiding grain	Enhancing grain
1 Use a slow film	1 Use a fast film
2 If black-and-white, use a fine-grain developer	2 Use a high-energy developer for black-and-white film
3 Enlarge as little as possible (so, the larger the film format, the better)	3 Enlarge a small portion of the image
4 Do not push-process	4 Push-process
5 Print with an enlarger that has a diffused rather than a condensed light source	5 Print with a condenser enlarger

1

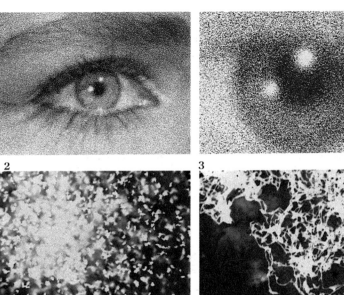

2

3

A progressively closer and closer look at a typical black-and-white negative (here treated as a positive image) shows the granular structure of a photograph. The first frame is a 2½× enlargement of a 35mm frame, with no graininess visible. A close-up of the eye at 20× shows some grainy texture, and at 60× in the third frame, individual grains of silver can be seen. At 400×, each grain is clearly visible, and underlying grains embedded in the gelatin can be seen out of focus in the background. Finally, an electron microscope view of part of one grain shows its filamentary structure. (Reproduced by permission of Kodak Limited.)

4

5

The graininess of ISO 400 Tri-X becomes apparent only at a reasonable enlargement. From a full frame (*above*), an enlargement of a section of this shot of a zebra in the Serengeti shows the beginnings of the distinctive grittiness at 7×.

Contrast

The third important film quality is contrast. The contrast range of a film is the scale of tones, from black to white, that it is capable of recording. This means, in effect, the range of density. Under normal circumstances, the ideal contrast range is one that produces an image which matches the subject. Most general-purpose films do this, and so are known as medium-contrast.

This sounds simple enough, but there is rather more to the choice and handling of contrast in practice. As we saw on pages 16–17, a contrasty image looks sharper than a "flat" image. Also, the bright, punchy effect tends to have an immediate, obvious appeal to many people. On the other hand, if you are concerned about preserving detail in all the areas of a scene, including both the highlights and the shadows, high contrast is a problem. The bright, hard lighting from a single light source, whether the sun on a clear day or a small flash unit, produces high contrast to begin with; if the film itself is also full of contrast, the results may not be so pleasing. In other words, contrast needs to be thought about subjectively as well as technically.

On page 13 we looked at characteristic curves. Technical though these are, they make a very easy way of judging the contrast range of any film at a glance. The straight-line portion of the graph is the important part, and its angle gives an idea of how contrasty the film is. A film with normal contrast shows an angle slightly less than 45°. If the slope is steeper than that, the film is, to some extent, contrasty. In film technology, the expression used instead of the angle of slope is "gamma". A gamma of 1.0 means a slope of 45°; higher numbers are steeper. High contrast line films (pages 54–9) have gammas of 3.0 and more.

Judging and dealing with contrast is an important part of exposure decision, and we look at this in detail later in the book. The ultimate contrast range in the picture can often be altered, either when you compose and light the view or by choosing the appropriate film and developing it in a certain way. There is, in any case, a difference in the way negative and transparency films should be approached. A negative is only the first step in the process of making a print, and it is better to reserve some of your options for the enlargement. In other words, if the negative looks a little flat and lacking in contrast, this is usually no bad thing; the contrast can be manipulated considerably during printing. A contrasty negative, however, leaves much less choice. Transparency films, particularly as used for slides, produce their images in one step, so that the exposure and development must be just right. Later manipulation is not usually a choice.

Apart from the overall range of contrast, there is also the matter of how well individual tones are separated. Some films show a distinct range at the shadow end of the scale (the toe portion of the characteristic curve); others do better in separating the highlight tones (the shoulder). These subtle differences between films become important when you start to make side-by-side comparisons. Usually, slow-speed fine-grain films are not only a little more contrasty than faster films, they also have different performances in the toe and shoulder. Adjustments to the development are one way of ironing out such differences, particularly with black-and-white films.

Differences in lighting and subject account for the variation in contrast in the two photographs *left* and *right* – both were taken on the same brand of film (Tri-X), which was given similar development, and each enlargement made on a normal grade of printing paper. Near back lighting on the dark hide of the buffalo *right* gives a range of tones that exceeds the range of the paper. The hippos *left* were photographed on an overcast day, with shadowless illumination: the range of tones is much more limited.

Negatives always show a much greater range of detail from shadows to highlights than a straight print, particularly in a high-contrast scene. The negative (*far left*) shows details both of the dimly lit cellar door and the daylit wall outside. A straight print from this (*center*) loses both ends of the scale when exposed for the mid-tones. To approach the range of the negative, the only answer is to use shading and printing-in during enlargement, as in the print *above*.

Film Formats

Film is available in three basic types: 35mm perforated in metal cassettes, 6.2cm-wide rollfilm and sheets (I am deliberately ignoring the sealed plastic film cartridges designed for snapshot cameras, as the cameras themselves are too basic for this Workshop series). Of the three, 35mm film is by far the most widely used, and virtually all pictures taken with it are on a standard 24× 36mm frame. Rollfilm, however, is used over a range of formats, and certain makes of camera allow a choice simply by changing the film magazine. Sheet films are cut to specific sizes for loading into holders, and also offer a choice of format.

35mm
Originally produced as short lengths cut from movie stock, 35mm film is still produced with a double row of perforations.

These engage with sprockets on the take-up spool in the camera and allow the film to be wound on with a positive action. The spacing of the perforations reduces the risk of the film tearing if it is moved rapidly, and makes fast motor-drive operation possible.

The film, which is normally supplied in lengths that are sufficient for 36 or 20 exposures in transparency film, or 36, 24 or 12 exposures for negative film (24×36mm frames), is wound onto a spool and enclosed in a light-proof metal container – the cassette. A slot in the cassette, made light-tight by the use of black velvet strips, allows the film to be fed out and rewound in daylight. The leader, which protrudes from this slot in an unused cassette, is cut to a thin tongue for attaching to the take-up spool. In some makes of camera, the leader simply has to be laid flat; the motor

mechanism and sprockets will then engage automatically.

DX coding is a system whereby a pattern of electrically conducting panels on the outside of the cassette denotes the film type and speed. Those cameras with the appropriate contacts in the film chamber can set the film control automatically.

Rollfilm
Rollfilm is 6.2cm in width and without perforations, for use in medium-format cameras. It is taped at each end to opaque paper to avoid wasting emulsion and still retain daylight loading (the surface area is significantly larger than that of 35mm film). In loading and unloading the roll, only the paper is needed to attach to the take-up spool and for wrapping up the exposed length later. Most rollfilm is sold as the 120

The three basic categories of film (excluding disc and cartridge-packed varieties for snapshot cameras) are 35mm, medium-format, and sheet film. Most medium-format films are in the form of rollfilm (120 and 220), with a few emulsions in sprocketed 70mm. Large-format sheet films are available in several sizes, with 4×5 inch and 8×10 inch the most commonly used.

DX coding
The speed of a film is indicated by a rectangular metallized pattern on the film cartridge, which is read by a strip of contacts inside the camera's film chamber. Automatic cameras transfer this information direct to the metering system.

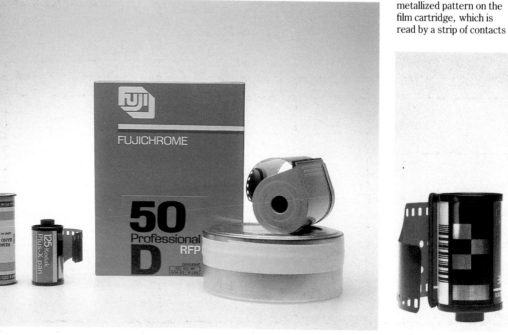

Shown *below* are the actual sizes of film frames from 35mm to 8×10 inches – a size range of more than 16:1. Image quality is heavily dependent on film size, as the larger formats naturally need less enlargement to produce a viewable image.

variety, in lengths sufficient for 12 exposures on square 55×55mm frames (for simplicity, this picture format is usually referred to as 6×6cm). The paper leaders on 120 film extend the full length of the film and act as a lightproof backing strip; the reason for this goes back to the days when the only practical way of telling how many exposures remained was to look through a small hole in the back of the camera at numbers printed on the paper. In contrast, 220 rollfilm has a greater length on the same size of spool by dispensing with the backing paper and retaining only the paper leaders. A less common form of medium-format film is 70mm sprocketed, giving similar picture areas.

Whereas nearly all 35mm cameras expose the same format of picture frame, rollfilm cameras are noted for their variety.

The larger film area makes it practical to have different formats, and these vary from 4.5×6cm to essentially panoramic formats such as 6×12cm and 6×17cm.

Sheet film

Sheet films are used almost exclusively in view cameras (although a few smaller cameras such as the Hasselblad have facilities for using cut-down sheets in special holders). The two most common sizes are 4×5 inches and 8×10 inches, but there are several others, including 3¼×4¼ inches, 4¾×6½ inches, 9×12cm, 6½×8½ inches and 11×14 inches. The much larger surface makes it necessary to use a polyethylene film base that is thicker and tougher than the cellulose triacetate of the smaller rolls (see pages 10–11).

Sheets must be loaded individually into film holders in the dark. In use, the holders are placed in position in the camera's back, a protective slide withdrawn, and the exposure made. A slightly quicker way of shooting is to use a Graflok back, which uses springs to push a series of thin metal film holders into position.

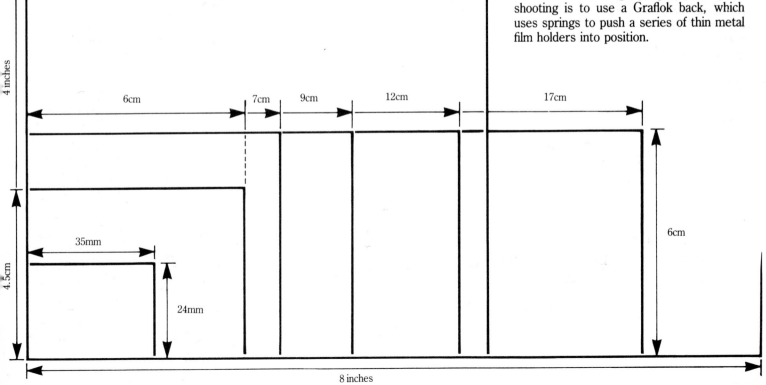

Film Handling: 35mm

The 35mm cassette is so well standardized that it is the most trouble-free format of any save plastic film cartridges. It is difficult to maltreat to the point where the image is affected, and basic handling is straightforward. Nevertheless, there are a few simple precautions to take, and it is as well to develop an efficient routine. For storage, protection against X-rays and general film care, see pages 162–79.

Light protection

Film cassettes are nominally light-proof, but really bright illumination, with the intensity of direct sunlight, can occasionally get through. For this reason, when loading and unloading – in fact, whenever the cassette is out of its opaque canister or the camera – find a place where the light is subdued. If this is not possible outdoors, face away from the sun and shade the film with your body. Notice that, while Fuji have adopted the convenient transparent plastic canister, which lets you see exactly what type of film you have, Kodak remain cautious about light damage and use black cans. One danger spot on the cassette is the end where the lip of the spool protrudes.

If you have a detachable motor-drive and are in the habit of changing it from one camera body to another, be careful about the hole in the camera's base plate that allows the motor's rewind lug to engage. When the camera is separated from the motor-drive, replace the screw cover rather than run the risk of light entering.

Loading

Loading methods vary between makes of camera but, typically, the back swings open on a hinge, and the cassette is dropped into the film chamber (normally, the rewind knob must be raised first, and then pressed back to engage the spool). The leader is then drawn across the back of the film gate and inserted into one of the slots in the take-up spool. Here is a principal danger, and there are few photographers who, at some time or another, have not discovered too late that the tongue of film was not secure. If it fails to catch, the film will not advance, and although the lack of pressure on the advance lever should tell you that something is wrong as you start shooting, it is possible not to notice, particularly if you are in the middle of some urgent or involving situation. And, if you regularly use a motor-drive, the speed of the wind-on and its noise easily conceal the mistake.

The first precaution is to take your time and pay attention, even if you think you may be missing a shot. Make sure the tongue is inserted in the direction that the spool will wind, otherwise the first movement of the advance lever will loosen the tension on the film, which may be enough to free it. A final safety check is to rotate the rewind knob in the opposite direction from its normal movement. After the slack is taken up, you will feel tension. Also, as you advance the film during shooting, the moving rewind knob indicates that all is well. Don't worry if it does not rotate fully every time – there is always some slack inside the cassette.

As you unload and load cassettes, make a quick check of the inside of the camera – the film chamber, take-up spool and the rails that run across the film gate. Look for particles, whether of dirt or small chips of film. If you work the advance lever roughly, the perforations may tear and leave small sharp pieces of the film inside the camera, and these can scratch the emulsion. Even a motor-drive in normal use can do this.

Most film canisters are black and lightproof, as an additional precaution against strong light entering through the top or bottom, but Fuji uses a transparent design for the convenience of identifying the film quickly. The danger of light fogging of film inside its cassette is disputed.

When removing certain kinds of motor-drive from the camera body, be careful of the drive coupling that engages the film cassette. This is for rewinding, and in bright light there is some danger of light entering through the exposed hole in the baseplate. Use the screw cover.

Loading
In this example, a Nikon is used. Other cameras have some different mechanisms.

1 Open the camera back and place a fresh cassette in the left-hand film chamber.

2 Close the spindle that engages the film spool.

3 Draw the film leader across the film gate.

4 Insert the tapered tongue in the slot on the take-up spool. Be very careful about this; push it through as far as it will go to avoid the risk of the film not being taken up by the winding mechanism.

5 With the back still open, stroke the wind lever until you are sure that the film is winding and that both sets of teeth on the roller have engaged in the film's sprocket holes.

6 Close the camera back and wind on until the figure "1" appears in the frame counter window.

If you are in the habit of changing films in the middle of a roll, one way of helping to make sure that the film is not completely rewound into the cassette is to crimp the tongue when loading. Then, when rewinding, the crease will make an audible click as it leaves the take-up spool.

Remember, when changing types of film, to reset the film speed selector. As an extra reminder of what film is loaded, some cameras have a window into which you can fit the end of the film's card box.

During shooting, make it a habit to check the frame counter regularly. At the point where the last few frames are approaching, you should have a fresh roll ready. This will save valuable time in situations where you need to shoot quickly.

Unloading

Full tension on the advance lever shows that you have reached the end of the film (what you can feel is the tape at the end of the film pulling on the cassette's spool). Automatic power-driven cameras have some indicator, such as a small light electronic display (LED) that lights up. To release the take-up spool there is a catch or button, often on the camera's baseplate. The rewind knob can then be turned, or the power rewind switched on, until the slight tension slackens, indicating that the leader has come free.

Under normal circumstances the entire film can be wound right back into the cassette, but there are times when you may want to rewind a partially used film and save it for later. For instance, if you are carrying fewer camera bodies than types of film, failing light may mean that you have to change films in mid-roll. In this case, you have to be able to re-load the film you are removing, and for this you should leave the leader still protruding from the cassette. Do not use a power rewind, as this will take the film straight back before you have a chance to stop it. Instead, rewind gently, feel for the free play as the leader comes off the take-up spool and listen for it as well, with the camera to your ear if necessary.

One tip if you do this frequently: when you load the film to start with, crimp the very end of the tongue. Then, when you rewind, this will make an audible noise as it comes free. Immediately mark on the cassette the number of frames exposed: write it with a thick marker on the metal or on the emulsion side of the leader. If you delay doing this, one day you are likely to forget, and the result will be a double-exposed film: a loss of two sets of pictures.

On the occasions when the film has been completely rewound into the cassette yet you need to use it a second time, there are ways of pulling the leader back out. One or two proprietary kits are available, using plastic tongues with "hooks" that catch the perforations. Alternatively, you can make your own from a strip of thin plastic slightly less than the width of the film. Attach a strip of double-sided tape to one end of the plastic, push it into the cassette's slot and work it in, winding the spool at the same time. When you can feel the tape catch on the film, withdraw it gently, pulling the leader with it.

Unloading
1 Depress the release button (on the Nikon used here, it is on the baseplate).

2 Operate the rewind lever over the film chamber until you feel the release of tension (or until you hear the tongue come loose – see *opposite*).

3 Release the spindle that engages the cassette.

Identifying film

On a busy day's shooting, it helps if the film you are carrying is easy to get at and, if you have more than one type, clearly identified. As packed in manufacturer's boxes, 35mm film is fairly bulky and not so quick to load, even if the boxes have perforated openings. It makes more sense to throw away the boxes and instructions and carry film in cans. Transparent cans, like those used by Fuji, make it easy to see what they contain, but with opaque containers you will need to mark them, unless they come with adhesive identity labels. It is enough to use a simple abbreviation, such as "64" to indicate the film speed, or "64D" to show that it is daylight-balanced, or "KR" to identify the make (Kodachrome 64). A marker should be part of the standard kit in your bag.

Another reason for the marker is to make notes on the films that you have shot. If there are any special instructions, such as push-processing (see pages 72–7), the time to make them is immediately you unload the film from the camera. Some sort of numbering system is also useful if you are shooting a number of rolls in a day. Even if you do not have enough time to keep notes of every subject photographed, at least try to mark the sequence of films used. If you also need to mark the film type on the can lids, leave space for these numbers.

The card boxes in which 35mm films are packed take up space and extra time to open – both of these are best not wasted when out shooting. Remove the cans from the boxes when packing a shoulder bag for a day's shooting. If the cans carry no identification, mark a simple code on the lid of each with a waterproof marker.

When a roll of film has been only partly exposed and rewound, mark the number of exposures on the tongue. This avoids double-exposing the start of the roll when you use it a second time.

Bulk loading

In addition to the normal pre-loaded and ready-to-use cassettes, some 35mm emulsions are available in bulk. The usual form is in 100 foot (30m) lengths wound onto a plastic core and sealed in a metal can. Bulk 35mm film is designed not only for loading into special film backs (like the Nikon 250 Magazine Back), but so that it can be cut and loaded into regular cassettes. This is cheaper than buying film in the usual way, and also allows you to load very short lengths (on some occasions, such as when making duplicates, you may want to expose and develop only a few frames at a time).

If you load your own cassettes by hand, it must be done in darkness, and a light-tight room is much more convenient than a changing bag (by the time you have a 100-foot – 30m – spool of film, an open can, scissors, tape and the parts of a cassette, as well as two hands, the space inside the bag becomes very crowded and confusing). The alternative is a proprietary bulk film loader, like the Watson shown here. This must be loaded in darkness, but once only; after the entire spool of bulk film has been fitted, individual lengths can be wound onto cassettes with the loss of only a few inches each time through fogging. Bulk film loaders have a counter to measure out the number of frames wanted.

Specially made re-loadable cassettes are available, and these have convenient mechanisms for gripping the inner end of the film and for assembling. They are, however, a little expensive, and a common alternative is to use ordinary cassettes that have been discarded after processing. This means that the inner end of the cut film must be taped to the spool; for security, cut a strip of tape that is long enough to stick to both sides of the film.

If you use regular metal cassettes, inspect each one carefully for damage before loading. Make sure that the cap which was removed to extract the original film re-fits tightly, and that there is no bending of the metal which might cause a light leak. There is a constant risk that re-used cassettes may not be completely light-tight, and this is one reason for not using bulk film for everyday shooting.

Another danger that you should stay aware of is that the black velvet lips that make the exit slot of the cassette light-proof can trap particles, and it is not unknown for these to scratch the emulsion. The more you re-use a cassette, even one made for the purpose, the bigger the risk.

Bulk loading equipment includes a loader (this machine is a Watson), bulk film in a can, empty cassettes (either reloadable or once-used regular cassettes), scissors for trimming the film, tape for attaching it to the spool, and a changing bag for first loading the bulk film in the loader.

Film Handling: Rollfilm

Lacking its own light-tight container, rollfilm needs more careful handling than 35mm; in many ways, the process of removing and licking adhesive tabs and feeding and wrapping paper leaders is a primitive way of preparing film for shooting. The emulsions continue to improve, but the basic structure of this film format remains unchanged. A sensible successor would be 70mm film, which is slightly wider to accommodate double perforations similar to those on 35mm, but the inertia of film and camera manufacturers keeps its use very limited. Few medium-format cameras have the interchangeable backs to accept the bulkier 70mm cassette, and film manufacturers are understandably reluctant to market a range of film types when the demand is so limited. It appears that rollfilm users will have to continue to put up with paper backing, at least for the foreseeable future.

Light protection

This is much more important than for 35mm film: the paper with its black inner coating is light-proof only to an extent, and if it is not tightly wound onto the spool, even subdued light will fog the edges of the outer part of the film. And there is ample opportunity for allowing the film to loosen; when the adhesive tab is removed, only your fingers hold the roll tight. Also, when the film has been exposed and wound fully onto the take-up spool, the release of tension in some makes of camera allows a few outer turns of paper to become loose. Follow the loading and unloading advice shown on these pages very carefully.

As long as the film's foil paper packet remains sealed, there is no problem. Open this just before loading and not before, and when you remove the exposed film from the camera, store it somewhere dark and dry (rollfilm is more susceptible to humidity than 35mm cassettes). If you are out shooting on location, reserve one inner pocket of the shoulder bag exclusively for film; an opaque paper or cloth bag inside this is an extra precaution against the film being damaged by light or humidity. Some photographers also save the individual foil paper packets, tearing them open carefully so that the film can be put back after it has been exposed.

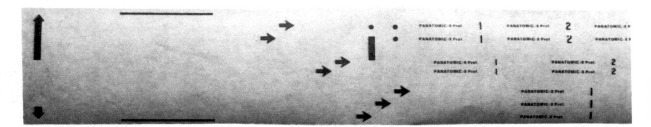

Rollfilm magazines vary in construction from make to make of camera. The most common system of film transport, used by Hasselblad, the Mamiya 67 models, Rollei, Bronica and others (including the rollfilm backs for view cameras shown here) has the film doubled back over two rollers. This keeps the magazine compact, while the tension between the rollers keeps the film flat across the film gate.

The opaque backing paper of rollfilm has the frame numbers printed on it, although most advanced rollfilm cameras have a display to count the number of frames exposed.

Loading

There are several systems for transporting rollfilm, depending on the make of camera or magazine. The simplest, and most familiar to 35mm users, is a simple left-to-right, film chamber-to-take-up spool, loading across the film gate, with the backing paper facing you as you load. In other systems, the film doubles back on itself. Follow the instructions for whatever camera you are using. In all cases, and unlike 35mm, the film is not rewound onto its original spool, but instead stays on the take-up spool. Consequently, each time you load, the old spool must be moved to the take-up chamber, where it becomes the new take-up spool for the next film.

First tear open the sealed foil packet, then carefully pull off the adhesive paper tab that is wrapped around the middle of the film. If you pull too sharply at the edge of the paper it can tear; it is safer to run the edge of your thumbnail under the seal first. Remove the tab entirely, or part of it may become caught in the loading mechanism. Holding the film firmly, place it in position, and with your thumb covering the roll to keep it tight, pull the paper leader across to the take-up spool. Insert the tongue in the spool's slot and wind on.

Modern cameras have an automatic counter, but one of the backing paper's arrows or numbers must first be brought into view in a window (exactly which depends on the make of camera). Close the back and wind on until the mechanism stops. Identify the type of film by inserting an end flap from the film box in the camera back's slot specifically designed for this purpose.

Loading
The example here is a standard Hasselblad magazine for 120 film.

1 Twist the locking key and use it to pull the insert out of the magazine.

2 Pull up the spool clamp bars, and transfer the empty spool from the previous roll of film to the other side.

3 Run a thumbnail or fingernail under the folded-back edge of the film's paper backing.

4 Carefully pull away the paper tab.

5 Place the film in the empty chamber and lock it in place with the retaining bar.

6 Pull out the leader of the paper backing.

7 Pull the paper backing over and round the roller so that the black inner side faces outwards at the front of the insert, like this. Twist the key on the side one half turn clockwise to raise the small strip that clamps the film, sliding the edge of the paper under this.

8 Insert the tapered end of the leader fully into the slot in the take-up spool.

9 Turn the knob clockwise until the arrow or triangle on the paper backing is opposite the pointer on the spool clamp bar.

10 Turn the key counter-clockwise and push the loaded insert back into the magazine.

11 Wind the film crank clockwise until it locks. The frame counter window will now display the figure "1".

Unloading

Wind on fully until you feel the release of tension; at this point, the last of the backing paper has come free. It may be better to open the back just before the film is fully wound onto the spool, depending on the make of camera or magazine, as sometimes the outer few inches of paper become loose. Holding your thumb on the paper as you complete the winding prevents this. If the paper is already a little loose, place the roll in darkness (such as the bottom of the camera bag) and pull it tight. Then lick the gummed tab and seal the roll. Mark on the tab any instructions for processing.

Unloading

After the last frame has been exposed, wind on several turns with the film crank.

1 Remove the insert from the magazine as shown at the start of the loading sequence, and fold under the end of the paper backing.

2 Remove the film and pull the end to make sure that it is tightly wrapped.

3 Lick the free end of the adhesive tab, and press down.

Film Handling: Sheet Film

Single sheets are the most basic form of film, and simple enough to use because of that. They must be loaded and unloaded individually, and in complete darkness. For this, either a small darkroom or walk-in cupboard is necessary, or – essential equipment for location work – a light-tight changing bag. Despite the undoubted advantages of a large format and all the image-controlling movements that view cameras have, a major drawback with sheet film is that preparing it for an exposure takes a long time.

The most common design of sheet film holder is double-sided for convenience, but even so, several sheets of loaded film are bulky. Particularly when shooting outdoors, it is hardly ever possible to carry enough pre-loaded film. This means becoming practised in changing film in a bag in what are often unsuitable locations.

Light protection

As every moment of handling sheet film must be in darkness, the precautions are obvious. If you plan to change film at home in a darkroom or cupboard, first check how lightproof it really is (see page 75). Camera film is considerably more sensitive than ordinary black-and-white printing paper, so be rigorous about blocking out all light. As for the changing bag, buy one that will be large enough to work in. You will need enough width for a film holder with its dark slide pulled almost completely out, space to slide in a sheet, and both hands. For 4×5 inch film, a changing bag measuring about 27×27 inches (69×69 cm) is usually sufficient, unless you want to change several films at once. This, though, can become confusing if your concentration slips. When choosing a changing bag, be careful about lint and loose fibers inside. Even some of the best quality bags are prone to this when new, and if bits are attracted to the emulsion, the photograph is likely to be ruined without you realizing.

In use, the film holder is held in place in the camera by a spring back (there are

other systems, but modern view cameras generally use this type). It should be tight enough to exclude light, but outdoors there is a danger of light leaking into the film, either through the gap between the holder and the camera, or through the slot from which the dark slide has been removed. If this happens, first check the seating of the spring back – it may need adjustment – and then, if it persists, make a habit of covering the back of the camera with a dark cloth before withdrawing the dark slide. Another

precaution that may help is to withdraw the slide only far enough to clear the film, leaving the end in the slot.

Loading

First assemble everything that you will need, either on a worktop in a darkroom, or inside the changing bag (remember to fasten both zips of the bag). You will need film holders, a box of film and, if you have already started shooting, an empty box into which you can unload the film already in the

The standard double dark slide *left* accepts two sheets of film; the protective slide for each is withdrawn just before exposure. For more rapid shooting – and more protection against stray light – a multiple holder (*center*) is pre-loaded with several sheets (here six). Since the introduction of standard reversal film into Polaroid's range the Polaroid 4×5 inch holder *right* becomes, in effect, an alternative to the other two.

The basic kit for loading sheet film includes a changing bag (if you have no darkroom), darkslides, box of film, empty film box for unloading exposed sheets, compressed air for cleaning slides, scissors, tape and a pen.

holders. Do not try and change several film holders at one time in a changing bag, for obvious reasons. Some photographers who are used to making very long exposures, or who plan to make double exposures, secure each sheet of film inside each holder with a small piece of tape at one edge: sheets can move a millimeter or so inside. Make sure you have opened any empty film holders before starting to load.

Open the box of film, tear off one end of the packet inside, and pull out one sheet. Sheet film has an identifying pattern of notches in one corner, which is also shown on the outside of the box. If you hold the film holder in your right hand with the slide sticking out to the right and the sheet in your left hand, make sure that the notches are in the top left corner. You can feel them with the index finger of your left hand, and this indicates that the emulsion is facing up. Slide the sheet in, holding only the edges. When it is fully in the holder, push the slide back until it is securely in its retaining groove. If the holder has a lock, make sure that it is fastened before repeating this sequence for the other side.

To become really familiar with the loading sequence, it is a good idea to practice in daylight with an old or discarded sheet.

Unloading
This is basically the reverse of the above sequence. Begin by making sure that the inner tray of the empty box you are using to store the film faces into the base of the box, not the top; that way there is a double light lock. Try not to store more than a few sheets together unless you interleave them with soft paper, otherwise there is a danger of the sheets becoming scratched when you move the box around (see Troubleshooting on page 81). Immediately you have done this, secure the lid of the box with tape or a rubber band and write on the outside details of the enclosed film.

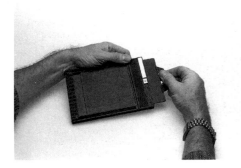

Loading
1 Press the release catch if the make of darkslide has one, and withdraw the slide.

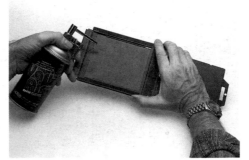

2 Clean the inside of dust and any other debris.

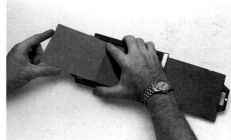

3 In complete darkness, hold the film with notch as shown (to identify the emulsion side) and guide it into the grooves, touching it at the edges only.

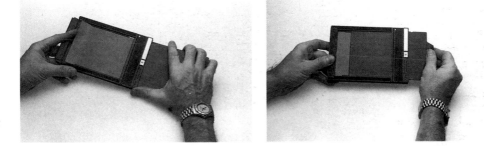

4 Push the film in as far as it will go.

5 Close the hinged flap at the end, and push the slide back fully.

Reciprocity Failure

At very long and very short exposures film behaves as if it were slower than its normal speed rating – but exactly what defines long and short exposure depends on the make of film and the use for which it is intended. With most daylight-balanced colour transparency films, for example, the effect starts at exposures of between ¼ second and 4 seconds, but films that are balanced for tungsten lighting are intended to be used at slow shutter speeds, and work well for up to several seconds.

This effect is called reciprocity failure (or, more properly, Reciprocity Law failure) because it is a result of what happens to the relationship between aperture and shutter speed. Over a normal range of speeds, say from ⅟1000 second to ⅟15 second, there is a reciprocal relationship between the aperture and shutter speed, which is to say that if you halve one and double the other, the exposure will look just the same. An exposure of ⅟125 second at *f* 11 should give exactly the same density of image as ⅟60 second at *f* 16. This is the Reciprocity Law, and its failure is what causes a certain amount of grief to anyone not expecting it at long exposure times. Some of the most interesting lighting conditions are when there is very little – the afterglow just before nightfall, for instance, or moonlight – and it is at these times that it helps to know how to overcome the effects of reciprocity failure.

Project: Testing for reciprocity failure
Try this simple test for yourself. Choose a black-and-white film and lighting conditions that allow you to make a normal exposure at about ⅛ second with the lens wide open. Make a series of exposures of the same scene with the camera on a tripod, starting at ⅛ second. Each time, double the exposure time and reduce the aperture by 1 stop, until you reach the minimum aperture. If you have any neutral density filters, continue the series. A typical lens has an aperture range of about 7 stops, which will take you to around 8 seconds. When processed, the film will show a progressive darkening from frame to frame.

This is easy enough to compensate for, as the table *below* shows, although if you increase the exposure time to make up for the apparent loss of film speed, you will actually increase the reciprocity failure even more. Take this into account when working

Reciprocity correction for black-and-white film

(These figures are those recommended by Kodak. Other makes of film behave similarly.)

Film type	Exposure time (seconds)	⅟10,000	⅟1000	⅟100	⅟10	1	10	100
Tri-X, Plus-X, Panatomic-X	Increase aperture by	+1 stop	–	–	–	+1 stop	+2 stops	+3 stops
	OR							
	Increase time by	–	–	–	–	+1 sec	+40 secs	+1100 secs
T-grain films	Increase aperture by	+⅓ stop	–	–	–	+⅓ stop	+½ stop	+1 stop
	OR							
	Increase time by	–	–	–	–	–	+5 secs	+100 secs

Reciprocity correction for colour negative film

Vericolor II & III	NR	NR	NR
Kodacolor VR100 and Kodacolor VR200	+1 stop, +CC10R	+2 stops, +CC10R, +CC10Y	NR
Kodacolor VR400	+½ stop, No filter	+1 stop, No filter	+2 stops, No filter
Kodacolor VR1000	+1 stop, +CC10G	+2 stops, +CC20G	+3 stops, +CC30G, +CC10B
Kodacolor Gold 100 and Kodacolor Gold 200	+1 stop, +CC20Y	NR	NR

out the exposures. Where reciprocity failure becomes a headache, however, is with colour transparency film. Even if you ignore it when shooting black-and-white, you can usually compensate for reciprocity failure when printing; the same applies to colour negative film. With colour slides, however, what you expose is what you get, so you will need to take this into account before you begin to shoot.

Problems with colour film

Another problem with colour film is that the reciprocity failure is not exactly the same for each of the film's three layers, with the result that the colour changes, too. To work properly, colour film depends on the three emulsion layers behaving accurately and in concert. If one falls out of step, as happens when the exposure times are long, the colour balance is changed. The solution is to use complementary filters over the lens as well as increasing the exposure, and the table on this page shows which (occasional changes made by manufacturers tend to go unheralded, so make a practice of checking that the data shown here remain the same).

Unfortunately, some manufacturers give only limited recommendations, and the unhelpful "not recommended" appears in the technical specifications for the kind of exposures needed for night-time landscapes and small-aperture naturally-lit interiors. The only answer is to make your own tests. One useful tip is this: use tungsten-balanced film even with daylight, adding an 85B filter or whatever is appropriate. Tungsten-balanced films, as you can see from the table, are intended for long exposures, and have better reciprocity characteristics at long exposure times.

All this presupposes that you want to correct the colour change resulting from reciprocity failure. It may be an idea, before going to the trouble of making colour filtration tests, to try shooting at long times in a variety of circumstances. You may find that you like the colour shift.

Reciprocity correction for colour transparency film (NR=not recommended)

	1 sec	10 sec	100 sec
Kodachrome 25	+½ stop, No filter	NR	NR
Kodachrome 40 (Type A)	+½ stop, No filter	NR	NR
Ektachrome 50 (Tungsten)	None, +CC05R	NR	NR
Fujichrome 50	None, No filter	+½ stop, No filter	NR
Agfachrome 50S	+½ stop	NR	NR
Agfachrome 50L (Tungsten)	–	+⅓ stop, No filter	+⅔ stop, +CC10R, +CC10Y
Kodachrome 64	+1 stop, +CC10R	NR	NR
Fujichrome 64	None, No filter	None, No filter	+1 stop, +5M
Ektachrome 64	+½ stop, No filter	+1 stop, No filter	NR
Ektachrome 6117	+½ stop, +CC10M	+1½ stops, +CC15M	NR
Ektachrome 6118	Varies: see film instructions (intended range 1/10 sec to 100 sec)		
Ektachrome 100	NR	NR	NR
3M 100	+⅔ stop, +CC05Y	+1½ stops, +CC10R	+2½ stops, +CC15R
Fujichrome 100	None, No filter	+½ stop, +5R	NR
Agfachrome 100S	–	+⅔ stop, No filter	+2½ stops, +CC10G
Kodachrome 200	NR	NR	NR
Ektachrome 200	+½ stop, No filter	NR	NR
Ektachrome 6176	+½ stop, +CC10R	NR	NR
Ektachrome 400	+½ stop, No filter	+1½ stops, +CC10C	+2½ stops, +CC10C
Fujichrome 400	None, No filter	+½ stop, +5Y	+⅔ stop, +5Y
3M 400	+½ stop, No filter	+1 stop, +CC05R	+2 stops, +CC10R
3M 640 (Tungsten)	+½ stop, No filter	+1 stop, No filter	+2 stops, +CC10Y
Ektachrome P800/1600	NR	NR	NR
3M 1000	–	+⅔ stop, +CC10B	+1½ stops, +CC15M

This sequence of frames shows how reciprocity failure affects one make of film – Kodachrome 64. The top exposure, at $\frac{1}{30}$ second and f 3.5 is unaffected; this is a shutter speed for which the film is designed. The second exposure is at $\frac{1}{8}$ second and f 6.3; there is very little colour difference, but the result is slightly darker, as the film is fractionally less sensitive to the light. In the third (*bottom*) exposure, 8 seconds at f 32, there is a noticeable shift towards blue-green, and the exposure is distinctly darker.

A subject that allows a carefully composed shot with a tripod-mounted camera is ideal for extra-fine-grain film. This gryphon at the entrance to the City of London was photographed on Panatomic-X.

graininess is so fine that it becomes noticeable only at enlargements of about 40×. All will give sharp prints without any obvious grain at 20× enlargement.

The first choice to make is between the two groups, slow or medium-speed. As both give fine grain, neither is a good choice if you want to make visual use of the grain texture; in that case, you definitely need a fast film (see pages 46–9). Selecting a slow film over a medium-speed film, therefore, usually depends on how large the prints will be. The more recent emulsions that use flat grains also slightly blur the distinction between the two groups. Kodak's T-Max

100, for example, uses tablet-like triangular silver halide crystals instead of the more traditional compact shapes, and so gets a better sensitivity to light for the size of grain. So, this film has the characteristics associated with slower emulsions, and may well replace both Plus-X and Panatomic-X.

The distinctions within each group are extremely fine. T-Max stands out in the medium-speed group, as does Technical Pan in the slow group. This depends to an extent on how the films are processed, and to get the finest grain, a fine-grain developer should be used, although this will also alter the sensitivity of the film.

Project: Comparing slow and medium-speed

For a detailed comparison, photograph one scene with more than one brand of film in each group, and make the maximum enlargement possible. The best type of subject is one that contains some fine, easily distinguished detail, a full tonal range, and a smooth, featureless area of middle tones (these are best for showing up grain). A more immediately valuable exercise, however, is to do this kind of comparative test with a slow, a medium and a fast film. The grain of the fast film will put that of the other two groups in perspective.

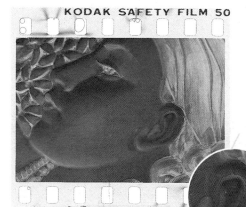

A detail from a ceramic plaque was here photographed on slow, medium, fast and ultra-fast film. At a small enlargement the differences are insignificant, but when the enlargement is greater (here 15×) they can be seen clearly.

Panatomic-X ISO 32

Plus-X ISO 125

Tri-X ISO 400

Recording film ISO 1000

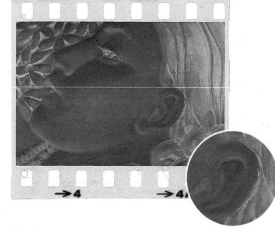

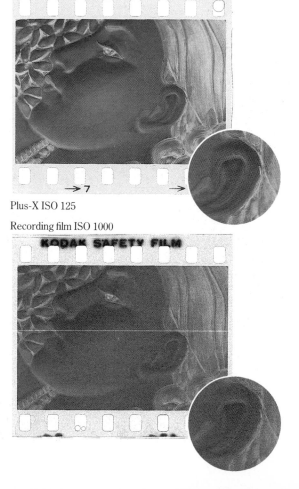

The same film as on page 42 – FP4 – in a smaller size was used here for a 35mm shot in Washington's Air and Space Museum. In the negative, a hint of graininess is just detectable at this 3½× enlargement, but even this is suppressed in the print.

Fast Film

Standard black-and-white fast films have a speed rating of ISO 400: Kodak's Tri-X and T-Max 400, Ilford's HP5, Fuji's Neopan 400 and Agfa's Agfapan 400. By comparison with the slower and medium-speed films looked at on pages 42–5, the grain is much more noticeable, but objectively it is still quite fine. Kodak's flat-grain technology makes T-Max 400 noticeably different from Tri-X, despite the same rated speed. In short, Tri-X tends to hold shadow detail better, and particularly when photo-processed, while T-Max 400 is sharper and less grainy.

Although it is difficult to make direct comparisons between black-and-white and colour films because of a number of psychological factors that come into play, it is still fair to say that the image quality from one of these fast films, when printed, is higher than that from a colour film of the same speed. One good reason is that there is only one emulsion layer in a black-and-white negative, but three in colour film. The typical RMS Granularity (see pages 18–19)

of an ISO 400 colour transparency is around 16 or 17, but for one of these films it is around 14, and Kodak's flat-grain T-Max 400 is even better at 10.

It is for this reason that ISO 400 films are considered by many photographers to be the standard black-and-white film type. For general outdoor photography – reportage and similar types of shooting – this makes camera handling considerably easier than it is for most photographers working with colour transparency film. In daylight, high shutter speeds and relatively small apertures are normal.

Project: Enlarging grain
The limit for normal use is set by the degree of enlargement. Make this the basis of one project: make a short series of enlarged prints from one negative, from about 5×7 inches (13×18 cm) up to 16×20 inches (40×50 cm), and decide for yourself at what point the graininess begins to interfere with the image. This is, as you might expect, a subjective judgement, but

make it on the grounds of the amount of detail that is resolved and on the smoothness of grey tones.

Since film speed is a priority with fast films, the emulsions can be rated at higher than ISO 400 successfully, provided that an energetic developer is used or the development is extended. This in turn exaggerates the graininess, so that if you are going to make regular use of this film type, do the same comparative test with rolls that have been given different development.

This project treats the image in a conventional way, with lack of graininess as the yardstick of quality. Under many circumstances this is difficult to argue with, but there are also occasions when the actual texture of the grain gives an attractive edge and grittiness to the photograph. Once again, it is entirely a matter of taste, but if you have not considered it already, it is worth doing so. Try a number of picture situations with fast and fine-grain film, make a print from each, and see which you prefer. Grain can be enhanced by extended development, by enlarging a detail from the negative, and can be made more obvious by printing on a harder paper grade. Among photographers who value graininess, there are different preferences for the variety of grain patterns among different brands.

Fast films available range from ISO 400 to Kodak's ultra-fast recording film with a speed rating of between ISO 1000 and ISO 4000.

The visibility of grain depends on the degree of enlargement. Both these prints, of a vervet in Tanzania, were made from the same ISO 400 Tri-X negative. The print *left* is enlarged 3½×, while the more magnified view *below*, which has a distinct grainy texture, is enlarged 20×. Note that the grain is most visible in the smooth mid-grey areas, such as the out of focus background.

Ultra-fast films

The ISO 400 films are not the limit for speed ratings, even when push-processed. Kodak's Recording Film 2475 is an ultra-fast black-and-white emulsion that is intended to be rated at between ISO 1000 and ISO 4000. With normal development, Kodak recommends ISO 1600. The resolution, at 63 line pairs per millimeter for a high contrast subject and 32 line pairs per millimeter if low, could hardly be called very good and the grain is distinctly coarse, but for very low-light situations where flash is not an option, this film fits the bill. Available-light photo-journalism and indoor sports photography are typical. Unless you intend a very impressionistic grainy effect, enlargement has to remain low. Recording Film has extended red sensitivity, so giving a lighter rendering of red objects.

A newer ultra-fast film, using flat-grain technology, is T-Max P3200. Its granularity is similar to Tri-X, and although it gives its best results at ISO 1600, can be used practically up to ISO 6400 (or even ISO 12,500 if your expectations for image quality are not too high). T-Max P3200 can be processed in most developers, but Kodak's liquid concentrate T-Max Developer gives the best speed.

Detail and focus both have an important effect on the way grain texture is rendered. The enlargements *above right* show how an unfocused blur allows the grain to come through strongly in appearance, while the detail of wrinkles in the skin suppresses the texture.

Taken on the same film as the photograph on page 47 – Tri-X ISO 400 – this shot of an Indian water buffalo being washed in the Ganges demonstrates that graininess depends on the composition, tonal range and subject as much as on the emulsion. The reason why this negative and print appear to be more finely-grained is that there is no large undetailed area that is mid-grey. Instead, the background is too pale to show much grain, while the main subject is quite detailed with sharp edges.

Chromogenic Film

A different and more recent approach to black-and-white photography dispenses with silver in the final image, borrowing from colour film chemistry to use dye instead of silver grains. Although it is certainly a radical development, and in some senses a breakthrough, this kind of film has not, in the event, made a great impact on the market. Initially, both Ilford and Agfa launched versions of what are called chromogenic or dye-image films, but now only Ilford continues to produce them. In its specifications, chromogenic black-and-white film has some considerable advantages, but there are drawbacks.

The principle is very similar to that of producing an image in colour. Initially, silver halide is used to record the light, but once it has been developed, the silver is replaced with a dye. In colour film, the dye is used for its hue, but here it is used only for its tone. The dye image lacks the distinct graininess of a metallic silver image, and so has some of the characteristics of a finer grained film. In practice, if you compare one shot taken on, say, Tri-X with the same picture photographed on Ilford's XP1 400, the XP1 image will appear smoother and less gritty, particularly in grey, featureless areas.

If you enlarge both negatives greatly, either in a print or under a high-powered scope, you can see the reason for this. The Tri-X negative has a distinct grain texture, but that of the XP1 is made up of softer dye clouds, which in appearance merge together more smoothly, with less of the clumping that gives a conventional silver image its distinctive character. This may or may not be a good thing, depending on whether you like grain texture or not.

The other major feature of chromogenic film is its tolerance of a wide range of exposures – in other words, its latitude. Ilford claim that it can be exposed over a range from ISO 50 to ISO 800 quite satisfactorily, and even up to ISO 1600 if really necessary. Its nominal rating is ISO 400, but the ISO 50 to 800 range will still give an acceptable print with normal development. In effect, this means that XP1 can be underexposed by 1 stop and overexposed by 3 stops. Only if you need to uprate it as far as ISO 1600 does it call for extended development. In uncertain or changing lighting conditions, this makes a chromogenic film very reliable to use, and with its fine grain, it can replace a selection of slow, medium and fast films.

Chromogenic film must be given extra processing steps, however, because the silver image that is first developed must be removed and replaced with dye. In fact, C-41 colour negative processing chemicals will give very good results. For optimum quality, however, Ilford's own XP1 chemicals should be used, as in the table shown here.

Now that Agfa have ceased production of their dye-image film Vario XL, Ilford XP-1 is the sole remaining film of this type, and is available in 35mm and 120 rollfilm.

Although labelled as an ISO 400 emulsion on the pack, this film is intended by the manufacturer to be used up to 3 stops slower and 1 stop faster than this.

Process	Temperature °F (°C)	Time (min)	Comments
Water bath	104 (40)	–	36°F (2°C) above processing temperature.
Developer	100 (38)	5	Mix at 104°F (40°C). Use once and discard.
Bleach fixer	100 (38)	5	Mix at 104°F (40°C). Use once and discard.
Wash	95–104 (35–40)	3	Temperature may be lowered slowly.
Final rinse	95–104 (35–40)	–	ILFORD ILFOTOL wetting agent (a few drops per liter).
Dry	Up to 122 (50)	–	Wipe with a squeegee. Dry in a dust-free atmosphere.

For comparison, a silver box was photographed with both XP-1 (*above*) and a conventional ISO 400 film: Kodak's Tri-X (*left*). Apart from the brown tint to the dye-image negative, which is not, of course, transferred to the print, the two most obvious differences are in the graininess and contrast. Graininess is, as usual, most evident in smooth mid-tones – in this case, the background – and is both finer and more blurred in the XP-1 negative. The softer contrast in this film also helps account for its greater printing range.

Large Format Film

All the discussions and choices around graininess and sharpness on the previous pages are premised on the need to enlarge the image considerably when making the print. Pictures taken on 35mm film will certainly need to be enlarged, and as this is now the most popular format, enlargements will be necessary in the majority of cases. For most photographers, the degree of enlargement depends simply on how large a print is needed, and even this has less of a visual effect than the figures suggest. A 30× or 40× enlargement may well strain the ability of a negative film to hold detail without the graininess taking over, but a full frame printed to those dimensions is normally seen from a greater distance. Small prints tend to be held close, large prints encourage the viewer to stand back. To an extent, then, the natural viewing distance for a picture will even out the differences in graininess.

If, on the other hand, the negative is large to begin with, it needs less enlargement for any print size that you choose. In appearance, this is almost the same as having the image on a finer-grained film. In terms of conventional quality – sharpness, lack of grain, freedom from large specks and blemishes – everything improves if you shoot on a large area of film to begin with. Tonal gradation also benefits, for instead of the slight texture of even a fine-grained film that has been greatly enlarged, a print from a large-format negative can hold the most delicate transitions in tone. A clear blue sky, appropriately filtered (yellow, orange or red – see pages 154–7) to give it substantial tone, shows this particularly well.

Large-format photography uses mainly sheet film – typically 4×5 inch and 8×10 inch negatives – and long-format rollfilm negatives, measuring 6×9 cm or 6×12 cm, also qualify. Sheet film also offers a possibility of even greater image quality: the contact print. This gives a distinct leap in image quality because it does not need any optical system to produce the print, and so the detail in the negative is transferred to the paper almost without any loss at all. With 4×5 inch film this only allows miniature prints to be made, but a contact-printed 8×10 inch negative is a reasonable size and has the potential for outstanding image quality.

Two precautions are important with large-format negative film. The first is to load the sheets carefully enough to avoid dust and lint on the emulsion surface (see pages 34–5). There is more film area to attract them, and in some ways tiny blemishes are the hardest to take out on the print with a brush. The second is to take care in processing: the developer must be given the chance to work on all parts of the sheet at once. Uneven development, by filling the tank slowly or agitating incorrectly, is more likely on a large sheet of emulsion than on a small frame on a roll.

Black-and-white sheet films are available in slow, medium and fast (ISO 320–400) ratings. Some specialist emulsions, such as High-speed Infra-red, are also available.

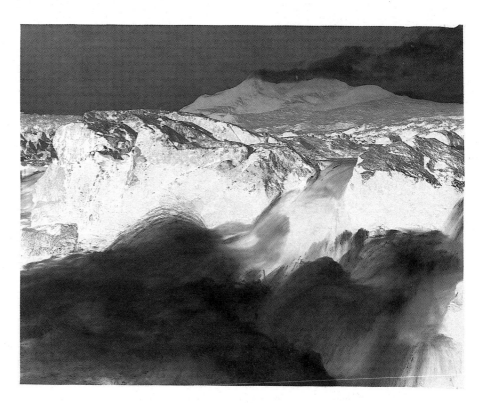

Sheet film's primary advantage is immediately obvious in a black-and-white print: it needs so little enlargement that image quality can be virtually as high as the camera lens allows. In a print from a 4×5-inch fine-grained negative, graininess is not a practical consideration. Working lens apertures for this size of camera are much less than for smaller formats, and slow shutter speeds are common – the streaking of the water shows that a $1/15$ second exposure was used.

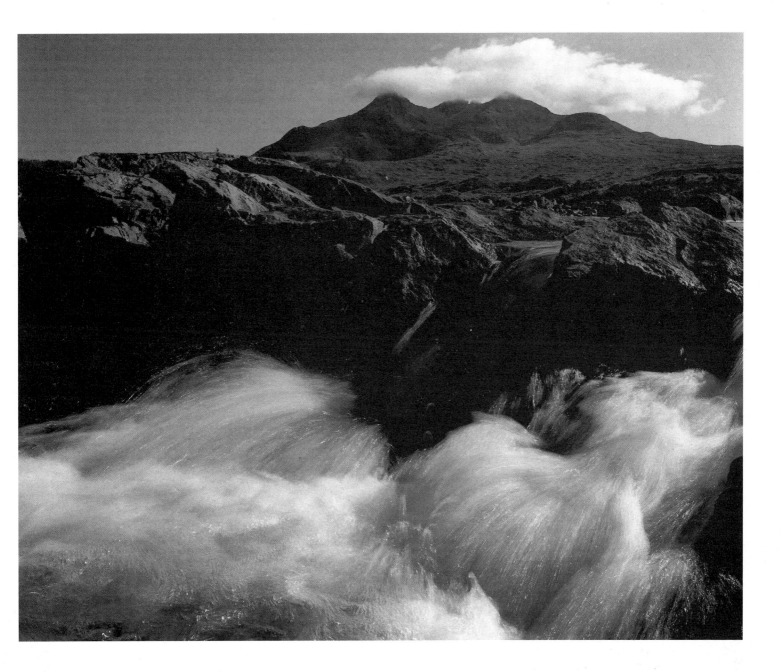

Line Film

Line or lith films have such high contrast that, given the appropriate development, they will produce an image with only two tones: pure white and pure black. A typical piece of processed line film carries a dense black image with sharp edges on a background of completely transparent film. Unlike regular black-and-white emulsions, there is no pale grey tone to the film base; wherever the film was shielded from light, it remains entirely clear. They are known as graphic art films, because their main application is for photomechanical reproduction, but this in no way restricts their uses in regular photography. For certain kinds of copying they are unsurpassed, while a whole range of special effects are possible, including the purest silhouettes.

Several manufacturers produce line emulsions, but the largest variety is from Kodak. Most of the choice is of significance only in graphic art, and for practically any photographic use that you can think of, a basic emulsion such as Kodalith Ortho 2556 Type 3, or Ilford Line Film, will do the job. Practically any black-and-white developer will produce some kind of image, and if you are interested in experiment, try out a variety, including a standard tone developer such as D-76 and even a paper developer like DPC. For the maximum line effect use the chemicals designed purely for line films, such as Kodalith Super Liquid, a two-part concentrate. Films and developers from different manufacturers are compatible, but for consistency, the examples here were all shot on Kodalith 2556 Type 3 and processed in Kodalith Super Liquid.

Most line films are orthochromatic, and so insensitive to red. For the occasional inconveniences of shooting reddish subjects, the advantage of this is that you can process line film by inspection – by watching how the image comes up during development, you can halt it at just the moment that it looks right. With such a high-contrast material this is often important, as the exposed image tends to develop into black silver quite suddenly. For instance, if you have copied a page of type from a book, the negative image on line film will be white lettering on black. If the film is left even a little too long in the developer, the large area of black surrounding each letter will spread, cutting into the type. As long as you can watch the development under a red safelight (a light red filter and a 25-watt pearl lamp no closer than 3 feet or 1 meter), this should not be a problem.

Being orthochromatic, line film has a different speed rating under tungsten lamps, which are reddish, than under flash or daylight. It also differs according to the developer used, but as an example, Kodalith in daylight or flash has a speed of ISO 12 if developed in Kodalith Super Liquid diluted one part developer to three parts water (1+3). Under tungsten lighting, the speed is ISO 8. Even so, line film is very forgiving of different exposure times, and reduced or extended development can usually take care of moderate errors.

With 35mm film, a normal spiral-reel tank is the most convenient method of processing a full roll, but short cuts of film and large-format sheets are best developed in a dish. Any shallow dish will do: tip the liquid from side to side continuously for the 2¼ to 3¼ minutes that most line development needs, with the developer at the usual 68°F (20°C). Rinse the film briefly, then agitate it in the fixing solution for between 2 and 4 minutes. Finally, wash it for 10 minutes in running water, and dry.

Beginning with a normal, continuous-tone black-and-white negative and a piece of outline artwork, the colour transparency *right* was built up with a set of line film conversions. The first stage was a fairly straightforward photograph of a man digging, against a skyline (*opposite page, far left*). A positive line image was made from this by contact copying onto Kodalith Ortho 2556 Type 3. This version was a pure silhouette, with the background completely transparent on the film. The next step was to copy a simple piece of artwork of a power station, also onto line film. The resulting line negative was then contact copied, also onto line film (*below*), for a second-generation positive image. The final shot was taken in a studio, with the line positive of the man in front of a milky perspex sheet and the line positive of the power station behind (to simulate mist). Colour was added with orange and reddish sheets of gelatin behind the translucent perspex, which was backlit.

Project: Copying using line film

One of the strictly practical uses of line film is in copying. An engraving, woodcut, lettering, or anything at all that lacks shading and tones is better copied on line film than on any other. The texture and tone of the paper is removed, and the lines of the subject remain crisp and dense. To do this, use the following set-up. Position the camera facing and parallel to the paper (the two easiest ways are with the paper attached to a wall or flat on the floor or a desktop) with two lamps on either side, each pointing at 45° to the paper. Take either an incident reading with a hand-held meter, or a grey card or white card reading with the camera's TTL meter (see pages 130–1). Remember to rate the line film at a slower speed for tungsten if you are using continuous lighting rather than flash.

Copywork such as this is worthy, but not as interesting a use of line film as special effects. There are a large number of ways of producing effects with line film, and we deal here only with a few basic examples. All rely on the special quality of being able to produce an image that is impenetrably black against a transparent background.

First and second generation conversions

By copying an original photograph onto line film, and then copying that again on line film, you can have the choice of two alternatives: positive or negative. You can also confine any retouching to the black parts of the film (much easier than trying to remove any of the silver image cleanly). So, whether the original is a slide, print or negative, either a reverse or positive image can be made.

One of the easiest techniques with a negative or slide original is to make a contact conversion. Use sheet film and either a contact printing frame or just a plain sheet of glass. All that is needed – and this can be done under a red safelight – is to place the unexposed line film face up, the original on top, facing down, and then switch on a light briefly (the wide exposure latitude of line film means that the time that the light is on is not too critical). Then process the film and dry it. If you are in a hurry to move on to the next step, use a hairdryer. Do any spotting or retouching that is necessary as described on page 59, and then make a second-generation conversion with a fresh sheet of line film. The result will be identically scaled positive and negative versions of the same image.

Line film is ideal for copying artwork and illustrations that have no continuous tones themselves, such as this old engraving. The upper limit to exposure is just before the most closely spaced lines begin to merge. Use the line film as a normal negative.

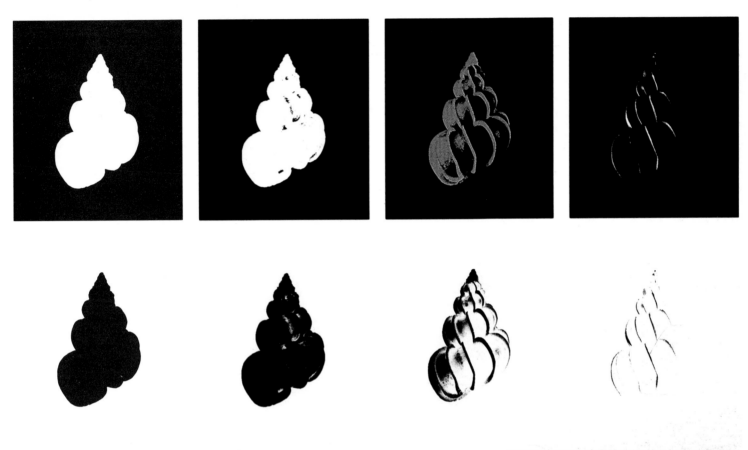

The original shot of the wendletrap shell was made on regular black-and-white film; the negative (*left*) formed the basis for the colour separated image *right*.

By copying the original negative at different exposure times onto line film, a series of images was produced in each of which different tones were recorded. This technique, known as tone separation, is possible because of line film's "either-or" response. The image does not get darker or lighter; instead, the areas of dark and light change.

From the first series of four line negatives (*top*) a set of line positives (*above*) was made. Combining different ones from each set and copying them onto colour film through coloured filters produced a series of transparencies like the colour separated image shown *right*.

Silhouettes

This type of image is one of the most straightforward, and can be shot either directly from the subject, or copied from an existing print, negative or slide. Provided that there is a reasonable separation in tone between the subject and its background, there should be no real problems. Retouching is nearly always necessary with line conversions, but as explained on page 59, this is usually simple and rarely needs skilled artistry. If there is any point at which the dark tones of the original silhouette subject merge with something equally dark, however, this will be awkward to separate, and may need careful retouching that amounts to re-drawing.

The advantage of doing a silhouette with line film is that it can be made absolutely stark and graphic, and any distracting details, such as objects in the background, can be removed entirely simply by blocking them out on the film. The original does not even need to be a dark-on-light silhouette; a white subject against dark can be turned into a line silhouette just as easily. Whether you need to make a second-generation conversion or not depends on the form of the original and whether you are going to print from the line film or copy it as a slide.

Sandwiched silhouettes

Line silhouettes are ideal for adding to regular transparencies to make a sandwich; the clear parts of the processed film do not interfere with the image on the transparency, and the black of the silhouette is strong enough to obscure whatever lies underneath it. Indeed, at times the density of the line image is too strong to match realistically the dark tones in the transparency, and in this event, the answer is to make a copy of the sandwich, with a thin diffusing layer over the line film. This is what was done in making the image of the two men standing on the rock *below*: the line film silhouette of the men was underneath a sheet of the frosted acetate used as backing in transparent slide sheets, which softened the tone and edges of the line image, and on top was the transparency of the landscape. In most cases, making a duplicate of the sandwich is a sensible idea, as the sandwich itself will trap dirt in time.

With care, a line film silhouette can be sandwiched together with a normal transparency and still look natural. Here, the intention was to have two men standing on a rock that had already been photographed. The men were photographed on normal black-and-white film, and a line positive made via a negative on which the background had been blocked out. To blend the two images, they were copied with a sheet of frosted acetate softening the hard line silhouette. The stars were added by double-exposure.

Line into colour slides

An even wider range of visual effects is possible by copying onto colour transparency film with a selection of filters. Treat the line film original as a normal slide for duplicating (see pages 180–5). To colour the image as shown in the example on this page, the filters themselves can be fairly crude. Two or three strips of coloured filter arranged in series can produce the effect of merging hues; you can control this by altering the aperture of the lens (to change the depth of field) and the position of the filters (nearer the lens blurs the edges more). You might also experiment with using another transparency as a colouring filter – a shot of a clear sky at dawn, for example. Simply place the transparency in front of the lens and shoot through it. The slight extra density in the film base will give a mild diffusing effect, and this is often an advantage when copying line film; it takes some of the edge off the black-on-white starkness. A regular diffusing or soft-focus filter can also help.

Retouching line film

Line images lack intermediate tones, so their edges are hard and large exposed areas are simply opaque. Spotting is therefore very easy indeed, and hardly needs any care. The ideal retouching medium is one that is itself opaque, and the most commonly used is a reddish-brown paste known as photographic film opaque. This can be used straight from the bottle, adding water from time to time to keep the consistency smooth and workable, or from a solid "cake". To prepare a cake, just allow some of the paste to dry on a small palette, and use it by working water into its surface with a brush. If you use the paste from the bottle, be careful to mix it thoroughly first; many opaques contain some oil, and if the brush picks this up, you will find that the retouching does not dry completely, but remains tacky.

Retouching does not have to be confined to spotting. Large areas can be blocked out (red masking tape can also be used), and the outline of the image altered, depending on your skill with a brush. The opaque may be applied to either side of the film.

If there are exposed areas of black silver that you want to remove (spots, blemishes, unwanted parts of the original picture), the easiest way is not to try and bleach or scrape them off the clear film background, but to make a second generation line exposure. Then retouch that, later making a third generation conversion if necessary. The hard edges of the image will enable you to make several generations of contact-exposed line conversions with little, if any, loss of detail.

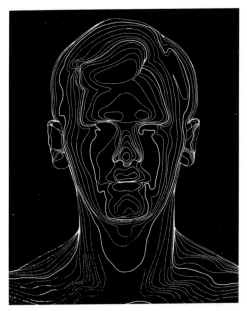

Colour can be added to line film images by simple re-copying onto slide film through coloured gels. If these are positioned close to the lens, their edges will blend smoothly, as shown here.

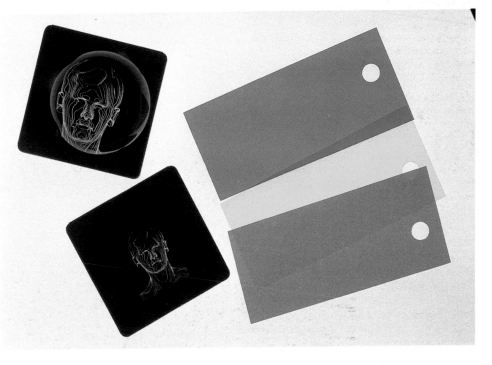

Infra-red Film

Kodak's High-speed Infra-red Film 2481, supplied in standard 36-exposure 35mm cassettes, can produce strange and surreal images out of quite ordinary scenes. The subjects remain recognizable with a full tonal range, but the exact tones are shifted, sometimes in very unusual ways. Grain is extremely prominent, and this adds a distinctive textural quality. Although it is by no means the easiest material to use, high-speed infra-red can be a great deal of fun to experiment with.

Infra-red film is sensitive to infra-red radiation far beyond what the eye can see (but not to the heat radiation given off by the human body – that needs special thermographic equipment to make images). It is also, however, sensitive to the normal range of light and ultraviolet, as are regular emulsions, and in order to take purely infra-red photographs you will need to use quite strong filters, hence the high speed rating of this film. In the first trials you make with high-speed infra-red, shoot the same scenes with no filter, with a dark red filter and with a virtually opaque infra-red filter. The visual differences will be striking.

Although the sun emits infra-red radiation, the levels do not correspond exactly to its light output, but tend to be relatively higher in the early morning and late afternoon. Nor do many surfaces reflect infrared in the same way as they do light; a clear sky reflects less, and so appears dark in an infra-red photograph, while vegetation reflects much more, and can appear white. For this reason, light meters are not very helpful – they are as insensitive to infra-red as your eyes – and there is no ISO speed rating. Until you have considerable experience of shooting high-speed infra-red under a variety of conditions, judging the exposure settings is something of a hit-and-miss affair, and even with experience there are frequent surprises. Fortunately, if you are using this film for pictorial effect rather than for some scientific purpose, rules of correct exposure are not particularly important. Underexposure and overexposure can

In 35mm 36-exposure form, Kodak's High Speed Infra-red film has moderately high contrast, but no exact speed rating, as the proportions of light and infra-red radiation vary from scene to scene.

Most lenses are not fully corrected for all wavelengths of light, and for infra-red light must be focused at a slightly different point. A small red dot or mark is usually engraved on the barrel; this should be used for focusing, rather than the larger central focusing mark.

With a deep red filter, infra-red film reveals some, but not all, of its special qualities. Here, the high chlorophyll content of the grass and palm trees appears brighter than normal.

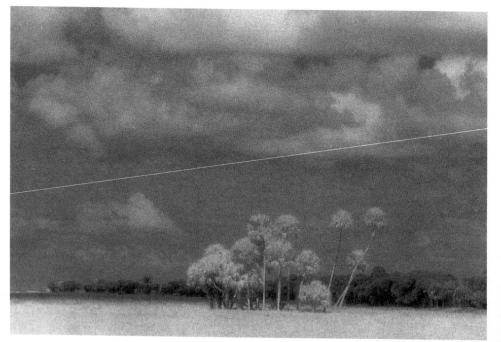

sometimes produce pretty unusual and interesting images.

The basic technique for exposure is to bracket quite heavily around a known setting. This itself varies according to the filters you use, but as a starting point, on a bright, sunny day in the open, try $\frac{1}{125}$ second or $\frac{1}{250}$ second with a 25 red filter. Without a filter, close down 2 stops, or with an opaque 87 filter open up 2 stops. Bracket up to 2 stops above and below these settings. Overexposure will, as with any film, enhance the graininess, and this will be the most visible in broad areas of smooth tones. If you like the textured effect of high-speed infra-red grain, this is a useful technique to remember.

The filters make a surprising difference. Without any, the effect is not very distinctive, and with some subjects appears almost normal, though grainy. The contrast also is likely to be low. A red filter, however, cuts out the ultraviolet and blue light and produces the characteristic infra-red image: clear skies almost black except on the horizon, vegetation white and glowing. A Kodak Wratten 25 red is probably the closest thing to a normal filter for this film, but the darker 29 and 70 will exaggerate the infra-red effects even more (at the cost of longer exposures).

For the most extreme effects try one of the range of filters that eliminate virtually all visible radiation: Wratten 87, 87C, 88A or 89B. Focusing and composing is impossible with any of these filters fitted, unless you are using a rangefinder camera, and the most reliable method is to use a tripod and set up the camera without the filter, fitting it in front of the lens just before shooting.

Infra-red wavelengths are longer than visible ones, and so focus further back, behind the sharp focus that you can see. For this reason, some lenses have a red dot on the barrel offset slightly from the normal focusing mark. Use this for focusing, or else focus the lens forward from its sharp visual focus by $\frac{1}{4}$ per cent of its focal length (for example, 0.25mm for a 100mm lens). Lenses made with ED (extra dispersion)

glass do not need any adjustment, and if you stop the lens down, the depth of focus will also take care of inaccuracies.

Film care is particularly important. High-speed infra-red film is so easy to fog that if you take the cassette out of its canister in anything other than complete darkness, some of the film is likely to be ruined. Take no chances and load the camera at home, if possible in a light-tight room. If you plan to shoot more than one roll, carry a changing bag (and still try to use this in subdued light as far as possible).

Another high-speed infra-red film is available for view camera users: Kodak's number 4143, available in 4×5 inch sheets. The value of this is that, if you want the tonal effects of infra-red without the grain, this film format is large enough. It is, however, even trickier to use, as sheet film holders offer less protection to fogging than a 35mm cassette in a closed camera. Another problem is that the emulsion itself is more delicate, and pinpricks and scratches are difficult to prevent.

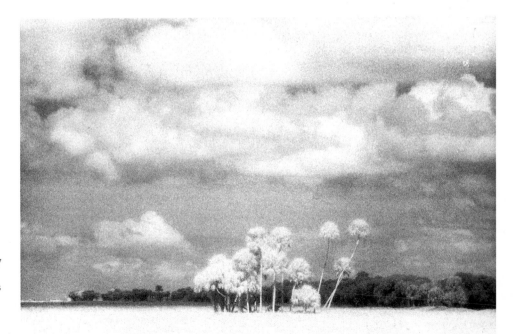

With a visually opaque 87 filter, the same scene as that shown *opposite* looks more surreal. The grass and palms are a brilliant white, and the sky contrast is higher.

Instant Film: 35mm Slide

Although the majority of instant films are in the form of colour prints, there is a significant and useful range of black-and-white materials. For 35mm cameras there are black-and-white transparency films available in conventional cassettes and needing no special backs or adaptors to use; for medium- and large-format cameras there are different print films and one very valuable instant negative material.

There are two black-and-white slide films presently available for 35mm cameras. Both are loaded and exposed just as conventional film, needing only one item of special equipment: the Polaroid Autoprocessor, a self-contained unit that develops the film by hand-cranking or with an electrically-driven motor (there are two versions available). Each cassette is supplied with its own sealed pack of chemicals.

Polapan CT

Like most conventional black-and-white films, this is a panchromatic emulsion, available in 36-exposure cassettes, with a medium speed rating of ISO 125. The difference is that the final product is a transparency. As a slide film, it has less exposure latitude than normal negative emulsions, and in shooting it is probably better to think of it as a colour slide film; for instance, slight underexposure is usually more acceptable visually than the equivalent amount of overexposure.

The Autoprocessor, here the hand-cranked model, can be operated outdoors as easily as inside. The processing pack is loaded first, and its leader attached to the winding spool. The exposed film is then loaded, and its leader also attached. The cover is closed and the chemical pod broken with a lever. The crank handle is turned as far as it will go. Then, after a pause of 1 minute for Polapan or 2 minutes for Polagraph, the lever is returned and the crank rotated to rewind the film.

The two principal black-and-white 35mm instant films are continuous-tone Polapan CT, available in 36-exposure cassettes and high-contrast Polagraph HC, in 12-exposure cassettes. Each comes with its own box-like pack of chemicals.

The principle of this instant process is a sandwich of two layers of film, with the exposure made *through* the clear film base (back-to-front when compared with conventional films). The first silver to be developed is in a negative layer that is eventually stripped away; the final image is formed by the remaining unexposed silver halide grains that migrate down to the receiving layer and are reduced to black metallic silver. The full processing sequence is the same as for the colour slide version, and shown on pages 122–3.

A major precaution is to protect the developed emulsion from damage. Polaroid slide films are particularly vulnerable for two reasons: the protective layer is thinner than that on conventional films and by no means as tough, and viewing is done with the emulsion side uppermost. Never slide a loupe over the surface; it would do little to a normal colour slide or negative, but it is likely to scratch a Polapan slide.

This back-to-front construction of the film creates a slight problem if your camera uses an off-the-film (OTF) metering system. OTF metering methods rely on a matt surface from which to take readings, but with Polapan it is the shiny film base that faces the lens and meter. It is safer under these circumstances to use a manual meter setting, but the fact that this is an instant film at least allows you to check the accuracy within a minute or two.

Polapan's fairly high contrast compared with regular black-and-white negative emulsions suits it to graphic scenes, like this view down the driveway to an English country estate, with its bands of sunlight and shade.

Using the hand-cranked Autoprocessor, the processing sequence begins when the processing fluid pack is broken by pressing a lever. After a pause, the crank handle is turned to feed the strip sheet from the processing pack alongside the film *left*. Once development is complete, the crank handle is turned to rewind the film into its cassette and the strip sheet back into its pack *right*.

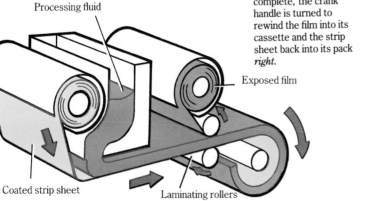

Processing fluid

Exposed film

Coated strip sheet

Laminating rollers

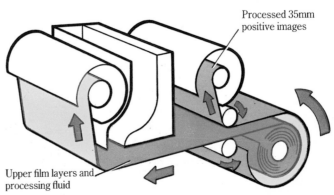

Processed 35mm positive images

Upper film layers and processing fluid

Polagraph HC

This is the high-contrast version of instant black-and-white slide film. Although its contrast is not quite as high as that of lith film (see pages 54–9), it produces acceptably clean, dense black/clear film base copies of artwork. It is, in fact, intended for audio-visual use, although this by no means invalidates it for normal use. To achieve the dense blacks, development is twice as long as for Polapan and Polachrome: two minutes instead of one. In all other respects, it is constructed and used in the same way.

The exposure latitude for this high-contrast film is, in theory, very narrow. To produce a "correct" exposure, you have a leeway of only ⅓ stop over and under. In practice, however, the stark, graphic treatment that Polagraph gives to normal, toned subjects makes the idea of correctness largely academic. As the examples here show, different exposures simply produce different images with many types of subject, and these may be acceptable or unacceptable according to personal taste. Polagraph's great value in conventional photography is its ability to add life and contrast to views that are tonally flat. Try using it for outdoor subjects when the lighting is overcast and uninteresting.

Polagraph is panchromatic, unlike other lith films which are blue-sensitive. This has a special use in outdoor photography: by using a red or orange filter, blue skies can be darkened to a dense black that would be impossible to achieve with a conventional black-and-white film.

When shooting artwork and lettering – Polagraph's intended use – follow the procedures recommended for lith films on page 56. One difference is that, as Polagraph is panchromatic, its effective speed does not change when orange tungsten lamps are used. You can use an ordinary table light or desk lamp without having to worry about the exposure setting. As with any other kind of copy work, either use a hand-held incident meter, or take a direct reading from white paper and add 2 stops.

Polagraph
Unlike other lith films, Polagraph is panchromatic, and responds to the use of a deep red filter. Here, a Wratten 25 red produces a deep black from a blue sky.

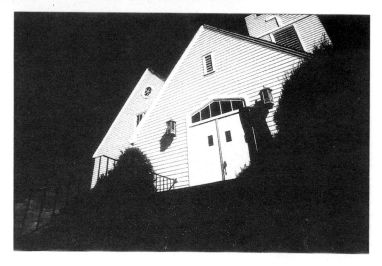

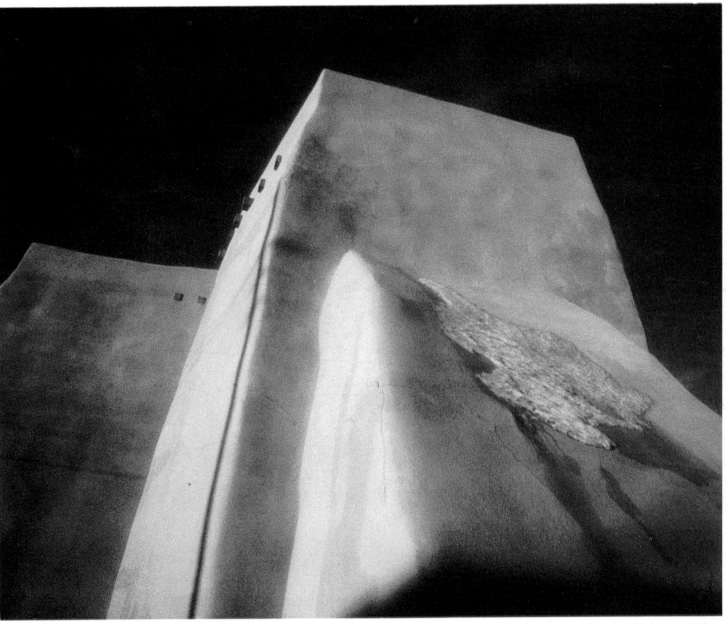

Part of the high-contrast effect from Polagraph film comes from the development. Using a Polachrome CS processing pack instead of the chemicals packed with the Polagraph moderates this for an unusual blend of continuous-tone and high-contrast.

Instant Film: Peel-apart Prints

Polaroid peel-apart films work on the principle of a pack that contains a negative and a positive receiving layer, with a sealed pod at one end of the sandwich containing the alkaline processing fluid. The Polaroid cameras that are designed to accept these films, and the special backs and film holders that attach to conventional cameras, hold the film pack or sheet in place.

The negative layer in the sandwich is exposed alone when shooting, but kept pressed to the positive receiving layer for processing and the fluid from the pod squeezed out between these two layers. After a specified time, which varies according to the type of film, the packet is opened, thereby separating the negative from the positive. The negative and used chemicals are then discarded, leaving a black-and-white print.

The only exceptions to this procedure are for Types 55 and 665, the Positive/Negative films, which produce a negative that can be preserved and used as any conventional black-and-white negative. The mechanics of doing all this vary according to the type and format of film, and according to the design of camera or holder, but all have in common a set of rollers that squeeze the pod containing the processing fluid.

Processing

There is nothing complicated about the use of any of these instant films, but it is important to take care over the processing stage. A well-developed, blemish-free print depends on the processing fluid being spread smoothly over the emulsion. To this end, the rollers must be spotlessly clean and properly adjusted, and you should learn how to pull out the film packet in a smooth action, neither too fast (which may leave areas uncovered by the fluid) nor too slow (which can cause uneven tones in the shape of bars across the picture).

There is considerable latitude in the processing time (the period between squeezing the pod and peeling apart the packet) and in the temperature at which the

Processing peel-apart film
The examples shown here are the 4×5-inch film size, but the smaller formats follow the same procedure in principle.

1 Having pulled the film packet smoothly out of the holder through the metal rollers, pull the two end flaps apart.

2 Tear the envelope down as far as the metal tab at the end in one movement.

3 Hold down the negative and its thin paper mask with a thumb or finger (to avoid traces of the reagent smearing the print), and pull up the print with the other hand.

4 Finally, unless the print is of the coaterless variety, place it on a flat, clean surface, and apply the coating liquid with the swab provided, in smooth, overlapping strokes.

film develops, but any big differences will affect the appearance of the print. The chemical reactions are slower at low temperatures, while very hot conditions can soften the emulsion to the point that it damages easily. An ideal temperature is about 70°F (21°C).

Remember that the only important temperature is that of the film pack from the moment it is pulled through the rollers. This may not be the same as the surrounding air temperature, and a tip on cold days is to slip the film packet under your clothes to keep it warm with body heat. It does not matter at what temperature you expose the film, so that even if the film is very cold at the time of shooting, there should be no problem provided that you warm the pack up as much as possible before starting the development process.

Coating and storage

All except two specialized films (107C and 87) need a little protective treatment after processing. Included in each film pack are swabs impregnated with an acidic solution. This serves two purposes: it neutralizes any trace of the alkaline processing fluid, which would otherwise continue to act slowly, and it dries to a hardened protective coating that will resist normal scratches. You should apply the coating as soon as possible, and certainly within half an hour, otherwise the highlights and pale tones will begin to bleach out (although this is a useful trick to know if you want to increase the contrast, as the dark shadow areas remain unaffected).

Under dry conditions, the coating will harden in a few minutes, but in cool or humid weather it can take considerably longer. While the coating is drying, take care not to touch it. If dust or fingerprints have spoilt the finish, you can dissolve the coating with fresh coater fluid and remove particles with a small brush. The coating can be removed entirely with a 6 per cent solution of acetic acid or vinegar, but remember that the print is then unprotected.

Development times (seconds) **(NR=not recommended)**

Temperature ▶ ▼ Film type	90°F (32°C)	85°F (29°C)	80°F (27°C)	75°F (24°C)	70°F (21°C)	65°F (18°C)	60°F (16°C)	55°F (13°C)	50°F (10°C)	45°F (7°C)	40°F (4°C)
Type 52	15	15	15	15	20	25	30–35	35–45	45–50	NR	NR
Type 552	20	20	20	20	25	30	35–40	40–50	50–55	NR	NR
Type 55	20	20	20	25	30	30–35	40	50	60	NR	NR
Type 665	20	20	20	25	30	35	40	50	60	NR	NR
Type 51 (high-contrast subjects)	15	15	15	20	20	20	20	20	25	25	25
Type 51 (average-contrast subjects)	10	10	10	10	10	10	10	10	10	10	10
Type 107C(667)	30	30	30	30	45	60	75	85	90	NR	NR
Type 107(084)	15	15	15	15	15	20	25	30	30–45	45–55	45–55
Type 87	30	30	30	30	45	60	75	85	90	NR	NR
Type 57	15	15	15	15	15	20	25	30	30–45	45–55	45–55

Instant negatives
A travelling kit for handling Polaroid Types 55 or 665 includes the plastic bucket (available from Polaroid) filled with a sodium sulphite solution, a line for hanging negatives to dry, negative hanger or film clips, and negative sleeves for storage.

With a hanger, clip the washed negative at each corner and hang on a line in a dust-free room.

Fine-grain black-and-white

Although the large-format Type 52 and medium-format Type 552 have the same sensitivity as conventional fast films – ISO 400 – they do not have the same degree of graininess. Like other instant print films, they are essentially contact prints, so that with no enlargement involved, their image quality is outstandingly good. The resolution is high, the tonal separation very clear, and in addition there is a special, delicate character – what the American photographer Ansel Adams, who used this film extensively, called "an acceptable degree of

perceived sharpness accompanied by a subtle 'glow' in the print that is often of great aesthetic advantage". The contrast is higher than an equivalent conventionally printed negative, making these films best suited for scenes with fairly even lighting.

Treated carefully rather than as a quick test prior to shooting on conventional film, these fine-grain instant prints can deliver images of the highest quality. They also allow considerable control over contrast, by means of the development time and delaying the coating. If you extend the development beyond the recommended time,

more silver is deposited on the print, making the image darker. This affects the shadow areas more than the lighter tones, thereby tending to increase contrast. Conversely, reducing the development time lessens contrast, although there is a risk here of uneven processing. The coating, as we have already seen, prevents further activity on the surface of the print, so that if you deliberately delay using it, the light areas will begin to bleach, again increasing contrast, but this time at the bright end of the scale. Used together, the two techniques can give considerable control.

Desired effect	Exposure	Development time	Coating
Darker shadows	Normal	Longer	Immediate
Brighter highlights	Normal	Normal	Delay
Darker shadows and brighter highlights	Normal or slightly longer	Longer	Delay
Lighter shadows	Normal	Shorter	Immediate
Darker highlights	Less	Shorter	Immediate
Lighter shadows and darker highlights	Slightly shorter	Shorter	Immediate

1

2

3

Contrast control
With Type 52 film, the contrast of the print can be manipulated by changing the development time and by delaying the coating. The table shows the permutations. In this example, the first print **1** was processed normally. The second was given extended development (60 seconds), which deepened the blacks. The third received the same long development, and the highlights were then allowed to bleach for about 20 minutes before the coating was applied.

Positive/Negative film
The exposure for a good print is not the same as for a printable negative with Types 55 and 665. At its normal film speed rating (ISO 50 for the Type 55 here), a well-exposed print is accompanied by a negative that is too thin.

To produce a good negative, the film was rated at ISO 32; the accompanying print is too light.

Positive/Negative

These films, Types 55 and 665, are extremely versatile, producing an exceptionally fine-grain print and a good negative that can be used for conventional enlargement. The negative, being thinner than conventional emulsions, has the very high resolution of 165 line pairs per millimeter (see pages 16–17). Special care is needed in order to clear and preserve it: after separating it from the print, you should place it immediately in a sodium sulphite bath to clear away traces of the processing fluid and the antihalation backing (an 18 per cent solution for Type 55 and 12 per cent for Type 665); Polaroid provide a small bucket with compartments that can be sealed with a lid and carried on location. After a few minutes' clearing, the negative can be washed in water and dried in a normal clip hanger. If you work on location with this film, it is usually a good idea to wash and dry each day's take to avoid overcrowding the bucket.

One thing you will find in exposing this film is that the settings that give a well-exposed print are not quite the same as those for the accompanying negative. In warm weather, the negative will appear about ⅓ stop slower than the print, but in cool conditions, it can be up to 1 full stop slower (and therefore thin). Bear this in mind if you are shooting for the negative rather than the print.

High-contrast

There is a single version of this film, Type 51, available only as a 4×5 inch sheet. It is by no means as high in contrast as lith film, but it has a very pronounced effect and, like lith films, is blue-sensitive. In practice this means that blue skies, for instance, reproduce white, and red objects very dark, if not actually black. The exposure range is narrow, as you would expect from a high-contrast emulsion, but the contrast and density can be manipulated in the same way as just described for fine-grain black-and-white (see page 68).

High-speed

These films have noticeably lower image quality, being more grainy than those already mentioned and with low-to-medium contrast. Nevertheless, with ISO ratings of 3000, they can be used in lighting conditions and at shutter speeds that would be impossible with conventional films.

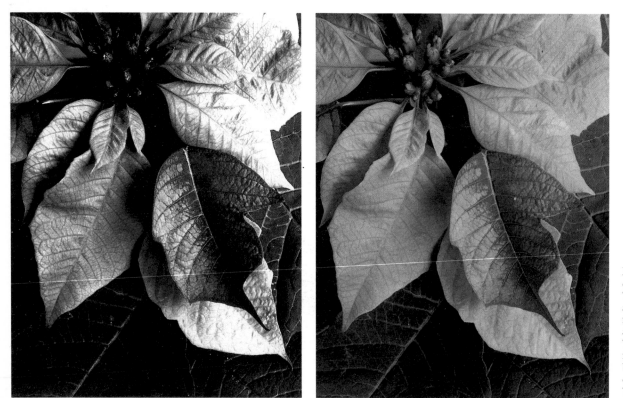

Normal versus high contrast
Type 51 (*far left*), available on 4×5 inch film, is orthochromatic and with high contrast. The contrast and colour-rendering differences can be seen when it is compared with normal Type 52 (*left*).

Film type	Type 52 Fine-grain	Type 552 Fine-grain	Type 55 Positive/Negative	Type 665 Positive/Negative	Type 51 High-contrast	Type 107C (667) High-speed coaterless	Type 107 (084) High-speed	Type 87 High-speed coaterless	Type 57 High-speed
Format inch (cm)	4×5 (10.5×13) single packs	4×5 (10.5×13) pack	4×5 (10.5×13) packs	3¼×4¼ (8.3×10.8) pack	4×5 (10.5×13) single packs	3¼×4¼ (8.3×10.8) pack	3¼×4¼ (8.3×10.8) pack	3¼×3⅜ (8.3×8.6) pack	4×5 (10.5×13) pack
Image size inch (cm)	3½×4½ (9×11.4)	3½×4⅝ (9×11.7)	3½×4½ (9×11.4)	2⅞×3¾ (7.3×9.5)	3½×4½ (9×11.4)	2⅞×3¾ (7.3×9.5)	2⅞×3¾ (7.3×9.5)	2¾×2⅞ (7.3×7)	3½×4½ (9×11.4)
Sensitivity	Panchromatic	Panchromatic	Panchromatic	Panchromatic	Blue-sensitive	Panchromatic	Panchromatic	Panchromatic	Panchromatic
Speed	ISO 400	ISO 400	Print: ISO 50 Negative: ISO 32 (varies with temperature)	Print ISO 75 Negative ISO 50 (varies with temperature)	Daylight (5500 K): ISO 320 Tungsten (3200 K): ISO 125	ISO 3000	ISO 3000	ISO 3000	ISO 3000
Contrast	Medium (1:48 or 5½ stops)	Medium (1:48 or 5½ stops)	Medium (print 1:24 or 4½ stops, negative 1:128 or 7 stops)	Medium (print 1:16 or 4 stops, negative 1:48 or 5½ stops)	High 1:4 or 2 stops)	Medium high (1:8 or 3 stops)	Medium high (1:8 or 3 stops)	Medium high (1:8 or 3 stops)	Medium high (1:8 or 3 stops)
Resolution	Fine (20–5 line pairs/mm)	Fine (20–5 line pairs/mm)	Fine (print 22–5 line pairs/mm, negative 150–60 line pairs/mm)	Good (print 14–20 line pairs/mm, negative 160–80 line pairs/mm)	Very high (28–32 line pairs/mm)	Moderate (11–14 line pairs/mm)	Good (16–22 line pairs/mm)	Good (16–20 line pairs/mm)	Good (18–22 line pairs/mm)
Normal processing	15 sec at 70°F (21°C)+	20 sec at 75°F (24°C)+	20 sec at 70°F (21°C)+	30 sec at 70°F (21°C)+	High contrast originals: 15–20 sec at 65°F (18°C)+ Average contrast originals: 10 sec at 65°F (18°C)+	30 sec at 70°F (21°C)+	15 sec at 70°F (21°C)+	30 sec at 70°F (21°C)+	15 sec at 70°F (21°C)+
Reciprocity compensation 1/100 sec	None	None	None	None	None	None	None	None	None
1/10 sec	None	None	None	None	None	None	None	+⅓ stop	None
1 sec	None	None	None	None	+⅓ stop	+⅓ stop	+½ stop or ½ sec	+1 stop or +10 sec	+1 stop or +1 sec
10 sec	+⅓ stop or +3 sec	+⅓ stop or +3 sec	+⅓ stop or +3 sec	+½ stop or +5 sec	+⅔ stop or +6 sec	+⅔ stop or +8 sec	+1 stop or +10 sec	+1 stop or +10 sec	+1 stop or +10 sec
100 sec	+1 stop or +100 sec	+1 stop or +100 sec	+1 stop or +100 sec	+1⅓ stop or +150 sec	+1⅓ stop or +150 sec	+1 stop or +220 sec	+1½ stop or +180 sec	+1⅔ stop or +220 sec	+1½ stop or +180 sec

Incomplete coating
Except for coaterless prints, it is important to apply the coating fluid evenly and well. If any part of the image is left uncovered, as in this example, it will, in time, bleach away almost completely.

Processing Black-and-White Film

Of all the chemical processes in photography, the most straightforward is the development of black-and-white film. Unlike the processing of colour transparency film, which most photographers wisely leave to professional laboratories, there is every good reason for developing black-and-white yourself. By careful choice of developer, and by occasional adjustments to the time or temperature (see pages 74–5), you can exercise important control over the negatives. Control is, of course, also possible with colour materials, but not to the same degree, and the sandwich of emulsions in colour film can introduce unwanted variations when you make processing adjustments. Moreover, as the bulk of mass-market photography is in colour, most laboratories have abandoned black-and-white processing, and some of those that do it in addition to colour work are not as rigorous as they might be in quality control. You are unlikely to find a laboratory that will give the same care to your black-and-white

film as you will. (For Altered Processing, see pages 146–7.)

Choice of developer

The action of a film developer is confined to the areas of the film that have been exposed to light; it reduces the silver halide crystals to black metallic silver. Modern developer solutions are a combination of chemicals, and the most common of these is the type known as M-Q. This combines metol, which gives detail and is gentle in its operation, and hydroc ne, which gives density. In practice, photographers who develop their ow choose one developer for a particula n and stick to that; there are obviou antages in making yourself thoroughl liar with one solution and knowing e y how it will behave.

If hat you need from a developer is ba redictable results, the best thing yo do is to take the film manufacturer's a . If your interests are deeper and you to explore subtle differences in effect,

make a series of tests using the same film and similar shooting conditions, and compare the results obtained from a selection of developers. These differences will certainly be very small, and whether or not they are significant will depend on you.

There are three main areas in which developers can differ, and major manufacturers such as Kodak produce a range of developers to suit different needs. These areas are grain, acutance and energy. All modern developers give good fine-grain results, but some, like Kodak's Technidol, are designed to produce the smallest possible size of silver particles. The graininess is, of course, determined much more by the type of emulsion than by the processing. If you want fine grain, start with the right film; do not make the mistake of using a fast, fairly grainy film and then trying to reduce the graininess by using, for instance, Microdol-X. The fine-grain developer will do its job, but the results will not be as satisfactory as those from a sensible choice of film.

Agfa Rodinal 1:25	Ilford ID–11 s	Kodak D–76	Kodak Microdol–X	Kodak LC Technidol
Agfapan 250 4 mins	Pan–F ns	Panatomic-X 5 mins	Panatomic-X 7 mins	Technical Pan 11 mins
Agfapan 100 5 mins	Fp–4 6½ mins	Plus–X 5½ mins	Plus–X 7 mins	
Agfapan 400 7 mins	HP–5 7½ mins	Tri–X 8 mins	Tri–X 10 mins	

Film/developer combinations Although there is nothing to prevent you from using any normally available developer with any brand and type of black-and-white film, these are the manufacturer's recommendations. Naturally enough, film manufacturers suggest using their own branded developers. The development times given here are for the standard temperature, 68°F (20°C).

**Equipment and
materials for
processing**

Processing tank with
spiral reel

Processing kit for black-
and-white films

Graduate containers for
solutions

Darkroom thermometer
accurate to within ¼°F
(0.15°C)

Darkroom timer

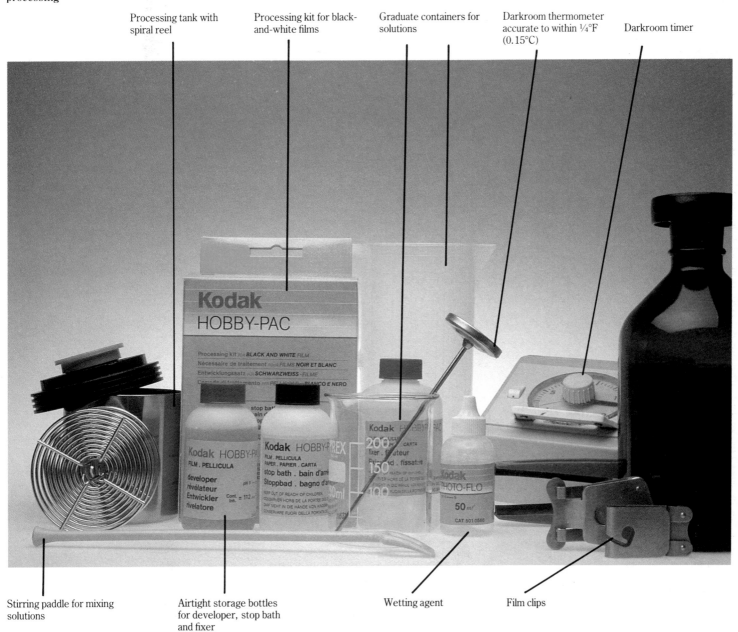

Stirring paddle for mixing
solutions

Airtight storage bottles
for developer, stop bath
and fixer

Wetting agent

Film clips

High acutance developers enhance the sharpness of the image by being more active in areas of fine detail than in larger, more heavily exposed areas of the film. Between areas of different density they also have a tendency to build up a thin edge of silver. Tetenal Neofin is an example; some basic developers such as DK-50 and Agfa Rodinal also give higher acutance if you dilute them strongly.

High energy developers are very active, enhance shadow detail and contrast, and are recommended for low-light photography. Their effect is similar to a speed increase, but image quality can suffer, particularly in graininess and fog levels.

Developers are available as powders for mixing into solution, and as ready-to-pour liquids. Most are recommended for use at different dilutions, with correspondingly adjusted development times. Single-shot developers are intended to be used once only, and are convenient if you develop film only occasionally. If, however, you develop large amounts of film regularly, you may prefer to use the type of developer that can be replenished. Provided that you follow the replenishment instructions to the letter, this can save you money.

Preparing the chemicals
The first thing to remember is to take no chances with the procedures, but follow the instructions that are packed with the chemicals to the letter – particularly when you are learning to process film for the first

	SMALL TANK – Agitate at 30-second intervals					LARGE TANK – Agitate at 1-minute intervals				
	65°F 18°C	68°F 20°C	70°F 21°C	72°F 22°C	75°F 24°C	65°F 18°C	68°F 20°C	70°F 21°C	72°F 22°C	75°F 24°C
HC-110 (Dilution B)	8½	7½	6½	6	5	9½	8½	8	7½	6½
D-76	9	8	7½	6½	5½	10	9	8	7	6
D-76 (1:1)	11	10	9½	9	8	13	12	11	10	9
Microdol-X	11	10	9½	9	8	13	12	11	10	9
Microdol-X (1:3)	–	–	15	14	13	–	–	17	16	15
DK-50 (1:1)	7	6	5½	5	4½	7½	6½	6	5½	5

Temperature and tank variations
The standard recommended temperature for black-and-white processing is 68°F (20°C), but developing can be carried out within a range of temperatures without a problem. The main thing to remember is that the warmer the developer, the more active it is, so that to compensate for temperature variation the development *time* must be adjusted. Equally, the amount of agitation affects the development; even if you follow the instructions given here, you must also make allowance for the size of the tank you use. Here, "small" means one-quart (1.14 liter) capacity or less. The variations given here are for one film: Kodak's Tri-X in Kodak developers.

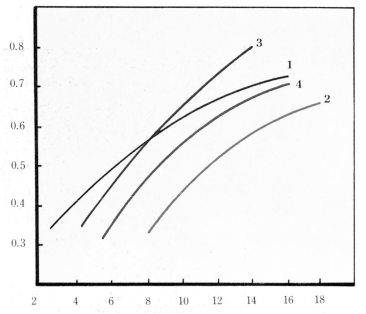

Time of development (minutes) 68°F(20°C) agitation at 30-second intervals

Developers
1 HC-110
2 Microdol-X
3 D-76
4 D-76 and Microdol-X

How developers affect contrast
Different developers, and different dilutions, can give you a choice in the amount of contrast, as this graph shows. One film – Tri-X – appears more or less contrasty if a single development time is used for a variety of developers. Alternatively, to ensure consistent contrast, the times must be adjusted if you change developer.

◀Clear film with rebate letters

Normal processing, but the film has not been exposed. Had there been even a hint of exposure, some detail would be visible; as it is, not even the edges of frames appear. Possibly a film has been processed that was not even loaded in the camera; alternatively, the film leader may not have been attached properly to the take-up spool (see pages 24–5) and remained in its cassette during what was thought to be a sequence of exposures.

▶Completely black film

Processing was normal in this case, but the entire film has been exposed severely to light. This is not overexposure through the lens, but overall fogging, enough to obliterate the rebate information.

▶Black frame

The rebates remain clear, indicating that the excess fogging of the film occurred through the camera's film gate. This is severe overexposure, possibly a result of the shutter sticking open, or the film being exposed to normal lighting with no lens fitted.

Thin and underexposed

The image is pale and lacks density, but the rebate lettering appears normal and strong. You can tell from this that the development was normal, leaving the alternative that the film received insufficient exposure. Perhaps a mistake was made in reading the meter, or in setting the shutter speed or aperture, or too high a film speed rating was assumed.

Thin and underdeveloped

The rebate information helps to distinguish between this and the negative *above*. The lettering is thin, lacking density, signifying that the film has not been developed sufficiently. This could be too short a development time, too low developer temperature, overworked or diluted developer, or a combination of these.

Dense and overexposed

There are no clear shadow areas, and even the palest areas are fairly dense. The rebate lettering, however, still appears normal. The film has received too much light during exposure in the camera, due to wrong settings, which may have been due to wrong metering.

Dense and overdeveloped
As with the pair of too-thin negatives on page 79, what distinguishes the exposure fault from the processing fault is the appearance of the rebate lettering. Here the lettering is so dense that it has begun to spread and merge. It could be that the developer was insufficiently diluted or too warm, or the film was left for too long in the solution or agitated too much. There may have been a combination of these errors.

Sprocket marks
These can be due either to excessive tension on the perforations (some motor-drives can do this, or violent use of the advance lever) or to incorrect agitation during development. The effect, most noticeable in smoothly toned areas of the negative, is of a shadow leading into the frame from each perforation.

Reticulation
The crazed effect on the emulsion that causes this specific film fault is relatively uncommon, as it needs a sequence of hot and cold solutions during processing. The probable cause is excessive developer temperature followed by a cold wash and/or fixer.

Undeveloped blotches
Irregular blemishes like this occur when two pieces of film are in contact during development, preventing the developer from acting on the emulsion. The usual cause is incorrect loading onto the spiral reel; if the film buckles in one groove, it can press against an adjacent emulsion surface.

Edge light leaks
This is not uncommon with rollfilm, if the film has been loaded in bright light or if the outer rolls of paper are loose on the spool (see page 30). As long as the leak is confined to the very edge of the rebate, there is no harm, but more severe exposure causes the fogging to extend into the frame.

Scratched and torn emulsion
This occurs after processing, while the film is still wet and the emulsion soft. Even slight pressure from a fingernail is sufficient to damage the emulsion. Take care when wiping the film down and hanging it to dry.

Overall grey veil
If the entire film, including the rebates, appears grey, the cause is overall fogging. A likely reason for this is a light leak in the darkroom while the film is being loaded into the tank.

Drying marks
The film has not been wiped down before drying, and has not been dipped in Photo-Flo. As a result, the water has dried unevenly, the last remaining droplets leaving marks on the emulsion. Re-wetting and drying carefully may help, but severe marks such as these cannot be removed entirely.

Printing Basics

Negatives are only a partway stage in the production of the final image, and on these pages we look at the best ways of producing black-and-white enlargements from them. If you are using colour transparency film, and your end product is a set of slides, then it is perfectly reasonable to ignore darkroom procedures; if, on the other hand, you are shooting with prints in mind, it is important to know what can and what cannot be accomplished during enlargement. This applies whether you have your own darkroom or not; if a laboratory will be printing your negatives, you will get the best results if you instruct them properly and accurately.

A great deal of manipulation of the image is possible in the darkroom, and some unprepossessing negatives can be turned into powerful photographs, given sufficient skill and patience during the processing. At this stage in the Workshop, however, it is probably a little dangerous to make too much of heroic darkroom measures. If relying on printing skills to create an image encourages you to be casual during shooting, there is little advantage. For the time being, it is best to perfect a standard printing technique, as shown here.

Equipment

The principal item, and the major investment, is the enlarger. For black-and-white negatives it does not have to be complicated, as there is no need for the light source to be colour corrected or for a filter system, but if you are buying one for the first time, you might want to consider whether you will also want to print colour negatives or transparencies. If so, look for an enlarger with a colour head, or one that can later accept a separate colour head.

There are two basic light source systems: condensers and diffusers. A conden-

1 Check that the enlarger lens and condensers are correct for the format of negative, adjusting the lamp until the picture area of the empty carrier is evenly illuminated. Remove the carrier and place the selected negative in it with the emulsion side facing down.

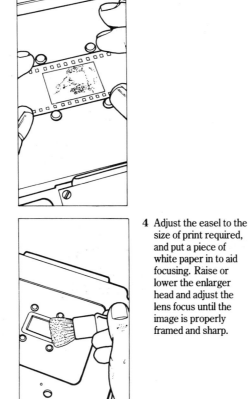

2 Switch off the room lights and hold the carrier at an angle under the enlarger lens to check for dirt on the negative. Use an antistatic brush to remove any dust.

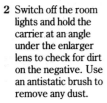

3 Place the carrier in the enlarger head.

4 Adjust the easel to the size of print required, and put a piece of white paper in to aid focusing. Raise or lower the enlarger head and adjust the lens focus until the image is properly framed and sharp.

5 Set the lens aperture (with a normal negative the setting should be about 2 f-stops less than the maximum for the best resolution). Cut a sheet of photographic paper into strips, place in the easel one at a time, and expose for different lengths of time.

6 Develop the test strips for between 90 seconds and 2 minutes (depending on the paper and developer being used) at 68°F (20°C), agitating continuously.

ser head uses a point light source (a small lamp) and a set of lenses that concentrate the light onto the film plane. The construction of the condensing lenses varies between negative formats, and some enlargers that are designed for printing different sizes of film have interchangeable sets of condensers.

The advantage of a condenser light source, which makes it valuable for black-and-white printing, is that it gives excellent sharpness when focused correctly, good contrast and short exposure times. A possible drawback is that it tends to enhance the appearance of scratches and particles on the emulsion.

A diffuser head is, as its name suggests, a broad source of light; there is usually an opalescent screen above the negative holder. The result is a slightly softer image, but one that is better at concealing blemishes. In colour printing, the lack of choice in paper grades makes a diffuser head the normal light source, to lessen contrast.

The other pieces of equipment needed for black-and-white printing are as shown here, and include an easel with adjustable masks, timer, contact printing frame, dark-room safelight, the trays, chemicals and tongs for developer, stop bath, fixer and wash, graduates, thermometer and a means of drying the print.

If you are using resin-coated paper, prints can be air-dried quite simply just by hanging them from one corner or by laying them flat on a towel or other piece of cloth. Fiber-based prints tend to curl if left to dry naturally, and a heated dryer that flattens prints by stretching a cloth cover over a metal platen is usually necessary. Ferrotyping involves drying a fiber-based print face down onto a chromed plate.

7 Drain and rinse in the bath for about 15 seconds.

8 Fix for the recommended time (this varies according to the type of paper). Switch on the room lights and examine the strips. The illumination must be bright enough to distinguish all the tones. Note the best exposure. If all the strips appear flat, select a harder grade of paper for the print.

To produce a thin black edge to an image within the normal white borders of the print, apply red masking tape (opaque to print paper emulsion) to the negative, as shown. Use a scalpel or other sharp blade to cut the tape cleanly; leave a thin blank space on the rebate.

Printing paper

Apart from the basic construction (resin-coated or fiber-based), there is a considerable variety of paper types, and their choice will make a major difference to the finished image. One of the most important areas of choice is the paper grade, from 0 or 1 to 5 or 6. These numbers signify the contrast, and as the examples here show, offer an important degree of control. Their main use is to compensate for deficiencies in the original negative, but they can also be used to extend the photographer's choice of the character of the image. Variable contrast papers achieve the same effect, but with one single stock of paper; the contrast is varied by means of filters.

Another variation among printing papers is in the surface texture. The most popular varieties are glossy, pearl and semi-matt, with personal taste being the major factor. Note, however, that while a glossy finish has the disadvantage of reflecting highlights from the surroundings when viewed from certain angles, its smooth finish also gives a denser appearance to blacks.

Assessing the negative

This is an essential skill that requires practice. Use the examples given here as an indication, but make a point of examining negatives regularly and carefully.

As soon as possible after developing the film, make a contact sheet. This does not need an enlarger, and although a contact printing frame is desirable, it is possible to make do with a sheet of glass large enough to cover the strips of film from one roll laid out in rows. If you do use the enlarger as a light source rather than a room light, defocus the lamp and adjust the condensers until the area of the printing frame is evenly lit. Place the film in the frame in strips, and in darkness take a sheet of normal, grade 2 paper and place it underneath. Close the frame and expose (the aperture setting and exposure time will depend on the enlarger, and you will need to experiment with different settings at first until you have the

experience to be able to judge), then process the contact sheet as you would a regular enlargement.

A good contact sheet should display most of the frames with the kind of brightness and contrast that you would expect from an enlargement of each. Check the borders of the sheet also: they should be a rich black. If the sheet is pale overall, try again with a longer exposure; if it is too dark, with no white highlights, reduce the exposure. If the contrast is too high, change to paper grade 1; if too low, use paper grade 3. Note the exposure settings and the contrast grade on the sheet itself – it will help to evaluate the negatives when the time comes to print enlargements.

When choosing which negative frames to print, begin with the contact sheet. This gives the best overall view of the picture contact – facial expressions in particular are

very difficult to judge from the negative alone. Examine the contacts with a loupe, and use a pair of L-shaped cropping frames if you intend to make any major alterations to the format.

Having selected what appear to be the best frames from the contact sheet, examine the negatives, again with a loupe. Look first at the basic technical qualities. Is it properly focused? Is there any evidence of camera shake or subject blurring? Are there any blemishes? If you have bracketed exposures or made any other important changes during shooting, note these also. Mark your final choice on the contact sheet with a wax crayon or china marker.

The final step in evaluating the negative requires more experience: judging how well-exposed it is and what contrast grade of paper it will need. Use the examples shown here as a guide.

Printing controls can make major changes to the image. In this photograph of a mountain stream on the Isle of Skye, in Scotland, the negative (*left*) contains all the information, but a straightforward print on Grade 2 paper, if exposed for the mid-tones, leaves the sky blank and uninteresting. In the second print, an extra $1\frac{1}{2}\times$ the exposure time was given to the sky, with the lower two-thirds of the print shaded by hand. The last version has been printed for the most drama on Grade 3 paper, with the sky given an extra $2\frac{1}{2}\times$ exposure.

COLOUR NEGATIVE FILM

In colour photography, the first choice to make is between negative and transparency film. The end product determines which of these you choose, but this may need a little forethought. If one form of the final image is of over-riding importance, the choice will be obvious: professional photographers who sell photographs for publication use colour transparency film because the separations for printing are made from these. If photographs are wanted for both slide shows and prints, prints can be made from transparencies, but then, slides can also be made from negatives. If, however, what is wanted is a top quality print and the ability to fine-tune

this, then colour negative film is obviously the natural choice.

The image is recorded onto colour negative film in the same way as on a black-and-white emulsion, with silver halide being reduced to silver, but this is then replaced with coloured dyes. So, although the image has a grain structure, it looks different. When coarse, or enlarged to the point where it becomes obvious, there is something of a multi-coloured speckled effect, rather like a pointillist painting composed of tiny dots of pure colour. This is the result of the clouds of transparent dyes in three colours overlapping one another.

Colour itself is such a subjective element that comparisons between different films become very much a matter of personal taste, and the difficulty of being able to make plain better/worse judgements is compounded by the changes that can be made to the image at the printing stage. This adds differences to the colour rendering, while the negative itself, with its orange mask and opposite colours, gives away very little information visually. To get the full value from colour negative film, it is important to be able to make your own prints – or failing that, to have your negatives custom printed to your instructions.

Technology

One fairly simple principle makes colour photography possible: a full range of colours can be produced by mixing just three. The three colours used in photography are blue, green and red, and a processed image contains one layer of each, in the form of transparent dyes. Both colour negative and colour transparency films work on this same basic principle, although they are structured and processed differently.

The three dyes in the film must be separate, making three layers of emulsion necessary instead of the single layer used in black-and-white film. And, just as a black-and-white negative records the opposite tones to those in the final picture, a colour negative contains the opposite *colours* to the ones that will appear in the print. Opposite colours are termed complementary, and for blue, green and red they are yellow, magenta and cyan respectively. Each of the three layers in a negative is sensitive to one colour and records it in a complementary dye. This, naturally, makes colour film technology more complex than that of black-and-white.

If we take a cross-section through a typical colour negative, still unexposed, the structure is considerably thicker than that of a black-and-white film (see pages 10–11). There are three principal layers, with a few other thinner ones to act as filters, protection against flare and scratching, and prevent chemicals and dyes from spreading.

The top layer of emulsion has a basic coating of silver halides, just like a black-and-white film, but is dye-sensitized to blue light. It also contains colour couplers, which are chemicals that will react during processing with a developer to produce a yellow dye (the opposite of blue).

The emulsion layer underneath this is sensitive to green, and contains magenta colour couplers. The third layer, at the bottom, is sensitive to red, and has green colour couplers. In addition to the protective supercoat, antihalation layer (see Glossary) underneath and the film base, there is a yellow interlayer underneath the blue-sensitive emulsion. This filters out the blue light during exposure so that it cannot

The characteristic orange cast to a colour negative is an integral mask added by the manufacturer, made up of a yellow dye to neutralize excess blue, and a pink dye to neutralize excess blue and green. Even with experience, fine judgement of hues from a negative is not possible.

reach the green and red layers underneath (all film emulsion is blue-sensitive), and is removed during processing.

The sequence of exposure and processing works as follows: the different wavelengths of light are intercepted by one or more of the three layers; for example, green light causes a minute reaction in the silver halide crystals only in the green-sensitive layer. During the first stage of processing, the developer amplifies these small changes and turns the crystals that were exposed into silver grains – exactly as in the black-and-white process on pages 72–7. At the same time, the by-products of the developer chemicals react with the colour couplers that are next to the silver grains to produce dye: magenta in this layer.

The silver has now served its purpose and is no longer needed; the next stage in the processing bleaches and removes the silver, leaving the coloured dyes to carry the image. The tones, of course, are reversed, as are the colours. When the negative is printed, the positive image and true colours are formed.

All colour negative film when processed has a distinctive orange cast that covers both the rebates and the image. While it adds to the difficulty of judging a negative, it is necessary in order to overcome certain problems in the use of colour dyes. Without it, some purple and blue-green hues would reproduce badly, because the normal cyan dye used in the film absorbs too much green and blue, and the magenta dye has a tendency to absorb too much blue.

The film manufacturer's solution is to add integral masks to the existing sandwich of three dye layers. The orange colour that is visible is made up of two separate masking layers. One, yellow, neutralizes the unwanted blue that the magenta layer absorbs. The other, a mixture of magenta and yellow (and so pink), neutralizes the blue and the green that the cyan layer absorbs. Colour printing paper is made in such a way as to allow for the resulting orange cast; it has added blue sensitivity.

Colour negative film is made up of five basic layers, here shown in cross-section. Three of these layers are each sensitive to a different colour; the remaining two act as filters. In addition, layers above and below protect and support the emulsions. When the film is exposed (1), the mix of halides and colour couplers (here shown as cubes and spheres respectively) does not change visibly. During development (2), those halides struck by light change into silver; any associated couplers turn into dye. Finally (3), the silver and unchanged couplers are bleached away, and only the dye remains.

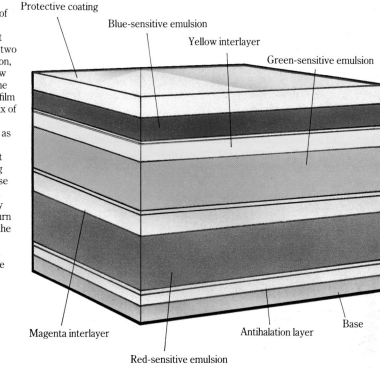

Protective coating
Blue-sensitive emulsion
Yellow interlayer
Green-sensitive emulsion
Magenta interlayer
Red-sensitive emulsion
Antihalation layer
Base

1 Latent image

2 Colour developer

3 Bleach and fix

Slow and Medium-speed Film

Like black-and-white negative film and colour transparencies, colour negative film is undergoing a considerable overhaul in technology. Much of this is due to the strong competition, with Kodak's traditional dominance no longer certain. The majority of casual amateurs shoot colour negative film, and the market is enormous. However much concern professionals and serious amateur photographers have for black-and-white and colour transparencies, this is where the volume business is for the manufacturers. As a result, the availabiltiy of films is as you might expect: a big choice of brands across a limited range of film types. Most of the slow and medium-speed emulsions are either ISO 100 or ISO 200, and balanced for daylight.

Improvements have tended to follow the needs of the snapshot market, but this has benefited all photographers. Two of the things that distinguish casual snapshot photography are that the prints are nearly always machine-processed by a high-volume laboratory, and there is a higher-than-usual incidence of underexposure. Custom printing is for the enthusiast. Successful colour negative films need to be easily printable even if the way in which they were taken was not perfect. In particular, one of the main demands is for richer colours, and the main technological improvements have been to give better colour saturation without increasing overall contrast. This is not so straightforward, as simply increasing the dye concentration in each emulsion layer makes the contrast higher as well. New types of colour couplers, which form the dyes, have been produced, and the orange mask described on pages 88–9 has also been worked on to keep unwanted colours out of some of the layers to avoid degradation. This is in addition to the use of thinner and fewer layers to increase sharpness.

As a result of continuing improvements by all major manufacturers, the range of available films is still changing. Specific films are now being replaced more quickly by improved versions than ever before, and the changeover period for any one brand tends to look confusing.

Inevitably, the printing stage introduces a massive variable into any comparison of colour negative films. It makes a test even more difficult than one between black-and-white negatives, because the element of colour brings enormously subjective preferences. In order to make a sensible comparison that you can use to choose between one film and another, the printing must be done on the same brand of paper and under the same circumstances. If not, then frankly any difference between the main brands is not going to be of much importance. A fairly objective comparison of grain and sharpness is possible by looking at the negatives: choose a subject that has some sharp detail (like eyelashes in a portrait) and some smooth tones (skin, clear blue sky, or a plain paper background). As for the colour accuracy and richness, the claimed improvements in the new ranges of films are real enough, but to choose between brands you must follow personal preferences.

Standard fine-grain colour negative films are rated at ISO 100, medium-speed films at ISO 200. The exception is Fujicolor's professional emulsion, at ISO 160.

Slow and medium-speed film is ideally suited to situations where the subject is well-lit, as in most studio or sunlit shots. In the printing, there is always some latitude in filtration – the final effect is largely dependent on taste.

Fast Film

The staple of the fast colour negative films has a rating of ISO 400, as is the case with black-and-white emulsions. All manufacturers produce one of these, and it fulfils the same function as in monochrome photography: handheld shooting by available light. Even so, ISO 400 does not open up entirely new areas of picture-taking, and the major breakthrough in colour negative films has been the ultra-fast emulsions, two at a high ISO 1000 and one at the remarkable ISO 1600. These are the cutting edge of low-light colour negative photography, and although enlarged prints are unmistakably grainy, they make available subjects and situations that were out of reach until now. Additionally, just as the grain texture from fast black-and-white negative can be used

graphically and deliberately, so the coloured grain in these films has its own special character.

The technology of fast colour negative film involves the tablet-shaped flat grains looked at earlier under black-and-white (see pages 46–9), special colour couplers and a colour response that takes into account the lighting conditions under which most people will use these films. The wider surface of the flat grains makes them more reactive to exposure, and improvements in colour couplers prevent oxidizers in the developer from attacking the latent image and reducing the potential film speed. And, as much available-light shooting includes tungsten-lit scenes, excessive blue in the shadows can be reduced by making the blue-sensitive

layer proportionately faster. These are among other, even more specific improvements aimed at minimizing the losses in colour saturation and sharpness that high sensitivity carries in its wake.

Two very important precautions with the ultra-fast films are cold storage and protection from X-rays. Keep these films at about 50°F (10°C) in a refrigerator for a short period, or, if you have to store them for long, do it at 32°F (0°C) or lower in a freezer. They are very sensitive indeed to X-rays, and may suffer noticeable damage even in one pass through a low-dosage machine. Fortunately, many airport security personnel understand this. (See pages 164–5 for Storage and pages 166–7 for protection against X-rays.)

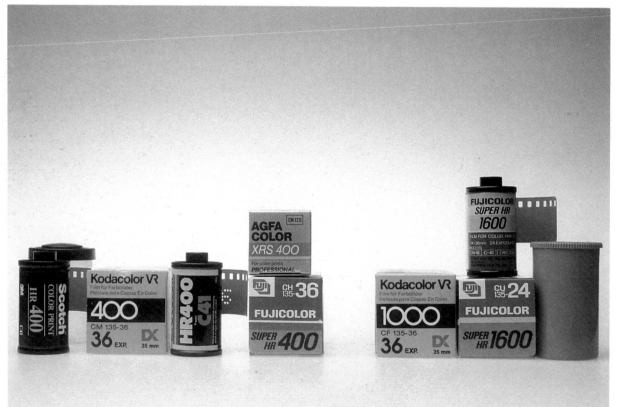

Two groups of fast colour negative films, here represented by the major film manufacturers' products, cover the older speed range of ISO 400 and the newer, more sensitive range of ISO 1000 and above.

The same view shot on ISO 100 and ISO 1000 negatives shows, when enlarged, a pronounced difference in texture and a lesser one in sharpness. In the paler, less exposed areas, such as the door and shadows, the fine-grained film is smooth, while the fast film has a speckled appearance. Edges, such as those of the railings, are a little less crisp in the ISO 1000 image *below*.

Instant Colour Prints

Despite the wide range of black-and-white instant films, the bulk of instant photography is in colour. Most of this is in the form of what is called integral film – a sealed packet which contains not only the developed picture, but also all the chemicals and materials needed to produce it – and needs a special instant film camera. In addition, there is a peel-apart film for medium- and large-format cameras that works in the same basic way as the black-and-white print films that we looked at on pages 66–71.

Integral film
At first look, it might seem to be stretching a point to include integral instant film in a section on colour negatives, when the final result is obviously a print. In fact, each film packet contains a three-dye negative that follows the same basic principle of all colour negatives, but the chemistry is sufficiently sophisticated that it does not need to be removed.

The film is exposed through a clear plastic window; the same window through which the print is viewed at the end of the process. At the bottom of this packet of film is the negative, consisting of three sets of layers, one for each colour. Each of these comprises a colour-sensitive silver halide layer above and a dye developer below, and are arranged so that the blue-sensitive layer is at the top, the green-sensitive layer in the middle, and the red-sensitive layer below that, as shown in the cut-away diagram on this page.

As with any colour negative, the light from a coloured scene activates the silver halide according to its wavelength. (This is covered in more detail in Volume III, *Light*.) Then, as the film packet is ejected from the camera, the pod of chemicals is squeezed out between the negative and the image-receiving layer above it (which has played no part in the exposure of the photograph). The alkalis seep through the packet, activating the dye developers. The dyes from the three different layers then migrate upwards towards the image-receiving layer, but each is filtered by the layer above it. For example, cyan dye is caught in the red-sensitive layer wherever red light struck during the exposure. This happens for each layer, and the combined effect is a positive

The fixed size of integral prints – only 3⅛ × 3⅛ inches (7.8 × 7.8 cm) in the SX-70 prints *below* – means that the most successful compositions are usually those with strong graphic elements. Prints like these have to work on a small scale.

The newer Image/Spectra camera (cut-away illustration *far right*) produces a different print shape: 2⅞ × 3⁹⁄₁₆ inches (7.3 × 9.1 cm). In both cases, the slightly hazy diffusion characteristic of integral prints can be seen.

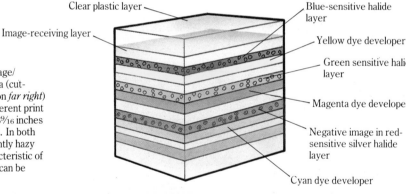

Clear plastic layer
Image-receiving layer
Blue-sensitive halide layer
Yellow dye developer
Green sensitive halide layer
Magenta dye developer
Negative image in red-sensitive silver halide layer
Cyan dye developer

◀ Compared with the structure of regular colour negative film on page 89, integral Polaroid film has three similar light-sensitive layers, but below each is a dye developer of the opposite colour. During processing, the molecules in these dye developers move upwards to be "trapped" in the three light-sensitive layers and colour whatever silver halide molecules were exposed.

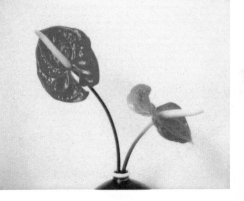

image of three dyes that forms just under the clear window.

That all this can take place in full light is due to an ingenious substance known as an opacifier. At the start, the opacifier spreads out from the pod as an opaque layer to protect the development from light, but as the level of alkalinity drops during development, it clears and becomes transparent. A white pigment below the receiving layer effectively hides the negative layers.

So much for the chemistry. Over the years, Polaroid have regularly improved their integral film, speeding up the development time, enhancing colour brightness and purity, and so on. These improvements on occasion have been accompanied by changes to the camera equipment, and to the original SX-70 launched in 1972, and the later SLR 680, is now added the Image system (also known as the Spectra in the United States).

To get the best out of integral films, it helps to understand how they differ in their visual appearance from conventional colour prints. Like any instant print, they are made by contact with the negative, and so are inherently sharp; no detail or tones are lost through enlarging with another lens. At the same time, however, this good resolution is overlaid with a diffuse haze that produces a slightly glowing effect. The nearest equivalent, though only a little similar, would be the combination of a soft filter and sharply focused lens. The plastic window adds to this hint of diffusion.

This mixture of qualities makes it possible to produce quite different styles of image quality with the same instant print film. To demonstrate this for yourself, try producing two contrasting types of picture: on the one hand detailed, strongly lit, bold compositions, and on the other soft, delicate subjects with broad areas of tone and a limited range of colours. The examples here show the difference. For the strong, sharp images, you should find that taking the pictures in bright sunlight or flash will help, as will slight underexposure to intensify colours and elimination of broad tonal areas. For the softer, pastel variety of instant print, try slight overexposure, soft lighting, back lighting and taking pictures of subjects with an intricate structure.

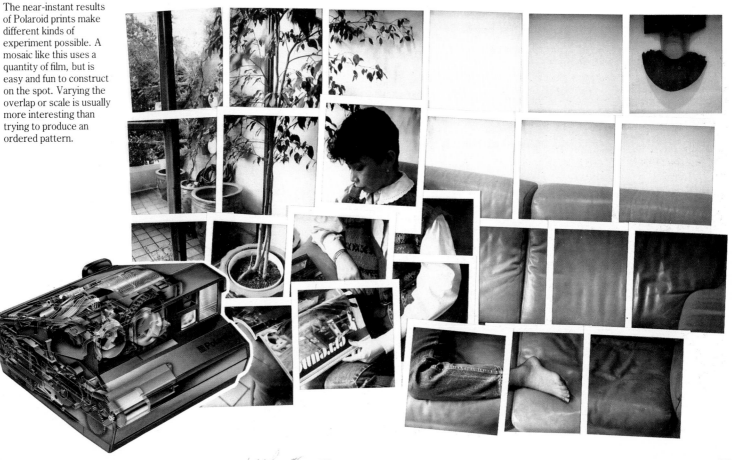

The near-instant results of Polaroid prints make different kinds of experiment possible. A mosaic like this uses a quantity of film, but is easy and fun to construct on the spot. Varying the overlap or scale is usually more interesting than trying to produce an ordered pattern.

Project: Testing with Polaroid

By producing colour prints rapidly and cleanly, instant film cameras open up a number of new possibilities in picture-taking. One of the most valuable of these is feedback. The nearly immediate delivery of the final image gives you, under most circumstances, the chance to alter and improve the photograph. Being able to imagine exactly how the scene you are shooting will appear as a printed image is one of the essential skills in photography, and even experienced professionals are sometimes a little surprised at the way in which certain subjects translate into a two-dimensional image. If you have access to an instant film camera, make a deliberate experiment in improving the composition of an image by means of a series of exposures. Take one, and then wait for a few minutes until the full intensity of colours and tones has emerged in the print, and study it, comparing it with the scene still in front of you. Consider how you might be able to improve the image – for instance, by changing the viewpoint, the camera angle, or the exposure. Try the same scene with and without the camera's flash.

Composite images

Another possibility that instant print makes relatively easy is the composite: building up an image in the form of a mosaic by adding a number of prints together. Although composites like the one on page 95 can also be shot with conventional film, the special advantage of instant prints is that the assembly can be worked out on the spot. In many ways, an irregular assembly of prints is more interesting than a well-ordered, squared up arrangement: like in a jigsaw, the overall image ties the prints together, while the overlap and variety of angles makes a pleasant contrast. Even if you are intending to shoot loosely like this, you may find it helpful to make a rough plan first: simply stand back from the scene you are about to photograph and take an overall instant print. Then make a rough sketch on this.

▲ **Polaroids for testing**
In studio and other controlled kinds of photography, Polaroid prints are a useful testing medium. Before this seafood picture was shot, the basic lighting and granite background were checked in appearance by an early Polacolor print (*left*). This rough check was important as the ingredients for the final shot had to be completely fresh, and would allow no delay once arranged.

▼ In location shooting, Polacolor tests can remove uncertainty in situations that may not permit a return visit.

Reciprocity failure
Polacolor has greater reciprocity failure than almost any other kind of film, acquiring a strong blue-green cast with long exposures. This happens even at exposure times of $\frac{1}{30}$ second; here, a 45-second exposure gives an intense effect. This can be corrected by the filters recommended in the table *opposite*; but in this instance it was deliberately retained, to enhance the gloomy atmosphere of a Washington State rain forest.

	Type 809 in (cm)	Type 59 in (cm)	Type 559 in (cm)	Type 668 in (cm)	Type 669 in (cm)	Type 88 in (cm)
Format	8⁷⁄₁₆×10⁷⁄₈ (22×27) single pack	4×5 (10.5×13) single pack	4×5 (10.5×13) pack	3¼×4¼ (8.3×10.8) pack	3¼×4¼ (8.3×10.8) pack	3¼×3⅛ (8.3×8.6) pack
Image size	7½×9½ (18×23)	3½×4½ (9×11.4)	3½×4⅝ (9×11.7)	2⅞×3¾ (7.3×9.5)	2⅞×3¾ (7.3×9.5)	2¾×2⅞ (7×7.3)
Sensitivity	Colour	Colour	Colour	Colour	Colour	Colour
Speed	ISO 80	ISO 80	ISO 80	ISO 75	ISO 80	ISO 80
Contrast	Medium (1:48 or 5½ stops)	Medium (1:48 or 5½ stops)	Medium (1:48 or 5½ stops)	Medium-high (1:12 or 3½ stops)	Medium (1:48 or 5½ stops)	Medium (1:48 or 5½ stops)
Resolution	Moderate (11–14 line pairs/mm)	Moderate	Moderate	Moderate	Moderate	Moderate

Polacolor
Normal processing (all film types) 60 seconds at 75°F (24°C)

Polacolor: Reciprocity compensation

Exposure	Exposure compensation	Filtration (daylight)	Filtration (3200–3400K tungsten lamps)
⅟₃₀ sec	None	+CC05 red	+80B
⅛ sec	+½ stop	+CC20 red	+CC20 cyan +CC30 blue
¼ sec	+⅔ stop	+CC20red+CC10 yellow	+CC10 cyan+CC30 blue
1 sec	+1½ stops	+CC30red+CC10yellow	+CC30 blue
5 sec	+2 stops	+CC40red+CC10yellow	+CC20magenta+CC10blue
10 sec	+2⅔ stops	+CC50red+CC10yellow	+CC20 magenta

Polacolor

This peel-apart film, available in a variety of sizes up to 8⁷⁄₁₆×10⁷⁄₈ inch (22×27 cm), resembles the black-and-white print films described on pages 66–71 in construction and use. The negative is separated from the positive print, although unlike Types 55 and 665 it cannot be preserved and used for conventional colour printing.

The image quality of Polacolor is extremely high, and although the print size is limited by the format that you use, it is intrinsically one of the finest colour printing processes available anywhere. The early problems of high contrast, which tended to produce pale, washed-out hues, were overcome in 1980 when Polaroid introduced the extended range (ER) emulsion. The prints need no coating; just allow several minutes for the surface to dry thoroughly.

There are a few precautions that you must take when exposing and processing, as under certain conditions the three layers can react slightly differently, and produce an unwanted colour cast. The first precaution is to avoid long exposures wherever possible. Like any film, the longer it is exposed to light, the less sensitive the emulsion becomes, and as the three dye layers do not respond equally, there is a shift towards blue-green. Unfortunately, Polacolor is more susceptible to this than virtually any other colour emulsion, and at exposures of even ⅟₃₀ second there are the beginnings of a cast. If you do use this film for tripod-mounted long exposures, it is essential that you follow the filter and time adjustments given in the table.

The temperature during development and the time that you allow are more critical for Polacolor than for any of the black-and-white instant print films: they affect the richness of colour and the colour balance as well as density and contrast. Extending the development improves colour saturation and the richness of blacks, which is usually an advantage, but at the same time it introduces a slight shift towards cyan.

The exact amount of colour shift varies, but if you want to use this method to intensify the colours, try increasing the development time by 50 per cent and use as a starting point a CC05 red and CC05 yellow filter over the lens. For fine-tuning the colour, wait several minutes until the colour values in the print have settled down, and make a second shot if necessary. There may be a greenish tinge as the print emerges; this will disappear over the next few minutes as the print dries.

Processing Colour Negatives

Much of what we have already been through on pages 72–7, when we looked at black-and-white processing, applies here. Before reading any further, have a look at those pages and refresh your memory. Developing colour negative film is only a little more involved, but it does demand more accuracy in maintaining the correct temperature and in timing. For this reason, it may be necessary to invest in a new thermometer and a dishwarmer. The thermometer should be mercury-filled and is easiest to use if the scale covers a relatively short range of temperature so that the degree markings are clearly visible.

The maximum variation that the normal C-41 process allows for the developing stage is only $\pm\frac{1}{4}°F$ ($\pm0.15°C$). Before developing your first film, make a trial run with the warm water bath technique described on page 75. If you can maintain the temperatures shown in the table on this page, well and good; if not, you will need to buy either a dishwarmer or one of several proprietary designs of processing unit (these contain heating mechanisms that use air or water). Here, to illustrate the basic steps, we show a simple water bath.

There are seven steps in the standard C-41 process, taking altogether $24\frac{1}{2}$ minutes, not counting the time it takes to dry the film. Whereas black-and-white film is processed in two main stages – development and fixing – colour negatives need three. The extra stage is the bleaching, which is necessary to remove the black metallic silver once it has been developed and the dyes have formed in three layers each of a different colour: yellow, magenta and cyan.

First prepare the chemicals, four in the case of Kodak's Flexicolor kit. The developer is supplied as three liquid concentrates, which must be mixed exactly according to the instructions (this applies to all stages of the preparation). The bleach is also packed in three parts, and there is a bottle each of fixer and stabilizer. Once these have been mixed, bring them up to the required working temperature, paying particular attention to the developer, which must stay within $\frac{1}{4}°F$ ($0.15°C$) for the $3\frac{1}{4}$ minutes of use.

Refer back to pages 75–7 for the basic procedures of opening the film cassettes, loading the tank, pouring and agitating. Between agitation cycles, keep the tank in its water bath. The safest procedure is to use freshly-prepared solutions each time you process negatives, but the developer can be used, once mixed, for up to six weeks. The fixer and stabilizer can be used for up to eight weeks, and the bleach lasts almost indefinitely.

C-41 process (Kodak Flexicolor)

Stages	Temperature °F(°C)	Time (mins)	Comments
Colour developer	100(37.8)	$3\frac{1}{4}$	Agitate for first 30 seconds, return to water bath for 13 secs, give 2 secs agitation, then repeat this cycle until 10 secs before end of development
Bleach	75–105(24–40.5)	$6\frac{1}{2}$	Agitate for 5 seconds every 30 seconds, following an initial 30-second agitation
Wash	75–105(24–40.5)	$3\frac{1}{4}$	
Fixer	75–105(24–40.5)	$6\frac{1}{2}$	
Wash	75–105(24–40.5)	$3\frac{1}{4}$	
Stabilizer	75–105(24–40.5)	$1\frac{1}{2}$	
Dry	75–110(24–43.5)	10–20	

Processing equipment
Although most of the equipment necessary for processing colour negative is identical to that for black-and-white film (see page 73), there is a risk of cross-contamination if you use the same items for both. It is safer to have a separate set for each process.

Processing kit (that shown here is the Kodak Flexicolor kit for the C–41 process)

Containers (bottles or graduated beakers) for processing solutions

Mixing container and graduate for measuring solutions to be mixed

Rubber gloves

Darkroom timer

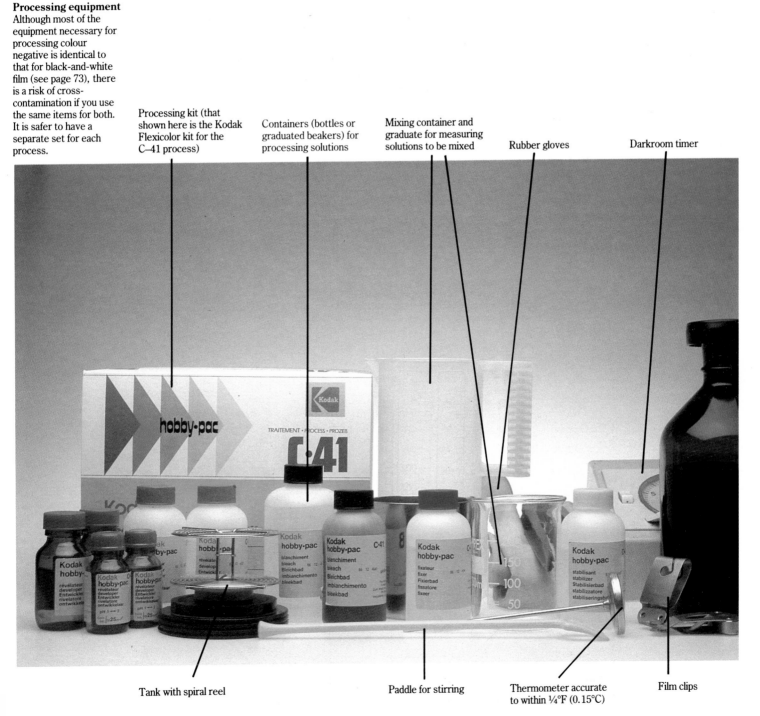

Tank with spiral reel

Paddle for stirring

Thermometer accurate to within ¼°F (0.15°C)

Film clips

Troubleshooting

Practice at assessing black-and-white negatives (pages 78–81) will stand you in good stead for colour negatives. Colour prints are even less reliable than black-and-white prints for judging results: they introduce not only the variables of density and contrast, but possible colour shifts as well.

Although it is by no means easy, try and do as much of your assessment as possible with the negative itself. The orange mask obscures any delicate differences between colours, and the stronger hues appear as their complementaries; these two effects combined make it practically impossible to judge the general colour of the image. Nevertheless, the most likely and important problems can usually be identified from the film alone, as these examples show.

Scratches caused in the camera when the film is being wound or rewound, or when the processed film is hung to dry and wiped down, appear horizontal and usually blue.

Light leak caused by opening the camera back appers dark and blue-green, as opposed to pale and orange in slide film.

Overall fogging that extends over the rebates indicates a light leak in the darkroom.

A blotchy dark stain suggests contamination of one of the processing solutions. This could be developer contaminated with bleach or fixer, or fixer remaining in a tank that has spilt onto the film before processing.

A completely black frame indicates extreme exposure to light: everything, including the edge markings, is obliterated.

Overdevelopment gives dense highlights, more contrast, and darker edge markings and numbers (compare with overexposure *below*).

An underdeveloped film is weak overall, the edge markings also. This negative would produce a flat, lifeless print.

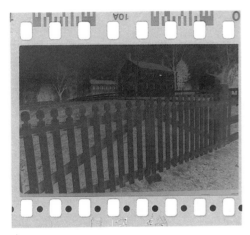

This negative has been correctly processed (you can see this from the appearance of the edge markings), but overexposed by 2 stops. The appearance is similar to that of overdevelopment, but shadows usually show rather more detail.

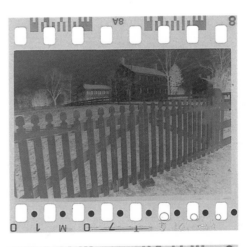

The same scene as *left* and *below* with a normal exposure. Use this for comparison.

The same scene as *above*, but underexposed by 2 stops. There is good detail in the brightest areas, but darker tones will print flat and dull.

COLOUR TRANSPARENCY FILM

Transparency film delivers its image in what is effectively a single stage, through a reversal process, in which the initial negative image is discarded and the unexposed parts of the film developed to colour. The film that is exposed in the camera carries the final picture. Although it can be printed by means of Cibachrome, Ektachrome, and other positive-to-positive processes, a transparency looks its best and shows off its colours at their most brilliant and saturated when light shines through it. A projected slide in a darkened room has a snap to it that no print can match.

By producing an image directly, without the intervening period of grace to tune the colours and density in the darkroom, colour transparency photography makes tougher demands on colour accuracy. If a colour negative has a slight cast in the direction of one hue, it is no great problem to compensate for this in the printing. The same colour shift in a transparency, however, is there forever. Shooting with these films teaches colour precision at the time the exposure is made; mistakes are not forgiven and cannot be corrected.

It is for this reason that photographers who work with colour transparencies are usually the most painstaking in choosing their film and worrying about the colour qualities of lighting. Also, this is the film type of choice for all professional photographers whose work is published. Modern photomechanical reproduction, which is the means of printing photographs in magazines and books, is geared to transparencies. A colour print, however well crafted, does not produce the same quality of reproduction. Because professional photographers are so closely involved in colour transparency film, they have always insisted on high quality of film from the manufacturer.

To satisfy the most stringent demands, manufacturers produce special selections of some of their transparency films, designated professional. Professional films are batches of emulsion that have been monitored with particular care by the manufacturer, and selected because they meet tighter specifications than the normal run of production. In particular, they have as precisely neutral a colour balance as it is possible to achieve. Professional versions of some black-and-white and colour negative emulsions are also made, but not as many as in this more critical area of colour transparencies.

Bear in mind when choosing film, however, that if it bears a professional designation it needs more care. It should be kept refrigerated until use, and processed promptly. On a long trip and less-than-ideal storage conditions, it may not be as good a choice as the regular amateur product, for all the appeal that its name has.

Technology

On the face of it, the sequence of producing a colour slide seems direct and straighforward: it delivers a viewable image in the right colours in essentially one step. The chemistry, however, is more complicated than that needed to make a colour negative. The reason is that the process has to begin in exactly the same way as for a negative: the image is recorded with silver halides in opposite tones. For the picture to appear positive by the end of the processing sequence, these tones and colours must be reversed chemically. Hence, transparency film is also known as reversal film, and several more steps are needed in the processing sequence.

The structure of colour transparency film is essentially the same as that of colour negatives, with the exception that there is no overall orange mask. There are three basic emulsion layers, in the same order: the top sensitive to blue light, the one underneath to green, and the third to red. When the film is exposed, it also reacts in the same way as a colour negative. A latent image is formed in each of the three separate layers in the silver halide crystals.

The first step of the processing is a developer – but only a black-and-white developer. The colour couplers that are mixed in with the silver halides are completely unaffected at this stage, and all that happens is that a silver negative is formed in each of the three layers. What remains is the important information: unexposed silver halides in the places that did not receive light, and accompanying colour couplers.

The next step is a reversal bath, in which the remaining silver halides are fogged and convert to silver. During the colour development, the colour couplers that are next to *these* grains produce dyes, but the colour couplers associated with the crystals that were originally exposed are not affected. In this way, the image has been reversed from positive to negative, not only in tones but in colours. All that remains now is to remove the silver (which covers the entire film), fix and stabilize.

Up to now, we have dealt with films that are not themselves the final product (instant films excepted). Once the negatives have been processed, there remains the stage of enlarging and printing, and this itself allows some freedom in controlling the image. The brightness can be adjusted, the contrast can be altered in black-and-white, and the colours can be manipulated in colour printing. If you are used to working with negatives, you will probably have come to expect this latitude, and may even take a little less care over exposure and colour balance than is strictly necessary.

Colour transparencies are much less forgiving. Granted, you may use them to produce prints by a positive-positive process such as Cibachrome, but even then, the printing materials offer no real contrast control. If you use transparency film for slides, then the shot you expose must be correct from the start. There is little in the way of exposure latitude and colour balance. As a test, bracket exposures by ½-stop differences and see for yourself how many of the frames seem acceptable when you examine them on a light box or project them. Depending on the subject and lighting, the choice is likely to be small.

Exposure accuracy
Particularly characteristic of using colour transparency film is its intolerance of exposure mistakes. Not only is the contrast in a Kodachrome 64 image such as this higher than in a negative of similar speed (see the example on page 91 for comparison), but the finished image is delivered in one step. Increments of only ½ a stop separate the exposures in this sequence of John Glenn's space capsule, yet the visual differences are substantial.

The basic structure of colour slide film is similar to that of colour negative materials – three colour sensitive layers and two filter layers – but the exposure and processing sequence is longer. On exposure (**1**) the halides (cubes) and couplers (spheres) record a latent image but show no visible change. In the first development (**2**), the exposed halides are converted to silver. The next step (**3**) is a chemical fogging and colour development in which the remaining unexposed halides are also converted to silver, while the couplers adjacent to them form dye. The final stage (**4**) bleaches away all the silver to fix the image.

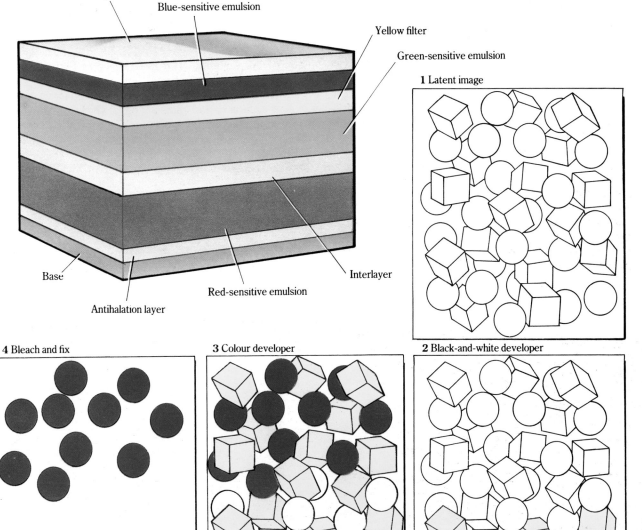

Protective coating

Blue-sensitive emulsion

Yellow filter

Green-sensitive emulsion

Base

Antihalation layer

Red-sensitive emulsion

Interlayer

1 Latent image

4 Bleach and fix

3 Colour developer

2 Black-and-white developer

Slow and Medium-speed Film

In the range of colour transparency film speeds, slow is around ISO 50 and medium around ISO 100 (Kodachrome 25 is something of an exception, and is dealt with on the following pages with the other non-substantive films). In image quality, these films are the standard, designed for as much sharpness, as fine a grain structure and as saturated a range of colours as possible, while still keeping a film speed that is practical. From every manufacturer, the films that are faster than these have poorer image quality and are compromises. Two of the major manufacturers, Fuji and Agfa, make ISO 50 and ISO 100 emulsions; Kodak still produces professional ISO 64

film, but is relying on improved technology to allow its Ektachrome 100 to carry most of the sales. In fact, there is not a great deal of difference between the slow and medium-speed films: the grain is slightly finer in one, while the other offers the choice of an extra stop.

This group of films has benefited very much from new film technology, and will certainly continue to do so. All of the major manufacturers – Kodak, Fuji and Agfa – have contributed to this state of affairs. Periodically, each one announces a new advance in a particular area, such as grain distribution or colour accuracy, and gains a temporary advantage, at least in the speci-

fications on paper. In the long run, however, the competition evens out, and the occasional breakthroughs are never the sole property of one manufacturer for very long. Still the best basic advice is to choose one brand that you prefer and stick with it, being very cautious about switching for the sake of every new claim.

The new technologies are usually given proprietorial acronyms by the manufacturers to make the most of any advantage. Across the board, however, the big areas of improvement have been in grain, colour couplers and interlayers. Flat-grain technology, which we saw in action in black-and-white films, has brought gains to colour

Led by Kodak and Fuji, there are four or five principal manufacturers of colour reversal film that is generally available over the counter. Excluding tungsten-balanced films, non-substantive Kodachrome and specialist materials, there are currently 11 fine-grained emulsions, most of them available in different formats. Most can be developed in Kodak's ubiquitous E-6 process.

Fujichrome 50D

Ektachrome 100

Ilfochrome 100

The judgement of colour is, for most people, highly subjective, and film manufacturers are faced with decisions that are not always straightforward. Fuji, for example, have made colour saturation a top priority, while Kodak, in Ektachrome 100, have concentrated on colour accuracy and differentiation between close hues. In the direct comparison shown here between three brands, colour saturation and overall cast are the most immediately obvious differences. Differences in grain and sharpness are in line with the film speeds.

slides as well. A mixture of grains allows small, compact pyramidal crystals to give fine grain, while the flat grains gain speed. An alternative is double-structuring, in which an outer shell gives more speed and a small, highly developable nucleus gives fine grain. With both techniques, a more even spreading of the grains gives a smoother, tighter pattern.

Colour couplers, which form the dyes in the emulsion layers during development have also been improved: tighter packing of the molecules gives a higher density and makes a thinner emulsion possible. Interlayers, which prevent the dyes spreading between the three emulsions and control what amount of light strikes each, are now more effective than ever before, by means of special screening dyes and new types of colour couplers.

The success of all this, however, depends not on the figures that the manufacturers claim (and they are all very similar), but on how they look to the photographer. You can look at the characteristic curves to compare contrast, check the granularity numbers and the resolution in line pairs per millimeter, but the exercise is not as edifying as you might imagine. For example, Kodak claim an RMS Granularity of 11 for Ektachrome 100, Fuji claims 11 for both its films, while Agfa claims 11 for its medium-speed and 10 for its slow film. Comparisons on figures like these are impossible, and not many people would agree that Agfa CT50 (50 RS is the professional version) appears less grainy than the others. Yet differences in the pattern are visible – just.

This brings us to the inevitable, but difficult, question: which film to choose? Apart from a few renegade emulsions from technologically backward manufacturers, the different brands share the same characteristics to a very fine degree. What you can expect from a slow or medium-speed film is fine grain, good colour saturation, accurate rendering of most colours, slightly higher contrast than for faster films, and an exposure latitude of not much more than ½ a stop either side of a good exposure. All else is highly subjective. This does not make it any the less important, but the only reasonable basis for choosing the image quality of one film over another is a side-by-side comparison *which you make yourself.* Magazines like *Popular Photography* and *Modern Photography* regularly publish exhaustive comparative tests, but the results on a printed page are not nearly as convincing as being able to see the slides for yourself.

Comparing all the brands thoroughly would be an expensive and time-consuming effort; instead, as you probably already shoot with one preferred film, simply compare it against one other at a time, ideally using two cameras. You will be able to see any grain and sharpness differences in the range of subjects that you shoot, but to make colour comparisons, choose different scenes that each contain an important hue: skin tones, neutral greys and whites, red (a good test of saturation), yellow (difficult to reproduce well, often tending towards a greenish or a warm cast) and a blue sky.

Non-substantive Film

The structure of a colour transparency emulsion that we saw at the beginning of this section (page 105) is true for most films, but not quite all. A small but important group of slide films goes under the name "non-substantive", and if the name is unfamiliar, the make is certainly not – Kodachrome. In the past, other manufacturers also produced non-substantive emulsions, but now only Kodachrome remains, and it is the special methods of manufacture and processing that have given Kodachrome its outstanding reputation.

In a non-substantive film, there are no built-in colour couplers. As you use it, it is literally a black-and-white film, with three colour-sensitized layers. The colours are added later, during a long and complex processing procedure. This K-14 process is too complex for home use, or even for most professional laboratories, and apart from a handful of custom labs, all Kodachrome processing is undertaken at special Kodak facilities. Altered processing (pushing and pulling) is not recommended, and even the few laboratories in the United States that will undertake it make no guarantees about the quality of the results.

For the undoubted inconveniences of the processing (for most users, the film must be sent away for a few days or even a week or two), the benefits are exceptional sharpness, richness of colour, and grain that is both fine and uniform. The single most important reason for this high image quality is that, not needing colour couplers, the emulsion layers are thinner and fewer.

Throughout the changes of formulation that have gone on at Kodak and at its competitors, the Kodachrome family of films has remained for many 35mm colour users the industry standard for about half a century. Although professional versions of these emulsions have been introduced relatively recently, it is professional photographers who have been the main champions. Among the image qualities just mentioned, the extremely fine grain and sharpness have a special importance to professionals, who sell pictures for reproduction at great enlargement (up to a double-page spread in a magazine, for instance). For the slowest film of the family, Kodak claim a granularity of 9 (see page 18) and a resolving power of 100 line pairs per millimeter (see pages 16–17) for a high-contrast target.

Acknowledging Kodachrome's popularity and loyal following, Kodak have now extended the range to include a much-needed high-speed film and a rollfilm version of the basic ISO 64 emulsion. Despite processing inconveniences (many users, including those in the UK, must have their films sent abroad), Kodachrome's high image quality makes it for many the standard among reversal films.

Kodachrome 25

Kodachrome 200

The principal difference between Kodachrome types is in sharpness and grain, both of which are in proportion to the film speed. In typical uses, this difference is more marked between Kodachromes 64 and 200 than between Kodachromes 25 and 64 – it depends on the degree of enlargement. What colour biases exist are towards pink Caucasian flesh tones and bluish greens in Kodachrome 25, greenish shadows in Kodachrome 64 and an overall warmth in Kodachrome 200.

Recent improvements in colour film technology have brought some serious challenges to Kodachrome from E-6 emulsions, such as Fujichrome's ISO 50 film. Nevertheless, Kodachromes are still the films of choice for many people, and Kodak have continued to add to the range. Most of the image-quality claims apply to Kodachrome 25, but there are also ISO 64 and ISO 200 versions available in daylight-balanced film, an ISO 40 tungsten-balanced film (available in the US – Ektachrome only is available in the UK), and a 120 rollfilm version of Kodachrome 64.

Kodachrome contrast is high, as their characteristic curve graphs (see page 13) demonstrate, and there are many circumstances in which this can be a problem. In particular, try shooting outdoor scenes in which bright clouds appear in the same view as a landscape. The highlights wash out in a way that is distinctive to Kodachromes.

As reduced development is not an option that you can use to lower contrast, the usual methods of dealing with a large range of brightness are either to alter the viewpoint or to reduce the exposure. Interestingly, Kodachromes often benefit considerably from underexposure, as this increases the colour saturation. Naturally enough, this happens with all transparency films, but the distinctive richness of Kodachrome colour is enhanced.

Many professional users either rate Kodachrome 25 at ISO 32 and Kodachrome 64 at ISO 80, or else consistently shoot with the aperture stopped down slightly from the meter reading. Try bracketing exposures yourself, and study the acceptability of the underexposed frames. When you compare the developed frames, you should find that in many situations the first impression is one of being richer rather than just simply darker.

Richness, like certain other descriptions of image quality (such as sharpness) is subjective, and so pointless to try and quantify. Nevertheless, it would be a mistake to dismiss impressions in favour of qualities that can be measured precisely. If you take photographs for pleasure and simple visual effect rather than making accurate reproductions of things, then your choice of colour film should be based on what you personally like.

All the technical specifications in the world will not convince someone who prefers the colour rendition of a particular make of film to change. Hence Kodachrome adherents tend to remain faithful, even though, for example, both the ISO 50 and ISO 100 versions of Fujichrome have a higher resolving power (125 line pairs per millimeter for a high contrast target). The different structure and processing of Kodachromes makes them quite distinctive in appearance from regular E-6 films, so you should try making comparative tests on these films for yourself.

Kodachrome 200
As with any higher-speed film, the main uses are in low lighting and with telephoto lenses, which have maximum apertures that are smaller than usual. Here, in a 400mm telephoto photograph of a Komodo Dragon on a cloudy day, the extra speed advantage of the film allowed a shutter speed of $\frac{1}{125}$ second at f 8.

Kodachrome 64
This is the general-purpose emulsion of the group, and shows off some of its best characteristics in images like this, with fine detail and saturated hues.

Kodachrome 25
The slow speed of this film – the slowest of any transparency emulsion – restricts its use to bright lighting and situations where the camera can be supported. Nevertheless, it is unsurpassed for still-life, architectural and other subjects that need the finest detail in the image. Here, for a group of unfinished Shaker oval boxes, a tripod was used for ¹⁄₁₅ second shutter speed.

Fast Film

Traditionally, the high-speed rating among colour transparency emulsions was ISO 400. With a 2- or 3-stop advantage over the fine-grain films, this was the film for hand-held shooting in poor light. Now, however, the situation has changed drastically, with much faster emulsions available from all the major manufacturers, some of them designed specifically for push-processing (see pages 146–7). This has extended the range of situations under which hand-held photography is possible, and this in turn is responsible for new types of subject appearing on film.

The choice of fast slide films now looks like this: ISO 200 films from Kodak and Agfa offering a small speed advantage over the main bulk of fine-grain films, ISO 400 staple fast films from all manufacturers, and ultra-fast films that perform at their best around ISO 800 to 1000 but which can be given altered processing to take them up to ratings of ISO 1600 and, in emergencies, some way beyond that. This choice reflects the quite different priorities in fast-film photography from those that concern people using the standard fine-grain emulsions. With the latter, the ideal is perfect image quality, and if the slower speed sometimes makes shooting awkward, few people complain about having to use a tripod or increase the photographic lighting; this is the accepted price to pay.

Fast film, on the other hand, meets the needs of photographers who want to shoot normally, without tricky slow exposures, in low-light situations. With this as the accepted top priority, no-one expécts a high order of colour saturation and sharpness. Grain is the biggest problem, and this is the reason for the existence of three groups of film speed. The ISO 200 films, for example, have their adherents despite what is now a very modest speed, because they still have the edge in graininess over the ISO 400 films. If the light levels will just allow an ISO 200 film, the grain advantage is a good argument for carrying at least one extra roll of this medium-fast film.

New film technology has altered the spectrum of fast films more than any other group. The traditional ISO 400 brands now look relatively slow in comparision to the new ISO 1000-plus emulsions.

Candlelight in the grounds of a Burmese temple provided the chief illumination in this shot. With ISO 400 film and a maximum lens aperture of f 2.8, a shutter speed of ¼ second was needed, with the camera mounted on a tripod.

The highest speed films, like Kodak's P800/1600, have no claim to any respectable image quality, but they make it possible to shoot naturally and quickly in poor lighting, without tripod or portable flash. The photograph of Muslim students in a Singapore school (*right*) was taken with a 105mm lens at ¹/₁₂₅ second and *f* 2. A feature of this film is that it offers a choice of speed rating at the time of use; the panel on the side of the cassette is for marking before sending to a processing laboratory (*left*).

The film used for this fish-eye view of a Hong Kong street market is Ektachrome 400 – an old stand-by. The photograph was taken before the availability of ISO 1000-plus films, and the roll was push-processed by 1 stop to achieve ISO 800. Note how poorly it performs with this treatment when compared with P800/1600: contrast is very high and the shadows have weak density with a magenta tinge.

Another factor enters into this choice, however. In practice, low-light shooting is less predictable than photography in full daylight, and much less so than photography with flash. Typical situations are in the evening, as the light is fading, and indoors, where light levels are very inconsistent. In other words, one of the demands in this kind of shooting is to stay flexible, and this has been the motivation for the most recent P-designated films. "P" in this case stands for push-processing, and these films offer an on-the-spot choice of film speed. Their optimum performance seems from testing to be around ISO 800, but they can be rated at anywhere from ISO 400 up to ISO 3200. The idea is that, by carrying only one kind of fast film, you can choose at the last moment how to rate it, depending on the lighting conditions.

Fast films are unmistakably grainy, and

this is the principal difference from standard slow and medium-speed emulsions. RMS granularity figures of 16 and 17 for ISO 400 films and 22 to 26 for the ultra-fast varieties tell their own story. The new technology applied to slower films is in evidence here, too, with particular efforts being made by manufacturers to squeeze the maximum sensitivity out of acceptably sized grains. Fuji's P1600, for example, has grains that start to develop into silver at different times, so that there is a continuing reaction as the development is extended. Practically, this means that the film is more sensitive with more development. Maximum densities are also designed to hold with long development – under these conditions shadows normally weaken and look veiled.

Push-processing is now a standard part of fast-film photography, and to discover its benefits – and limits – make a comparative

test on the same brand of film between the different ratings. Shoot one scene at ISO 800, ISO 1600 and ISO 3200, altering the speed setting on the meter. Process each as recommended by the manufacturer; to save film, you can use a third of a roll on each, cutting the film into three lengths for the different developments. (To do this accurately, measure out 20 inches – 51 cm – on the worktop and mark this length so that you can feel it in the dark.)

These films accept push-processing much better than do conventional emulsions, but it is still not faultless. A colour shift is likely (towards magenta or purple is common), graininess will increase, and the maximum density will weaken. Also, you may well find that the manufacturers' recommended times are optimistic, and that to achieve the higher ratings you should give even longer development.

When the lighting conditions allow, the finer grain of ISO 200 films may be worth going for. In this photograph of a Napa Valley wine cellar, Ektachrome 200 was used, sacrificing depth of field for a less gritty appearance than a normal high-speed film would have given.

Rated at ISO 800, the Ektachrome P800/1600 used here enabled shooting at $\frac{1}{125}$ second – just fast enough to stop the motion of this Javanese classical dancer at quieter moments in the performance. Colour accuracy was sacrificed for speed by shooting under tungsten lighting without a blue 80B filter.

Tungsten-balanced Film

The question of colour balance rarely comes up when we consider how scenes look to the eye. The overall lighting has to be strongly coloured to be intrusive, and under most of the lighting that we are accustomed to – from daylight to tungsten bulbs and fluorescent strips – white objects appear more or less white, greys seem properly grey, and other colours look as we expect them to. In fact, the colour of even daylight varies considerably – as described in *Light*, volume III of this Workshop series – but we tend not to notice because the human eye and brain adapt very well to the changes. Film does not adapt so well, however, and the dyes used in colour film must be balanced for a particular kind of light. All the films we have looked at so far are balanced for daylight or, more speci-

fically, for the colour of midday sunlight in a clear sky. On the scale of colour temperature (described more fully in volume III, *Light*), this is 5500 K.

Electronic flash units are designed to produce this same colour temperature, so that daylight-balanced films can be used. The other major source of light used for photography is tungsten, and most lamps made for the purpose produce a light that is much more orange than daylight, at 3200 K. If daylight-balanced film is used with these lamps, the image will have a distinct cast to it. One alternative is to use a bluish filter to bring the neutral colours in the picture back to normal – an 80A filter in Kodak's designation, or an equivalent from other filter manufacturers.

There is sufficient indoor photography

carried out under tungsten lights, however, for a (limited) range of specifically balanced films to be available. Those balanced for 3200 K are known as Type B films, those designed for the slightly more blue 3400 K are Type A (the latter are now almost obsolete). Accurate colour balance is much more critical for transparency films than for colour negative emulsions; filtration of the latter when printing can take care of most discrepancies, and thus nearly all tungsten-balanced films are reversal. Even so, the choice is small: Ektachrome 50 (its sheet equivalent is Ektachrome 6118) and Ektachrome 160 from Kodak, and Fujichrome 64T. In addition to these 3200K-balanced Type B films, there is Kodachrome 40, a 3400K-balanced film that is not widely distributed outside the United States.

Although the demand for tungsten-balanced film is relatively low, with most amateur photographers preferring to use portable flash for indoor tungsten-lit scenes, and studio hot-lights being less common than before, there is a surprisingly good choice of brands. All the speed groups are covered, although Kodachrome 40 is available only in the United States.

As a demonstration, this portrait of a Californian artist who paints electrolytically on titanium was photographed on both daylight-balanced Kodachrome 64 and tungsten-balanced Kodachrome 40. The lighting was 3200 K photographic lamps. The unfiltered Kodachrome 64 gives an orange cast – although by no means unuseable – which the addition of an 80B conversion filter reduces. However, there is a greenish cast due to reciprocity failure at the ½ second exposure. The Kodachrome-balanced film gives a perfectly neutral version (filtered with an 82A to convert this Type A film to type B lighting).

Kodachrome 64 + no filter

Kodachrome 64 + 80B filter

Kodachrome 40 + 82A filter

Projects: Comparative tests

The basic function of these tungsten-balanced films is to give a correct colour balance – in other words, to neutralize the strong orange of tungsten lamps – and so a basic comparative test is to shoot the same lighting conditions with one roll of each, daylight and tungsten. In fact, do this: shoot a tungsten-lit scene that you know to be 3200 K (by using photographic lamps) on daylight film and on Type B film, first without filters and then with an 80A conversion filter for the daylight film and an 85B filter for the tungsten film. Then choose a daylit scene, and repeat the exercise with and without filtration. Compare your results with the examples here.

A second, and more interesting, project is to experiment with using tungsten-balanced film in situations that are not lit to 3200 K. Normally, the strong blue cast looks distinctly wrong, but there are occasions and types of image for which it can add unusual qualities. Some landscapes and cityscapes, for instance, can appear very atmospheric and detached if shot on unfiltered tungsten-balanced film.

Finally, tungsten-balanced film has one special quality that makes it the best choice for long exposures, even in daylight – it is manufactured with better reciprocity characteristics than most daylight films (see pages 36–9). This is because tungsten lamps are weaker than daylight, and so studio photographers who use them are accustomed to longer exposures. As a result, tungsten-balanced films first show reciprocity failure at longer exposures than do daylight films. If you plan a several-second exposure by natural light, a tungsten-balanced film with an 85B conversion filter will spare you time and colour shift.

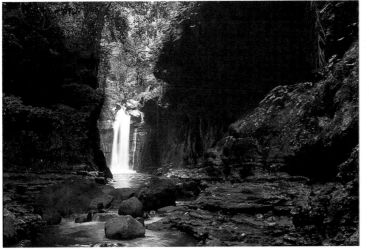

Kodachrome 64

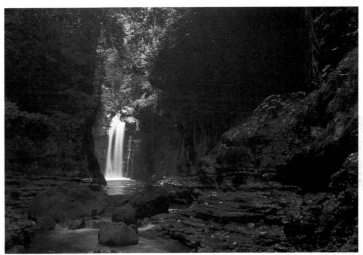

Ektachrome 50

A reverse use for tungsten-balanced film is to create an unusual twilit atmosphere. In this example, of a waterfall in a Philippine rain forest, both daylight (*left*) and tungsten (*right*) films were used. In some ways, the blue version on unfiltered Ektachrome 50 is more appropriate for the cool, dark scene.

Kodachrome 40 + no filter Kodachrome 40 + 85 filter Kodachrome 64 + no filter

Kodachrome 64 + 80B filter

Mixed lighting may sometimes be handled better on tungsten-balanced film than on daylight emulsions. If in doubt, and without a colour meter, it can be safer to use both. In this shot of Skylab's fuel tanks in Washington's Air and Space Museum, the lighting was a mixture of daylight through tinted windows, the museum's vapour lamps and an unfiltered 1000-watt tungsten lamp. Kodachrome 40 was used with and without an 85 filter, and Kodachrome 64 was used with and without an 80B blue. The most accurate was the filtered Kodachrome 40.

Large Format Film

As with negative film, a large format colour transparency has the edge over a normal 35mm slide when it comes to fine detail and delicate differences between tones. Enlarged to the same size, even a Kodachrome 25 slide cannot quite match the image quality of a good 4×5 inch transparency, although it is the one 35mm film that comes close. (Other, substantive, colour transparency films suffer from a more visible grain and rather thicker emulsion layers.) How important this undeniable extra quality is depends on the use you intend to make of the transparency. If it will simply go in a slide projector, there is no point in shooting on larger film. If, on the other hand, you want to be able to see the brilliance and saturation of colour that is only possible by viewing a slide, but without squinting into a magnifying loupe, only a large-format transparency will do. Professional photographers whose photographs are intended for publication have an even stronger incentive to use a large format when the circumstances permit: published colour images are made from transparencies, not prints. The same thing applies if you use positive/positive printing, such as the Cibachrome process.

The professional advantage in using sheet film has resulted in a good choice from the major manufacturers, at least in the category of slow to medium-speed films. As the benefits of a large format lie in conventional high image quality, and because very few view cameras can be used handheld, there is virtually no demand for a fast colour sheet film. If more light is needed, the answer is a longer exposure; if there is movement in the scene that must be stopped, a smaller format camera will have to do the job. ISO 200 is the highest rating for large format, available from Kodak and Agfa, while the three principal manufacturers, Kodak, Fuji and Agfa, make slow and medium-speed emulsions (Ektachrome 64 and 100, Fujichrome 50 and 100, Agfachrome 50 RS and 100 RS). In addition, there are sheet film equivalents of tungsten-balanced films Ektachrome 50 (called Ektachrome 6118 in sheet form) and Fujichrome 64T.

The major drawback of large-format photography is the sheer time and effort that it takes compared to 35mm shooting. The film has to be loaded and unloaded in darkness, accurate viewing and focusing is painstaking and must be completed before the film is put into the camera, and so on (see Film Handling on pages 34–5). One ingenious answer to this and a major handling improvement is Polaroid Professional Chrome, which comes in a daylight-balanced ISO 100 version and a tungsten-balanced ISO 64 version. Packed in the same way as the instant sheet films, in 4×5 inch format, this transparency film is loaded and exposed in the Polaroid 545 back, but after the shot has been taken, the packet is simply sealed and sent to any E-6 laboratory (or processed yourself). In fact, although Polaroid go to no trouble to publicize the fact, this is Fujichrome packed specially. The advantages are: no bulky dark slides (replaced by a single bulky Polaroid back, admittedly, but if Polaroids are being used anyway for testing, this hardly matters), no messy loading and unloading, and freedom from specks of dust and lint that can accumulate in changing bags and darkrooms.

A selection only of the range available to large-format users. Sheet film is available in sizes from 3¼×4¼ inches (8.3×10.8 cm) to 30×40 inches (76.2×101.6 cm), but the two most common, shown here, are 4×5 inches (10.2×12.7 cm) and 8×10 inches (20.3×25.4 cm). Kodak, Fuji and Agfa are the main manufacturers, with Polaroid providing a Fuji-made emulsion packed conveniently in single packets.

The advantage of large-format sheet film is simply a function of its size – image quality is that much better because of the greater amount of detail and the lesser effect of grain. The differences, however, can only be appreciated in enlargement. The main photograph (*below*) was taken on 4×5 inch film; the section (*right*) is an enlargement to the same size from a 35mm frame (*left*) taken at the same time.

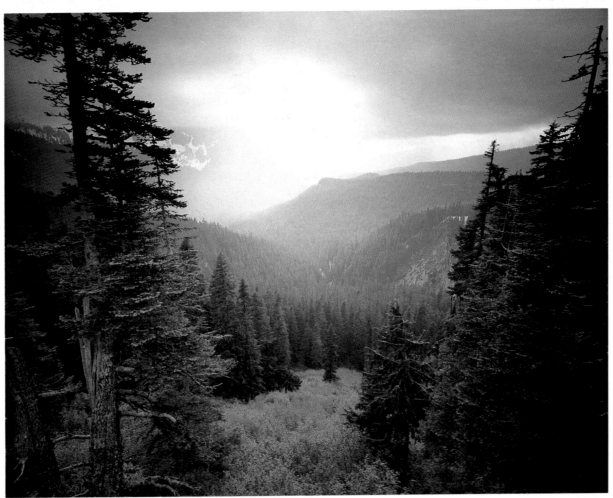

Infra-red Film

Kodak's Ektachrome Infra-red (IR) film is the one easily available emulsion that deliberately produces images in the "wrong" colours. Like its black-and-white high-speed cousin (see pages 60–1), it has a special sensitivity to infra-red wavelengths, but it handles these in an unusual way: the stronger the infra-red radiation is, the more red it appears, and this is combined with visible wavelengths. The result is a surreal rendering of scenes, with red vegetation, veins that stand out strongly in skin, and skies that can vary from cyan to yellow, depending on the filters used.

Regular transparency film has layers sensitive to blue, green and red, in that order (see pages 104–5). Ektachrome IR replaces the top blue layer with one that is sensitive to infra-red, so that the image combines visible light and infra-red. This, however, is not all. Whereas the dyes formed in normal film are the complementaries of the original colours (yellow in the blue-sensitive layer, magenta in the green and cyan in the red), in Ektachrome IR they are intentionally mismatched. The same dyes are used, but cyan appears in the top infra-red-sensitive layer, yellow below that, and magenta at the bottom. This arrangement accounts for the unexpected colours. For example, anything that has a high output of infra-red radiation, such as healthy, growing leaves, exposes the top layer strongly. This produces a very pale image in the cyan dye, which allows the yellow and magenta underneath to predominate; they combine to give red.

Even though there is no blue-sensitive layer as such, the green- and red-sensitive layers still react to blue (this is why a yellow interlayer is need in normal colour film, as we saw on pages 88–9). If you use infra-red film without any filter over the lens, blue is likely to be one of the strongest overall colours, which is why Kodak recommend a medium-to-strong yellow filter for most purposes. Filters, in fact, are what make the essential differences in using Ektachrome IR, and knowing what dyes are in which

layers, you can predict at least the overall colours. In a typical outdoor setting, no filter will give a blue cast. A red filter will allow the green-sensitive layer to predominate, giving a yellow cast to things that do not put out much infra-red.

The unpredictability comes from the differences in infra-red reflection between subjects, but with experience you can begin to judge how the final transparency will look. Healthy deciduous vegetation appears red, but conifers are dark purple. Diseased vegetation appears green or blue, but if stressed, yellow. Red roses are yellow, as are lips, but skin appears waxy, with prominent veins. Blue skies remain blue.

Film care
Ektachrome IR actually needs more care in storage than the black-and-white version, and should be frozen until you need it: 0° to −10°F (−18° to −23°C) is what Kodak

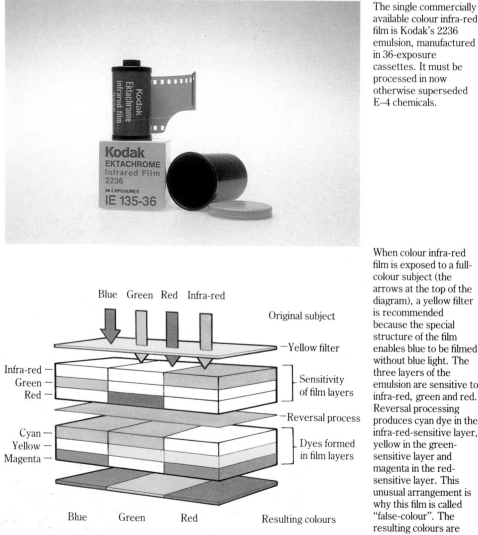

The single commercially available colour infra-red film is Kodak's 2236 emulsion, manufactured in 36-exposure cassettes. It must be processed in now otherwise superseded E–4 chemicals.

When colour infra-red film is exposed to a full-colour subject (the arrows at the top of the diagram), a yellow filter is recommended because the special structure of the film enables blue to be filmed without blue light. The three layers of the emulsion are sensitive to infra-red, green and red. Reversal processing produces cyan dye in the infra-red-sensitive layer, yellow in the green-sensitive layer and magenta in the red-sensitive layer. This unusual arrangement is why this film is called "false-colour". The resulting colours are shown at the bottom.

recommend. Otherwise, the film will lose infra-red sensitivity and suffer a colour shift towards cyan. If you do not process it immediately after use, return the film to the freezer for storage.

Processing is, unfortunately, something of a problem, as Ektachrome IR is one of the last remaining E-4 films. This process, long superseded by E-6, is carried out by very few laboratories. If you have difficulty finding one, make enquiries at a local medical research center or any company involved in aerial surveys; this film has specialized uses for these kinds of work. Alternatively, of course, you could contact Kodak direct for a list of laboratories.

Project: Using filters
Take one roll of Ektachrome IR, use a Wratten 12 yellow filter, and photograph a variety of subjects, including a natural landscape and a portrait. Then, with a second roll, take a landscape view and the same set of filters that are needed for the black-and-white colours-into-tones project on pages 156–7: yellow (Wratten 11 or 12), orange (15), red (25), blue (47) and green (58). Photograph exactly the same view through each of these in turn. As with black-and-white IR, the exposures are not easy to judge because the infra-red content in the picture does not affect the light meter. However, Ektachrome IR's addi-tional sensitivity to visible wavelengths makes the light meter reading a good starting point. Assume a speed of ISO 100 with the yellow filter, bracket around this, and allow for the filter factors with the other colours. Ektachrome IR is more contrasty than regular colour transparency films, and there is no more than a ½-stop of latitude on the optimum exposures.

Do not make the same kind of focus adjustment as recommended for black-and-white IR; although the infra-red wave-lengths focus further behind the lens, if you do this the visible wavelengths will not be in focus. Instead, focus by eye, normally, and stop down as much as possible.

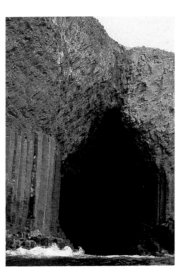

Ektachrome Infra-red's colour response is not always easy to predict, but depends very much on the filtration. As recommended by Kodak, it needs at least a deep yellow filter to show any useful differences in hue. The aerial view of South American rain forest (*below right*) used just such a Wratten 12 filter; the glowing red is typical of healthy green vegetation. The two photographs of the island of Staffa off the west coast of Scotland (*left*) were taken through, respectively, a Wratten 25 red and Wratten 21 orange filter. The fourth (*right*) used no filter at all, and so has a heavy blue-magenta cast.

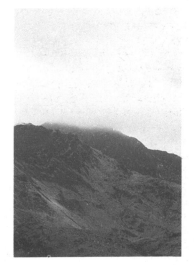

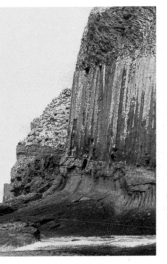

Instant Slide Film

There is just one type of instant colour transparency film available, but it works on such a different principle from conventional emulsions that it deserves special attention. As we have seen when we looked at the film technology underlying colour negatives and transparencies, conventional colour reproduction works by subtracting light, using filter layers built into the film. Polachrome, however, in order to produce an image within a minute or so, makes do with a very different process. Essentially, it is a black-and-white film, just like Polapan CT (see pages 62–3), with a colour screen sandwiched to the emulsion. This colour screen consists of very tightly packed transparent stripes of blue, red and green. There are 1000 of these triplets to 1 inch (2.5 cm), and although under magnification they look similar to the screen lines on a colour television set, at a normal viewing distance they simply give a distinctive, quasi-grainy appearance to the slides.

The screen works like this: during exposure, each coloured stripe passes only light of its colour through to the emulsion, where it activates the silver halide grains. During development, these silver halides are reduced to silver, but as with Polapan CT, it is the remaining unexposed halides that are eventually developed and deposited on the receiving layer to form the image. For example, the green stripes in the screen allow only green light through to the negative. The halides that are exposed to this are developed to silver, but then dissolved away, leaving clear film. As the slide is viewed through the same colour screen, what appears is clear, transparent green. Any red object, on the other hand, will not affect any of the silver halides under the green stripe, so that what will appear in the final positive image is the dense black of the unexposed grains.

This is known as the additive process, and because there is a screen next to the emulsion, Polachrome slides tend to look a little dense and even murky when seen side by side with conventional colour trans-

The special feature of Polachrome slide film is that it contains a transparent coloured screen of thin red, blue and green stripes. During exposure (1), light is filtered through this screen as it enters through the base. For simplicity only the green light is shown here; it passes only through the green stripes. At the start of development (2), the exposed halides are reduced to silver, and stay where they are, while the unexposed halides are dissolved by the processing fluid and move towards the receiving layer. At the end of development (3), the dissolved unexposed halides are all in place in the receiving layer, where they too have been reduced to black silver. The receiving layer is now transparent where the green light originally passed through. Finally (4), the layers that contain the earlier *negative* image are stripped off. The parts exposed to green light are now seen through the green stripes in the screen. The same thing happens to the blue and red light, passing through the blue and red stripes.

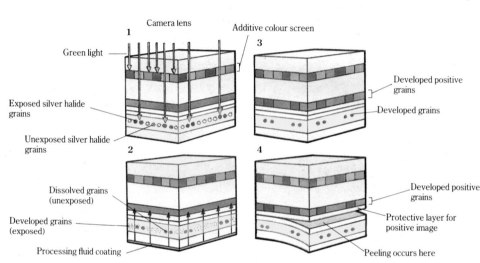

Camera lens
Green light
Additive colour screen
Exposed silver halide grains
Unexposed silver halide grains
Developed positive grains
Developed grains
Dissolved grains (unexposed)
Developed grains (exposed)
Processing fluid coating
Developed positive grains
Protective layer for positive image
Peeling occurs here

parencies. It is not a good idea to mix the two in a slide show, but seen alone in a darkened room with a bright projector lamp, the results are good. One special advantage is that, under fluorescent strip-lighting, Polachrome gives a more accurate colour rendering, with very little of the green cast typical of conventional film.

To use Polachrome successfully, it helps if you take a few small precautions to avoid making the high base density seem prominent. It appears strongest in, naturally enough, the highlights and palest tones, so that the best subjects for this film are usually those without large bright areas. Detailed scenes, and in particular those with rich colours, normally reproduce well.

The grain texture in a Polachrome slide has a quality not seen in conventional films.

This is because the graininess that you can see is the original black metallic silver (viewed through the colour screen). In conventional films, the silver grains that form the image in the first development are later bleached away so that they will not obscure the coloured dyes associated with them. What then remains is a soft-edged, transparent "graininess" composed purely of dye. The texture in Polachrome, however, looks more like that in a high-speed black-and-white negative. As we have seen when we looked at Tri-X and similar emulsions on pages 46–9, a distinct grain texture can enhance the graphic qualities of some pictures. Eventually, this is a matter of personal taste, but for some photographers, the image qualities of Polachrome offer a useful variety to colour photography.

Polachrome's additive process involves a screen of fine colour bands attached as a kind of viewing screen to the emulsion. The extra density of this screen inevitably muddies the highlights and lighter areas, and a side-by-side comparison between a Polachrome slide (*below*) and a Kodachrome (*left*) points out this deficiency. For the best appearance, Polachrome slides should be projected alone.

Provided that direct comparisons with regular colour transparency film are avoided, Polachrome works well within its own terms of reference, producing some delicate effects despite the high contrast.

Reversal Processing

The reversal stage in processing colour transparency film means that it takes rather longer than colour negative (37 minutes for the most common process rather than the 24½ minutes for C-41), and involves 11 steps as opposed to seven. Nevertheless, if you use a small tank kit such as Kodak's, it is no more complex, but you do have to be just as precise about the temperature and time, particularly in the two developer steps, as the table *below* shows. Before continuing, look at pages 72–7 (processing black-and-white film) and 98–9 (processing colour negative film) for all the basic information about procedure.

Although the different major film manufacturers supply their own processing kits, all the principal transparency emulsions are E-6 compatible. This process, developed by Kodak, is as straightforward as a reversal development can be. The sequence that we will follow here is the one for Kodak's Ektachrome Film Processing Kit, Process E-6. It is designed for amateur use, and has sufficient chemicals to fill a one US-pint (473ml) tank. Remember that this will not develop Kodachrome films; they have to be sent away for processing, either to Kodak itself or to a very few custom labs that have the necessary sophisticated equipment.

One final precaution before beginning: be very careful about getting E-6 chemicals on your skin. The developers in particular can be harmful. Always wear gloves, and if by chance you do splash yourself, wash immediately with an acid-based hand cleaner such as Phisoderm and then rinse with plenty of water. It is not a bad idea to stock up with a bottle of cleaner, just in case.

E–6 Process (Kodak Ektachrome Kit)

Stages	Temperature °F(°C)	Time (mins)	Comments
First developer	100 (37.8)	7	This time is for the small-tank kit, and after an initial test you may need to adjust it according to the instructions. Agitate for the first 30 seconds, rest for 15 seconds, and then agitate for 5 seconds every 20 seconds
First wash	92–102 (33.5–39)	1	Agitation as for the first developer
Second wash	92–102 (33.5–39)	1	Agitation as for the first developer
Reversal bath	92–102 (33.5–39)	2	Agitate for the first 30 seconds only
The remaining steps do not need darkness:			
Colour developer	100 (37.8)	6	Agitate for the first 30 seconds, rest for 25 seconds, and then agitate for 5 seconds every 30 seconds
Conditioner	92–102 (33.5–39)	2	Agitate for the first 30 seconds only
Bleach	92–102 (33.5–39)	7	Agitation as for the colour developer stage
Fixer	92–102 (33.5–39)	4	Agitation as for the colour developer stage
Final wash	92–102 (33.5–39)	6	Use running water. Agitation as for the colour developer stage
Stabilizer	92–102 (33.5–39)	1	Agitate for the first 30 seconds only
Drying	75–120 (24–49)	10–20	The film will appear opalescent when removed from the wash; this clears as the film dries

Processing equipment
Apart from the
chemicals, which are
easiest to buy as a
complete kit (as here),
the equipment is basically
that needed for colour
negative development,
although there are more
storage bottles needed
(see pages 98–9).

Darkroom timer

Rubber gloves

Thermometer accurate
to within ¼°F (0.15°C)

Mixing container and
graduate for measuring
solutions

Processing kit

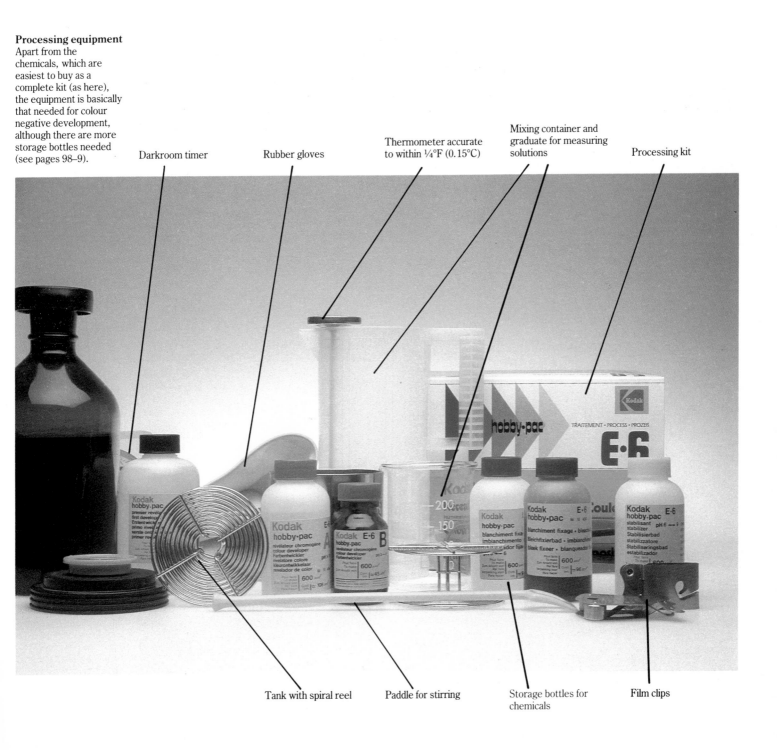

Tank with spiral reel

Paddle for stirring

Storage bottles for
chemicals

Film clips

Troubleshooting

The image on colour transparency film is positive and complete, so identifying any errors is straightforward. You need no experience to tell if anything is wrong. Analyzing the cause may not be so simple, however: reversal processing has more stages than that for negative film, and this provides the opportunity for more errors. In particular, colour accuracy is critical; if the transparency is intended to be used as a slide, there is no further stage (such as printing) at which to make corrections. To be able to judge the colours precisely, the light box that you use should have colour-matched fluorescent tubes (most proprietary light boxes will have these).

As with all faults – outlined on pages 78–81 – the causes of colour problems fall into three areas: the film stock, exposure, and processing. Try first to identify where the colour shift occurred; some of the examples here will help for comparison.

Here, the E–6 reversal bath is not working properly, and needs replenishment. The result is an overall paleness and light green cast.

The green and violet stains are due to the film getting wet in the camera bag after exposure and rewinding. The effect of this partial wetting was to allow the developer later to work differentially.

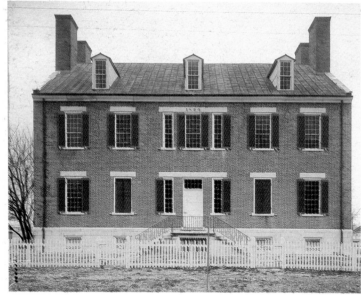

This frame has been fully developed, but unexposed. To check that it has received no light at all (and therefore has probably not passed through the camera), hold the film up to a very bright light. Certain shutter errors show a very dim image. The two most common causes of completely black film are that a new cassette of film has been mistaken for one that has been exposed, or that the film leader did not engage with the take-up spool when loaded.

126

The strong green cast and paleness are due here to the film having been left for one year after exposure before processing – in hot, humid conditions. This is a good example of extreme accelerated ageing.

The darkness of this shot is not necessarily a mistake, although if it comes as a surprise, the most likely explanation is that the film speed selector was wrongly set. The pinkish cast to the sky is the effect of one brand of neutral graduated filter (see page 151) on Kodachrome.

The shape of this violet stain identifies it as a drop of liquid falling on the emulsion and being wiped off. It is essential to keep different chemical solutions separate.

The thin, spidery blue lines in the dark part of this image (a small section of a 4×5 inch sheet) are scratches that occured before processing. Several exposed sheets were stacked together in a box, and moved in relation to each other. However, this would not normally cause sufficient scratching to remove the top layer of the emulsion, as has happened; in this case, a batch of Fujichrome 50D was given insufficient protective coating.

A broad, severe light leak extending over the rebates: caused by the camera back being opened before the exposed film had been fully rewound. When the leak happens in this way, you will know in advance, but similar effects are possible in the darkroom.

The overall dull green cast and slight underexposure are characteristic of reciprocity failures: this shot was taken on daylight-balanced film with a conversion filter and tungsten lights, at a shutter speed of ½ second.

Clumsy handling of the film causes a small, crescent-shaped crease. In this case, it happened before processing, with the resultant inadequate development of all three layers.

EXPOSURE

Among all the different types of film that we have looked at, one of the most important distinctions is the speed rating. In each major group there is a range from slow to fast, and for most photographers the immediate choice when shooting is on the lines of fast but grainy, or slow and fine-grained. The film speed rating is a guide to what exposure is needed to make an acceptable image. Deciding on that exposure, whatever the film, is the subject of this section of the book.

In practice, exposure is a matter of camera settings and meter readings, but the key to being able to make the right exposures easily and consistently is first to understand the criteria; you should first know what an acceptable image is. Ultimately this depends on personal judgement, and although most people would agree more or less on whether a particular print or slide appears too dark or too light, there remains a margin of individual taste. It is for this reason that there is no precisely set standard for correct exposure. The idea of correct exposure is a valuable one, but only if you allow it to be expressed a little loosely.

Under normal circumstances, the best exposure for a film is the one that allows the most information to be recorded. For most people, the aim is to produce a photograph that resembles the way the original scene looked to the eye, and in a typical view this means that the highlights are bright but still show a hint of detail, and that the shadows are dark, but not so much that they hide their detail. All the tones would be present, from shadow detail to highlight detail, recorded on the film. Parts of the scene that looked average in tone – neither bright nor dark – would have an average density on the film. This is as close as we can get to an objectively correct exposure. If the film received less light, some of the shadow detail would not register; if it received more, highlight detail would be lost.

Three main things decide what the amount of exposure should be to give this image. One is the level of light that strikes the scene, known as the incident light. Another is brightness or darkness of the subject: that is, how much of the light it reflects. The third is the sensitivity of the film: its speed rating. There are a number of other factors that come into play, like the development and any filters used, but the basic exposure is set by the main three. If you know these, you can adjust the camera and lens settings accurately. Only one important consideration remains: your personal judgement. There may be reasons for not wanting the image to look just as the scene did. A darker version may be more dramatic, or a lighter-than-normal exposure may create a different atmosphere. Individual preference is the final arbiter.

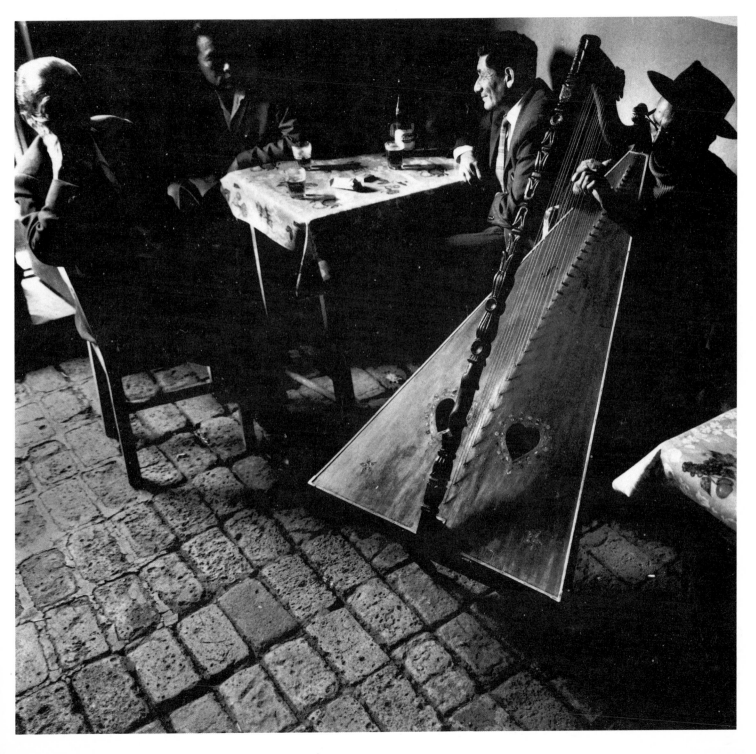

Direct and Incident Readings

Of the three controlling factors for exposure – incident light, brightness of the subject, and film speed – the film speed is the one variable that you can be certain of to begin with, and with any kind of exposure meter, it is simply a matter of entering the information. The unknowns that have to be measured are the light and the way it is reflected. In practice, either measurement will give a figure that can be used for the exposure settings, and there are advantages and disadvantages to each.

Given the right kind of exposure meter, measuring the incident light is extremely simple. Whether it is the sun, a flash unit or a tungsten lamp, the illumination is independent of the subject. However bright or dark the subject, you can ignore it completely if you are measuring the light. The meter, which is held facing the light and has an attachment to the sensor, will show the exposure settings that will make an average-toned subject appear with the same average tone on the film. All the other tones will be recorded as dark and as light as they are. The method is simple, easy, and more or less foolproof.

The other method, known as a direct reading or reflected-light reading, is to measure just the light that the subject reflects. The meter is aimed directly towards the subject, and measures its brightness. Like any other metering system, the exposure setting that it gives is one that will record the subject on film as an average tone – in black-and-white photography, a mid-grey, halfway between black and white. For most subjects this creates no problems, as average tones are the ones that look normal to the eye. However, if the subject is either white, such as sunlit snow, or black, the meter will still show the settings for making it appear grey, which is not likely to be what anyone wants.

This drawback with direct meter readings is inevitable, because there is no way in which the meter can tell whether the subject ought to be dark or light. Objectively, a black cat should stay black in a photograph, but the meter cannot distinguish between the low level of light that it reflects and the equally low level from the inside of a dimly lit room. Only the photographer can decide that, and in practice, direct meter readings have to be overlaid with judgement.

Put like this, the advantages seem to lie with incident readings, and their consistency is certainly a powerful argument. However, practical difficulties get in the way, and it is hard to fit this kind of measurement into the modern style of 35mm photography. To make an incident reading, you have to use a meter that is separate from the camera, *and* hold it in the same light that is falling on the subject. Simply needing to use a separate meter takes time, whereas a reading made in the camera as you prepare the shot is rapid and convenient. Moreover, if the subject is a distance away, as it will usually be if you are using a telephoto lens, it may also be in light that is different from where you are. Ultimately, the convenience of having a meter built into the camera, taking measurements through the lens (TTL) and being processed electronically, has made direct measurement more popular, despite its drawbacks.

The accuracy and flexibility of a hand-held meter (which can also, of course, be used for direct readings) are still good arguments for owning one. Not only do they offer a fallback measurement to compare with the direct reading, but hand-held meters will easily take care of many of the problem situations that face TTL metering. A basic exercise in familiarization is to take both readings in a variety of lighting situations. From comparing the two, you will be able to see which situations cause the greatest discrepancies, and decide for yourself when to rely on one or the other.

This white wall and balustrade is a non-typical subject in that it is naturally lighter than most scenes. A series of exposures demonstrates this: beginning with the exposure recommended by the camera's through-the-lens meter, the aperture was increased 1 stop at a time. The accurate exposure is between the second and third shown here; this is the level given by a hand-held incident reading.

TTL reading (¹⁄₂₅₀ second at *f* 11) TTL reading +1 (¹⁄₂₅₀ second at *f* 8) TTL reading +2 (¹⁄₂₅₀ second at *f* 5

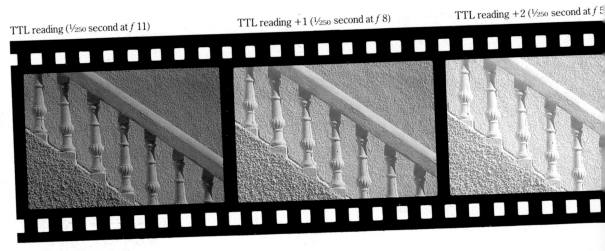

Highlight *f* 32

Shadow *f* 8

Average *f* 16

The weather is slightly overcast, and the range of tones is small and close to average. There is no difference between an incident reading and a through-the-lens reading with an average pattern. In other words, the average of the bright areas and shadows (a total 4 stop difference) is the same as the measurement of the light falling on the landscape.

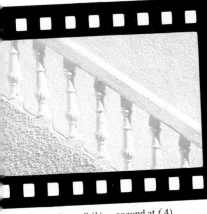

TTL reading +3 (¹⁄₂₅₀ second at *f* 4)

With a hand-held meter, compare incident and direct readings when the subject is bright: here a whitewashed wall. The incident reading shows that the aperture should be between *f* 11 and *f* 16: this is correct. A direct reading pointed at the wall, however, shows a smaller aperture – between *f* 22 and *f* 32 – but this would result in the wall appearing grey in the photograph, not white.

Average Readings

All exposure meters "average" in the sense that they are calibrated to give settings that will produce an average tone. So, if the scene you are photographing is of average brightness, more or less, the whole process will work smoothly. The average brightness will be converted into average tones on the film, and the image will look as the scene did. Most direct meters, whether in the camera or hand-held, measure most of the area being photographed, and integrate the different levels of brightness inside the picture to a single, average level.

The majority of picture situations actually suit this type of reading, and for this reason it is the most popular and normal. For most people, most of the time, it works. It only fails seriously when the subject is inherently very bright or very dark, and when the important part of the scene happens to be small in the frame and much darker or lighter than its setting. It is essential with this kind of reading to decide whether the image should be brighter or darker than average. If the subject is mainly white and you want its image to stay that way, then you must make allowance for that and increase the exposure beyond the settings that the meter gives.

Although an average reading like this is the one that you will probably be following on most occasions, it is important not to slip into the habit of making it blindly, without judging the scene for yourself. Even an average scene contains an important range of tones, and the darkest and lightest of these – the shadow areas and the highlights – are the ones most at risk. In a typical scene, there is important shadow detail, while the highlights appear to the eye bright but not empty.

Unfortunately, film cannot record the entire range of tones that the eye can see, and if the contrast in the scene is too high, the details in the shadows and highlights can be lost. Even when the contrast is not extreme, this is something to be careful about, and there is a slight difference between negative and transparency films in

the way this should be treated. Negative film in any case can cover a wider range of contrast, but the important tones to protect are usually the shadow details. A long-standing rule of thumb that still makes good sense is to make sure that the negative receives the minimum exposure necessary to hold shadow detail. If you want to think about it in terms of the characteristic curve (page 13), this means locating the shadows on the straight-line part of the graph, just above the toe.

With transparency film, however, the brightness of the highlights are set by the clear film base, and between overexposed highlights and underexposed shadows, the former definitely look worse. So, if the guide for working with negative film is to expose for the shadows, that for colour transparencies is to expose for the highlights, making sure that they contain a hint of detail and do not seem washed out and empty. It is usually safer to err on the side of slight underexposure.

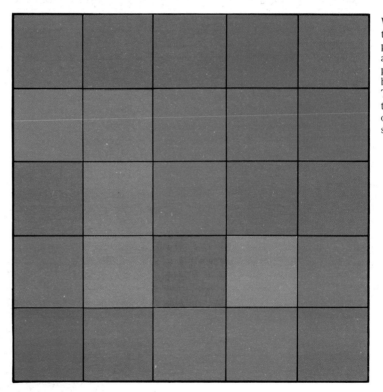

While mid-grey is the term commonly used in photography to describe an average tone, in practice you will normally be dealing with colours. The square *left* contains the coloured equivalents of the mid-grey square shown *below*.

This is the standard mid-grey, halfway between pure black and pure white. It reflects 18 per cent of the light falling on it and is, theoretically, the tone produced by following a normal meter reading.

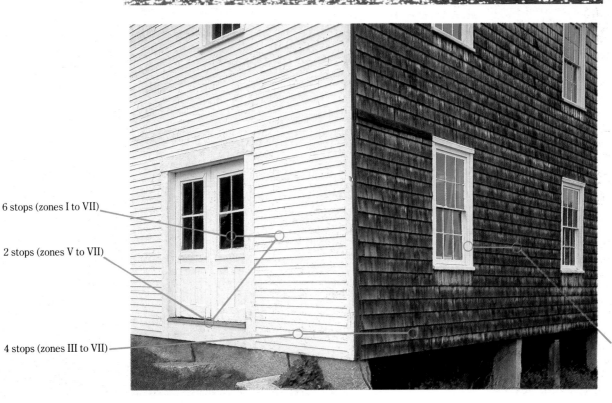

Overall contrast 10 stops

Local contrast 2 stops

High overall contrast/ low local contrast
The structure of this picture is a silhouette, making loss of detail relatively unimportant overall. However, the area under the jetty is in danger of losing definition, because the unlit areas of water are so dark. It is important here to maintain a distinct separation in tones between this water and the black posts of the jetty. If not, the shape of the jetty will be lost.

6 stops (zones I to VII)

2 stops (zones V to VII)

4 stops (zones III to VII)

3 stops (zones III to VI)

In this architectural picture, shot under overcast lighting, the local contrast on either side of the corner is different. On the white side of the building, the full range is 6 stops, but as this includes the black window panes and these contain no significant detail, the essential contrast is just 2 stops. On the darker half, the range is also quite small: 3 stops. These are the two local contrasts, but combined they give an overall contrast of 4 stops, covering five zones under the Zone System.

Testing Exposure

The ultimate proof of how accurate your exposure calculations have been is the developed image, and for many photographers there remains some uncertainty until they see the processed film. Such uncertainty is not confined to the inexperienced; there are many circumstances which create problems in deciding exposure.

In problem situations, it would be ideal if there were some kind of confirmation that the chosen camera settings were giving the result you expected. For this reason, it is common practice among professional photographers to test doubtful exposures.

If time is no consideration at all, it is perfectly possible to shoot and then leave the camera and subject undisturbed while the film is processed. This is not uncommon in studio photography, where the effort in constructing an elaborate set, for instance, may justify waiting a couple of hours for a sheet of colour film to be processed. It is particularly suited to large-format photography: a single exposure on a single sheet of film is less of a waste than 36 exposures on a 35mm roll.

This kind of testing only applies when the subject is static or the exact shot can be repeated without difficulty. In practice, a professional photographer who does this is usually testing a number of aspects of the picture, including composition and colour balance, and is not solely confirming the exposure. Most photographs, however, even if they are planned and set up, must be completed well before the film is developed, and test processing is only useful if it allows some alterations to be made as a result.

Fortunately, one option remains. Altered processing, which we have mentioned several times and deal with on pages 146–7, allows the overall brightness of an image to be changed, and is a fair equivalent of altering the exposure. Its main use is for transparency film, which has less exposure latitude than negative film and lacks the facility for making substantial changes in the printing stage. One exposure-testing method is to process one roll out of several

in advance of the others. Then, if the results appear underexposed or overexposed, the processing of the remaining films can be altered accordingly.

A less wasteful procedure is to process a short length from the end of a roll of film. This is known as a clip test, and looks like the example here: a short strip, sufficient to include about a couple of frames. If you know that you are going to make a clip test, it is easier if you leave the tongue of the film protruding from the cassette rather than rewind it fully. Otherwise, you or the laboratory will have to open the cassette, cut off the test strip, and then store the remaining loose roll of film in a light-tight container. As clip-testing is often performed at non-standard development, it is important to write on the film how it has been processed. Use an indelible marker or, if the film has been rewound fully and you must open the cassette in the dark, scratch the information with the point of a pair of scissors. "N+½" or "+1" are typical inscriptions.

Of all testing methods, however, the most widely used in large and medium-format photography is instant film. It is

virtually standard practice in professional studio photography to make test exposures on Polaroid film before shooting regular film. Polaroid backs are available for all large-format and most medium-format cameras, allowing a single instant film exposure to be made before attaching the normal film back. There is less choice for 35mm cameras, but the 12-exposure cassettes of Polaroid slide film are not too wasteful if used like this; some professional models of camera can also be adapted to take a Polaroid peel-apart film back, albeit expensively.

When making instant film tests, it is essential to compensate for any speed difference between the two films. You can do this by altering the shutter speed or aperture, but this has two disadvantages: there is a danger of forgetting to change the settings back for the regular film, and the treatment of movement and the depth of field will not be quite the same. It is more reliable to use a neutral density filter over the lens, either with the instant film or the regular emulsion, depending on which is faster. Use the table to identify the most appropriate instant film to use.

Polacolor prints were used here to test different lighting directions for a photograph of a famous natural pearl. The surface of the pearl was reflective and a problem; instant prints helped make the decision.

A typical clip test of transparency film, push-processed by 1 stop. About 8 or 9 inches (20 cm) from the beginning of the roll are pulled out of the cassette in darkness, cut and processed specially. Note that the laboratory has first pulled out a couple of inches in daylight and marked the film for identification.

Choice of instant films for exposure tests

Regular film	Film size	ISO	Instant film
Kodachrome 25, Kodak Technical Pan 2415, Agfapan	35 mm	25	Polapan CT+ND 0.7
Kodak Panatomic X	35 mm	32	Polapan CT+ND 0.6
Agfachrome 50S and 50L, Ektachrome 50, Fujichrome 50, Ilford Pan F	35 mm	50	Polapan CT+ND 0.4
Kodachrome 64, Agfachrome 64, Fujichrome 64	35 mm	64	Polapan CT+ND 0.3 or Polachrome CS (with ND 0.2 on the conventional film)
Ektachrome 100, Agfachrome 100, Fujichrome 100, Ilfochrome 100, 3M Color Slide 100. Agfacolor XR100, Kodacolor VR100, Agfapan 100, Fujicolor HR100, Ilfocolor 100, 3M Color Print 100	35 mm	100	Polapan CT+ND 0.1 or Polachrome CS (with ND 0.4 on conventional film)
Kodak Plus-X, Verichrome Pan, Ilford FP4	35 mm	125	Polapan CT, no filter
Ektachrome 160, Vericolor IIIS	35 mm	160	Polapan CT (with ND 0.1 on conventional film)
Agfachrome CT200, Ektachrome 200, Kodacolor VR200, Agfacolor XR200, Kodachrome 200	35 mm	200	Polapan CT (with ND 0.2 on conventional film)
Ektachrome 400, Fujichrome 400, 3M Color Slide 400, Kodacolor VR400, Agfacolor XR400, Fujicolor HR400, 3M Color Print 400, Ilfocolor 400, Tri-X, Ilford HP5, Agfapan 400	35 mm	400	Polapan CT (with ND 0.5 on conventional film)
Agfapan 25	120	25	Type 665+NF 0.9
Panatomic-X	120	32	Type 665+ND 0.5
Agfachrome 50S and 50L, Ektachrome 50, Ilford Pan F	120	50	Type 665+ND 0.1 or 0.2, or Types 669, 88+ND 0.2 (Agfachrome 50S only)
Ektachrome 64	120	64	Type 665+ND 0.1, or Types 669, 88+ND 0.1
Agfachrome R100S, Ektachrome 100, Fujichrome 100, Agfacolor XR100, Fujicolor HR100, 3M Color Print 100, Agfacolor N100S, Vericolor IIL, Agfapan 100	120	100	Type 665 (with ND 0.1 on conventional film) or Types 669, 88 for all except Agfacolor N100S or Vericolor IIL (with ND 0.1 on conventional film)
Plus-X, Verichrome Pan, FP4	120	125	Type 665 (with ND 0.2 on conventional film)
Ektachrome 160, Vericolor IIIS	120	160	Types 107C, 664, 107, 084, 87+ND 1.3
Ektachrome 200	120	200	Types 107C, 664, 107, 084, 87+ND 1.2
Ektachrome 400, Fujicolor HR400, Tri-X, HP5 Agfapan 400	120	400	Types 107C, 664, 107, 084, 87+ND 0.9
Royal-X Pan	120	125	Types 107C, 664, 107, 084, 87+ND 0.4
Kodak Technical Pan 2415, Agfapan 25	4×5 in	25	Type 55+ND 0.3, or Types 52, 552+ND 1.2
Panatomic-X	4×5 in	32	Type 55+ND 0.2, or Types 52, 552+ND 1.1
Agfachrome 50S and 50L, Ektachrome 6118	4×5 in	50	Type 55 (no filter). Types 52, 552+ND 0.9, or Types 59, 559 (+ND 0.2 if using Agfachrome 50S, or with filtration as indicated if using the tungsten-balanced films in tungsten light)
Ektachrome 6117, Fujichrome 64	4×5 in	64	Type 55 (no filter really necessary, but expect instant print to appear slightly darker than wanted). Types 52, 552+ND 0.8, or Types 59, 559+ND 0.1
Ektachrome 100, Fujichrome 100, Agfachrome R100S, Agfacolor N100S, Vericolor IIL	4×5 in	100	Types 52, 552+ND 0.6, or Types 59, 559 (with ND 0.2 on conventional film)
Plus-X, FP4	4×5 in	125	Types 52, 552+ND 0.5
Vericolor IIS	4×5 in	160	Types 52, 552+ND 0.4
Ektachrome 200, Fujichrome 200, Agfapan 200	4×5 in	200	Types 52, 552+ND 0.3, or Types 59, 559 (with ND 0.5 on conventional film)
Tri-X Professional	4×5 in	320	Types 52, 552+0.1
Various	8×10 in		Type 809 is rated at ISO 80, and so is suitable for the 8×10 versions of the emulsions listed above for 4×5 – in theory. However, it is for most purposes too expensive a film to use for testing. A more usual solution is to have a 4×5 reducing back, and use the 4×5 instant films.

145

Altered Processing

The film speed ratings and development instructions given by film manufacturers are based on what they judge to be optimum picture quality. In other words, if you expose Kodak Tri-X at its rated ISO 400, and develop it in, say, Microdol-X for the recommended 10 minutes at 68°F (20°C), you will have negatives that look as Kodak intended them to: moderate grain, low fog level and moderate contrast (a contrast index of just over 0.50). However, although the recommended speed rating and development is the manufacturer's ideal, it is not inviolable. Changing both of them will give you, under the right circumstances, two important benefits: it will alter the density of the image, and it will alter the contrast. When the subject gives you problems of exposure, changing the development may be the best answer.

The general effect of extending the development makes the film behave as if it were more sensitive – that is, with a higher speed rating. This is known as push-processing or pushing. Reducing the development – pull-processing or pulling – has the opposite effect. Both can be achieved either by altering the temperature during development or by altering the time; in general, altering the time rather than the temperature is more common, although when pull-processing there is a lower limit set by the minimum development time. Professional laboratories, which must process several films at any one time, do not have the choice of changing the temperature, and as a result are normally unwilling to pull-process by more than 1 stop (with the E-6 process the result of very short development is flat, muddy highlights and pale tones).

In its least imaginative use, altered processing is a means of correcting mistakes, such as forgetting to alter the film speed setting on the camera's meter when changing to a faster or slower film. A more positive reason, however, is when the lighting conditions would otherwise prevent you from shooting. Typically, if there is insufficient light in a particular situation to allow a safe shutter speed, the photographer would assume that the film was, say, 1 stop faster, compensating later by extending the development. The kind of situation that calls for reduced development seldom occurs.

A rather more sophisticated use is to control the contrast of the picture. Push-processing has the effect of increasing the development of the areas that are already well-exposed, and the result is that the contrast is extended. If the lighting and subject appear flat and lacking in contrast, push-processing will help to clean up the highlights and bring some sparkle to the image. Pull-processing, on the other hand, reduces contrast, which can also be useful with scenes that have too great a spread between dense shadows and brilliant highlights. Adjustments of up to about 1 stop are standard procedure for photographers who regularly use the Zone System (see pages 140–1) and for studio photographers.

Individually tailored processing to control contrast is more convenient if you are using sheet film, as the changes can be made to single images without affecting any of the others. Used like this, altered processing must go hand in hand with a change in the speed rating of the film, in order to keep the same overall density of the image. Altered processing is possible with black-and-white film and with colour transparency film, but is not recommended for colour negative emulsions, the colour response of which would be changed too much because of the different reactions of the three dye layers.

The option that pushing and pulling offers is, however, not without a price. Push-processing in particular creates problems with the image quality, as it increases both graininess and fog levels. As graininess is the accepted penalty for higher film speed (see pages 112–15), this may not be a major drawback, but the increase in fog may come as an unpleasant surprise. When the film is left in the developer for any length of time, even the unexposed silver halide crystals begin to develop into silver. The result can be a merging of tones, not always compensated for by the increase in contrast. These problems are in proportion to the degree of altered processing that you give. With colour transparency film there will also be some shift in colour, because the three layers do not respond to pushing and pulling equally. Generally, with the E-6 process, pull-processing causes a shift towards blue and push-processing towards red.

Altered development

Black-and-white process (T-max 400)		E-6 process (Normal time = 6 mins)		
Alteration	Development time	Alteration	First developer time	First developer temperature*
Pull 1 stop (N–1)	−2½ mins	Pull 1 stop (N–1)	−2 mins	−5.9°F (3.3°C)
Normal (N)	6 mins	Pull ½ stop (N–½) Pull ⅓ stop (N–⅓)	−1 min −½ min	−3.9°F (2.2°C)
Push 1 stop (N+1)	+2½ mins	Push ⅓ stop (N+⅓) Push ½ stop (N+½)	+⅔ min +1 min	+4°F (2.3°C)
Push 2 stops (N+2)	+5 mins	Push ⅔ stop (N+⅔) Push 1 stop (N+1) Push 1½ stops (N+1½)	+1½ mins +2 mins +3 mins	+7.9°F (4.4°C)
		Push 2 stops (N+2)	+5 min	+12°F (6.7°C)

*Alter time or temperature, not both. (Developer times less than 4½ mins may result in unevenness.)
These figures should be taken as rough guides only, and will vary according to a variety of factors, including the make of film and purpose of picture.

Reduced development

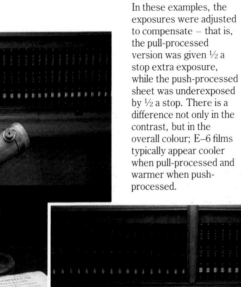

The effects of ½ a stop difference in the development of E–6 colour transparency film are subtle but noticeable. In these examples, the exposures were adjusted to compensate – that is, the pull-processed version was given ½ a stop extra exposure, while the push-processed sheet was underexposed by ½ a stop. There is a difference not only in the contrast, but in the overall colour; E–6 films typically appear cooler when pull-processed and warmer when push-processed.

Normal development

Extended development

Colour Correction and Colour Compensating Filters

Colour correction filters

These filters are, for the most part, designed to improve the accuracy of colours recorded on film. They are particularly important for colour transparency film, as most people can easily detect a colour shift of as little as 5 or 10 per cent. Colour negative film can be filtered quite strongly later, during printing, and does not need the same degree of precision.

Filter terminology can be confusing, with different descriptions commonly used for the same group of filters, but there are basically two types: one alters the colour temperature, and the other covers primary and secondary colours. Filters on the colour temperature scale are either bluish or amber, in a variety of strengths, and are designed to match the light source to the film. As we have already seen, there are two kinds of colour-balanced film – daylight and tungsten – and each is intended to give a neutral rendering of colours when used with its respective lighting. For convenience, strong amber and blue filters allow film balanced for one kind of lighting to be used in another. These filters – 80A for using daylight-balanced film in photographic tungsten light and 85B for using tungsten-balanced film in daylight or with flash – are the extremes of this range of filters. They are sometimes known as colour conversion filters, but also as colour balancing or light balancing filters.

In between these two points on the colour temperature scale are filters in milder tints of the same colours. On the Kodak scale, the "80" series and "85" series are for major conversions between film types, but the "81" series and "82" series are for making small adjustments. In daylight, the colour temperature varies from the standard of a bright midday sun in a clear sky. In cloudy weather the colour temperature is slightly higher, and the effect a little more blue, or "colder", and in open shade under a blue sky, the blue cast is even stronger.

Both of these conditions can be made to appear neutral with one or more of the straw-tinted 81 series of filters. Towards sunset and sunrise, the colour temperature on a clear day falls as the sun appears more orange, and in theory at least, this could be brought back to "normal" by using a bluish filter from the 82 series. In practice, hardly anyone ever bothers to do this, as people are used to seeing light from a low sun that *is* rich and warm. The 82 "cooling" range of filters is more often used in tungsten lighting to make non-photographic lamps appear less orange.

Colour compensating filters

Colour compensating filters are available in the six colours used in film dyes – the colours of the photographic process, in other words. These are red, green and blue, and their complementary opposites

81A Normal 82A

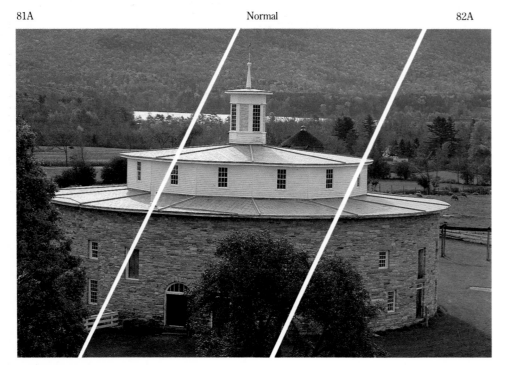

For making small adjustments to the colour temperature in daylight shots, the mildest colour correction filters are 81A (*left*, warming) and 82A (*right*, cooling). In practice, 81A and its slightly stronger companions 81B and 81C are the most commonly used, when overcast weather raises the colour temperature.

cyan, magenta and yellow. One major use of these filters is to correct the greenish and bluish casts from fluorescent and vapour discharge lighting. This is dealt with more thoroughly in volume III, *Light*, but the table here gives an indication of the starting point for filtration.

There are also, however, less extreme shifts of colour that may need attention, and the range of colour compensating filters includes very faint tints, from CC05 (a density of 0.05) to CC50 (0.5 density). The range can be added together to produce any density and colour combination. One reason for using compensating filters is if the colour accuracy of a particular batch of film is not perfect (manufacturing tolerances and ageing effects may throw the balance out of neutral). Another is when duplicating slides: in this case, a mismatch of dyes between the original transparency and the film with which it is being photographed is a fairly common occurrence.

1

2

Colour balancing (Light balancing) filters

Effect	Filter	Mired shift	Use	Filter factor	Approximate exposure increase needed (*f*-stops)
More blue	82	−10	Slight cooling effect, 3100 K to 3200 K	×1.1	—
More blue	82A	−18	Slight cooling, 3000K to 3200K, and 3200K (Type B) to 3400 K (Type A)	×1.2	⅓
More blue	82B	−32	Slight cooling, 2900K to 3200K	×1.4	⅔
More blue	82C	−45	Moderate cooling, 2800K to 3200K	×1.5	⅔
More blue	80A	−131	Converts 3200K tungsten to 5500K daylight	×3	1⅔
More blue	80B	−112	Converts 3400K tungsten to 5500K daylight	×2	1
More blue	80C	−81	Converts 3800K clear flash bulbs to 5500K daylight	×1.7	⅔
More blue	80D	−56	Converts 4200K clear flash bulbs to 5500K daylight	×1.2	–
More amber	81	+10	Slight warming effect	×1.2	–
More amber	81A	+18	Slight warming effect, overcast sky. Also, 3400K·(Type A) to 3200K (Type B)	×1.3	⅓
More amber	81B	+27	Slight warming effect, overcast sky	×1.4	⅓
More amber	81C	+35	Warming effect, open shade	×1.5	½
More amber	81D	+42	Warming effect, open shade	×1.6	⅔
More amber	81EF	+53	Strong warming effect, open shade	×1.7	⅔
More amber	85	+112	Converts 5500K daylight to 3400K tungsten (Type A)	×1.6	⅔
More amber	85B	+131	Converts 5500K daylight to 3200K tungsten (Type B)	×1.7	⅔
More amber	85C	+81	Partial correction, 5500K to 3800K	×1.3	⅓

Fluorescent striplighting nearly always needs some compensating filter, although the strength is not easy to predict. Here, unfiltered (**1**), the green cast is relatively mild, needing only a Wratten CC10 magenta filter (**2**).

Graduated Filters

If you hold a coloured or neutral density gelatin filter so that it covers only a part of the camera's lens, its edge will appear blurred in the viewfinder. Exactly how blurred will depend on the distance at which the lens is focused and on the depth of field. In turn, the depth of field depends on the aperture setting and on the focal length. At one extreme, a fully stopped-down wide-angle lens focused close will make the filter's edge almost sharp, at the other, a telephoto focused at infinity and at full aperture will hardly even show that the filter is there. If you could control the exact amount of blurring of the filter's edge, it would be possible to cover just a selected part of the image without an obvious line across the picture.

This is the principle of the graduated filter, long a standard item in cinematography, where none of the tonal controls used in printing still images are possible.

On a wide-angle lens the edge will be less soft, as it will if the lens is stopped down. In practice, the range of settings that can be tolerated visually is wide, but a graduated filter has little use with a telephoto lens. The distinction between the two halves is too soft to be noticeable, and the thickness of the filter (most are plastic) can cause a significant deterioration in image quality.

A graduated filter has an even tint covering half of the area; the remainder is clear. The border between the two is critical, for to be unnoticeable in a photograph, it must shade smoothly between the two halves. Even so, it depends for successful use on the psychology of perception, as shown in the project. The neutrally tinted version is extremely useful in adjusting the light selectively. Its most common use is to darken the sky without affecting the remainder of the scene. Although a graduated filter has the same effect on any film, it is needed less with colour or black-and-white negative emulsions, as these are always used for printing and it is a relatively simple matter to darken a broad area during enlargement by the equivalent of a few stops. Colour transparencies, unless used only for printing, offer no opportunity for post-correction, and any alterations to the density of the image must be made while the film is in the camera.

One occasional problem with colour transparency film is that the toned part of the filter may not appear neutral with certain emulsions. This is another version of the familiar problem of using one set of dyes (in the film) to photograph another (in the filter). A mismatch sometimes occurs; in addition, the dyes in a filter are also prone to fading and discolouration with time.

Project: Using a graduated filter

You can demonstrate this for yourself with a standard lens and a typical landscape view. Take a normal neutral graduated filter, which has a tone equivalent to about a 1½-stop reduction, and move it into position in front of the lens with your eye to the camera's viewfinder. The edge, though soft, should be obvious. Position it so that the edge coincides, more or less, with the horizon (and with the dark half of the filter

To enliven this monochrome view of a Scottish loch in very dull weather a brown graduated filter was used. The tinted area was kept to the very top of the frame so that the effect was not overpowering.

150

covering the sky). With the filter in place, it will be almost impossible to tell that it is there. Even if you move it up slightly so that the edge is above the horizon, this will simply look like a normal pale-horizon effect. As soon as you pull the filter away, however, you will see the edge as it moves. The principle is that, although the edge is there in the picture, the eye ignores it as long as it resembles a natural condition of light and appears to coincide with a line within the picture.

The straight soft edge will not always align with a boundary inside the image, and this limits its use. If there is no convenient line in the picture to coincide with it but you still need to reduce the light levels from one frame edge to another, open the aperture to make the shading less obvious. Although darkening the sky to reduce the contrast range is the typical use of a neutral graduated filter, it can be used at different angles in any number of lighting situations – for instance, indoors to darken the view through a window.

The same scene photographed with and without a filter shows the effect very clearly: this is an exercise you should try for yourself. The typical use in a landscape is to bring the brightness of the sky colour to that of the ground (or, in this case, water). Note that it also concentrates the attention more towards the center of the frame.

Two sizes and strengths of plastic neutral graduated filter are shown here in different combinations. The two larger filters are in normal strength (*above*) and double strength (*below*). For a stronger shading, filters can be overlaid (*top left*). To emphasize a horizon only, filters can be opposed (*far left*). All the photographs shown on these two pages used a single normal strength filter.

Polarizing Filters

Polarizing filters, medium-grey in appearance, are made of specially stressed plastic sandwiched in glass, and will cut certain kinds of reflected and scattered light. What makes them particularly useful for photography is that they have three main practical effects: they can darken blue skies, cut down reflections from non-metallic surfaces, and increase the colour saturation in colour images. They are visually neutral, and so they add no colour cast to the picture. For photographers who value intense colour images in outdoor photography, they are among the most useful accessories, and for more specialized applications, such as copying paintings under glass, they can solve problems in a unique way by cutting reflections.

Polarization is not an immediately obvious quality of light, but the diagram *opposite* helps to illustrate how it works. Light, although it travels in straight lines, vibrates from side to side – that is, at right angles to its directions of travel. Under normal conditions, the light vibrates in all possible directions (i.e. right, left, front, back, etc). Under certain conditions, however, the light can be made to vibrate in one direction only (e.g. left to right) – still at right angles to its path. Any non-metallic surface has the ability to make this happen when light bounces off it. So, light reflected from water or glass, as two common examples, is partially polarized, although this is still not a visible effect.

A polarizing filter is made in such a way that it passes only light that is vibrating in one plane. An analogy would be trying to drop a series of thin straight rods through a slatted screen: only those that fell parallel to the slats would fall through.

Sunlight is rarely completely polarized, so that even if the filter is rotated for its maximum blocking effect, some light still passes through. Reflections from water and glass, where the light has been partially polarized, can often be virtually removed. The effect on a blue sky occurs because the atmosphere scatters light by reflection.

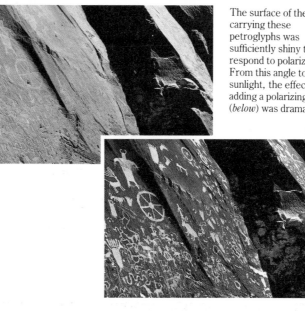

The surface of the rock carrying these petroglyphs was sufficiently shiny to respond to polarization. From this angle to the sunlight, the effect of adding a polarizing filter (*below*) was dramatic.

One of the most common reflection-cutting uses of a polarizing filter is in a situation like this – shooting through a window.

Colours in general appear more intense because the amount of light reflected from a coloured surface and striking the film is reduced, so reducing the brightness of the surface as seen through the viewfinder.

Project: Polarizing effect

So much for the theory. For some practical experience, fit a polarizing filter to a standard lens on the camera and view different outdoor scenes through it, rotating it to find the maximum and minimum polarizing effects. The effects are all strongest in clear weather and intense sunlight. On cloudy days the blue-sky effect is, of course, not possible, but reflections also submit less well to the filter. This is because the light source – the sun – is diffused and so reflects from a broad range of directions. On clear days, blue-sky darkening occurs most strongly at right angles to the direction of the sun. This is simply because the minute particles that scatter the light in the atmosphere behave together as a giant reflector, acting more or less as a mirror to the sunlight. Aim the camera just off from the sun and rotate the filter right round. The effect will hardly be noticeable. Turn the camera until the sun is at right angles to your line of view. The difference between darkest and lightest is now at its greatest.

A side-effect of the blue-sky darkening happens if a wide-angle lens is used. The angle of view of a 20mm lens, for example, is 84° across the horizontal, and so covers almost a quarter of the sky. Even if you point the camera at exactly right angles to the sun, the coverage will still be so great that the polarizing effect changes across the scene. This usually looks peculiar, as if a dark stain has spread across part of the sky in the image. Unless you can find a way of working this unevenness into the design of the photograph, or reduce the area of sky visible, polarizing filters generally do not suit wide-angle lenses in landscape shots.

The price to pay for these effects is a considerable loss of light. Most polarizing filters have a filter factor of about ×3, needing an extra 1½ stops of exposure.

▶ As the scattering of short wavelengths that gives a blue sky its colour is a type of reflection, a polarizing filter has a darkening effect. This effect is strongest at right angles to the sun, so that with a wide-angle lens, as used here, the tone changes across the view.

▼ A polarizing filter will only let light through that is vibrating in the same plane as the filter. If the filter is turned through 90°, so that it is no longer aligned, this light will be blocked.

Colours into Tones

Black-and-white film converts colours into shades of grey, and the exact shade depends not only on how dark or light the colour is, but also on its wavelength. In other words, the colour sensitivity of the film plays an important part, as shown in the graph on page 14. So, changing the overall colour of the scene can alter the black-and-white image, and this is the principle of using coloured filters in black-and-white photography. Using a strongly coloured filter will make little difference to the appearance of any object in the scene which is that same colour, but other colours will look darker in the final print. As a result, a set of perhaps six filters of different strong colours gives you the means for exercising real control over the image.

Project: Comparing effects

As a first step, make a series of comparison tests, shooting the same scene in colour and in black-and-white. Do this in a number of different situations, with different colours predominating. As we saw on pages 14–15, normal black-and-white film has a slightly different response to that of the eye. Compared with what you see, blues will appear too light (and in a landscape this will be exaggerated because of the film's extra sensitivity to ultraviolet), greens a little too dark, and reds slightly pale.

A word of warning about making the black-and-white print: these differences are not particularly strong, and are easily overwhelmed by relatively small changes in the exposure and development of the print. Also, the choice of paper grade will affect the contrast, and this will change the tonal relationships. In order to make a useful comparison between the colour slide and the black-and-white print, make every effort to give the latter average treatment. In fact, for the purposes of this exercise, also make a comparison between the colour slide and the *negative*. This applies to the following exercises as well.

In a landscape view with a clear sky, the most obvious difference will be the paleness of the sky, the lack of definition in clouds, and a slight haziness in the distance (these are typical conditions, not universal ones, and may not apply in every case). These effects are due mainly to the film's over-sensitivity to blue and ultraviolet. The logical answer, then, is to cut down this extra portion of blue reaching the film, by means of a filter in the complementary colour: yellow. A Wratten No. 8 filter is just yellow enough to "normalize" a typical outdoor scene, darkening the sky slightly. Of course, in a large number of other situations, it is unnecessary and will even give too pale a version of yellow objects.

Filters with black-and-white: uses and exposure increase

Filter	Wratten number	Use	Exposure increase in daylight	Filter factor
Yellow	8	Standard filter for darkening blue sky and slightly lightening foliage. Also reduces haze.	1 stop	×2
Yellowish-green	11	Corrects for tungsten lighting. Also lightens foliage more than yellow, and lightens Caucasian skin tones to a natural appearance.	2 stops	×4
Deep yellow	12	"Minus blue". A similar effect to Wratten 8, but more pronounced, strongly darkening blue sky.	1 stop	×2
Yellow-orange	16	Stronger effect on sky than yellow filters. Reduces skin blemishes and spots in portraiture.	1⅔ stops	×3
Orange	21	More pronounced contrast than Wratten 16, particularly at sunrise and sunset. Lightens brickwork, darkens foliage.	2⅓ stops	×5
Red	25	Darkens blue sky dramatically, deepening shadows and exaggerating contrast. Underexposure gives a moonlight effect, especially combined with a polarizing filter	3 stops	×8
Deep red	29	Same effect as Wratten 25, but even stronger. Useful with long-focus landscapes to darken sky close to a distant horizon.	4 stops	×16
Magenta	32	"Minus green". Darkens green.	1⅔ stops	×3
Light blue-green	44	"Minus red". Darkens red.	½ stops	×6
Blue	47	Accentuates haze for a sensation of depth in landscapes.	2⅔ stops	×6
Green	58	Lightens green foliage.	3 stops	×8

In outdoor scenes, one of the most consistently strong colours is the blue of a clear sky, and the example here is chosen for being particularly intense. Black-and-white film's slight over-sensitivity to blue gives a weak rendering when unfiltered (*below left*). A red filter intensifies it (*below right*), and in this photograph also lightens the red-painted roof and fence.

Lightening and darkening specific colours

Colour of subject	To darken appearance, use filter of complementary colour	Wratten numbers	To lighten appearance, use same colour filter: Wratten numbers
Red	Green	58,47,44	29,25,32,21,16,12
Orange	Green	58,47,44	25,32,21,16,12
Yellow	Blue	47,44	12,11,8,16,21,25
Yellow-green	Blue	47,32	11,12,8,16,58
Green	Red	29,25,47,32	58,11,12,8,44
Blue-green	Magenta	29,25	44,47,58
Blue	Yellow	25,16,12,11,8,58	47,44,32
Magenta	Cyan	58,11,16	32,47,25

Manipulating contrast

Basic correction for the inaccuracies in normal black-and-white film is a very limited use of filtration. Much more important are the possibilities for changing the tonal relationships to suit your own taste. A filter works like a window on the spectrum of colours. It passes light of the same colour almost unhindered, but blocks, to different degrees, other wavelengths. The colour that it blocks the most strongly is its complementary, its opposite. This is the way in which colour films work, by incorporating dyes that act as filters. A blue filter blocks yellow, a red filter blocks blue-green, and a green filter blocks red-blue. These are the precise complementaries, but in practice it is actually only the broad effect that matters.

The basic and most useful set of filters for black-and-white contrast control includes yellow, orange, red, blue and green; for most situations these will give you full control. No. 8 or 12 is a reasonable choice for yellow; 15, 16 or 21 for orange (the higher these numbers, the stronger the hue), 25 is the normal red filter, 47 blue and 58 green. These identifying numbers are from Kodak's Wratten series, but other filter manufacturers produce equivalents for most of them, usually in plastic or glass. Start with this basic set, and to get an idea of their potential effect, hold each up to your eye and view different scenes. After the few seconds it should take your eye to adjust to the overall colour cast, you will be able to see the tonal effects that they have. In fact, the strongest colours will drown the colours in the scene to such an extent that they give a monochromatic view.

Project: Colour contrast

Assemble a small group of objects with very pure, contrasting colours, as in the example shown here. Try and include things in yellow, red, blue and green. Light and set fairly evenly, with plenty of shadow fill, and use daylight or flash, *not* tungsten (the orange colour of tungsten lamps will itself affect the tones on the film). Set the camera on a tripod, so that the composition remains fixed, and begin with a straightforward exposure on black-and-white film with no filter. Use an incident light reading to judge the exposure settings. Then repeat the shot through each of the filters, increasing the exposure according to the table on this page . Finally, take the same shot on colour transparency film as a record for comparison. Process the films.

When you print each negative from this series, take care to give each the same exposure and development, and use the first, unfiltered shot as the basis for the enlarger's aperture and time settings and choice of paper grade. The obvious lesson from this project is how extreme the results are. In addition, however, what you may find during printing is that the exposure is not necessarily a simple matter.

If, instead of sticking to identical exposures and development, you try and judge each negative independently, and print each by eye, what can you use as standard tone? In the example here, there are no neutral colours, and so no area in the picture that you could use to match one exposure to another. If you were to give the negatives to someone else to print and they had to print each as they saw fit, you might be surprised at the results.

Repeat this exercise in an outdoor scene, preferably a natural landscape. Unless you have chosen a very stark, bright and colourful location, such as a red rock in the American West, what you should notice is how much more subdued the effects are. Usually, a blue sky is the picture element most strongly affected, while typical green vegetation shows very little difference in tone, even between a red and green filter. The reason for this is that most colours in nature at this scale are degraded. The purity of green in a tree seen at a distance is hardly ever the same as that of a lettuce leaf or a slice of lime. Distance itself degrades colour because of the atmosphere, and different colours that can be distinguished in close-up tend to merge when seen from a long way away.

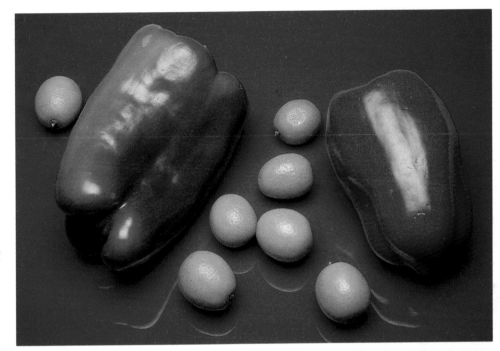

Using objects chosen for the intensity and purity of their hues, this arrangement shows the tone-altering effect on black-and-white film of coloured filters. Under these conditions, the results are distinct.

No filter

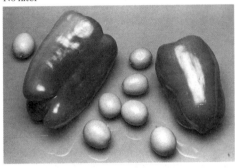

Wratten 11 yellow

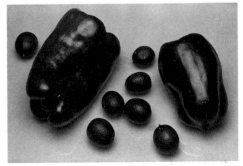

Wratten 15 yellow-orange

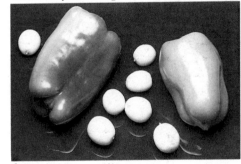

Wratten 25 red

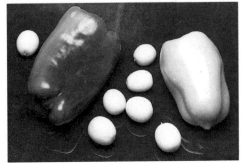

Wratten 47 blue

Wratten 58 green

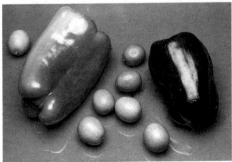

Depth Control

Although there are many ways of reducing and enhancing the sense of distance in a photograph – for example, through the choice of lens and perspective and by means of the composition (all of these are treated thoroughly in volume II of this Workshop series, *The Image*), one of the most straightforward controls is over haze. This is a control because the effects of haze (increasing the impression of distance) can be filtered, both for black-and-white film and for colour. As all normal camera film is more sensitive to ultraviolet than is the eye, the usual advice is on how to reduce haze so that the image resembles more closely the way the scene looked. However, enhancing haze also has value in some pictures, helping to demonstrate depth.

Atmospheric haze is bluish, and is caused by the scattering of light in the atmosphere by the air molecules, by water vapour and fine dust in suspension. The wavelengths of light that are most easily scattered are the short ones, hence ultraviolet and blue.

There are two approaches to controlling the amount of haze recorded on black-and-white film: one is to tackle the blue colour, the other is to treat the invisible ultraviolet. As already mentioned on page 154, blue is blocked by yellow. Thus a mild yellow filter – for example, a Wratten no. 8 – will reduce the blue to the point where it looks in the photograph as it did in life. This will preserve the haze at approximately the level that you remembered. To reduce the haze more, use a deeper yellow filter; such as a no. 15, or orange (no. 21), or even a no. 25 red. This strong red filter is as far as you can go in haze reduction by colour filtering alone, and even then it will not eliminate haze completely. In a long view on a clear day, there will still be a progressive lightening of tone in the sky from high overhead down to the horizon.

Conversely, the haze effect can be strengthened by using a blue filter. A no. 47, for instance, will pass the blue wavelengths but partially block the others. So,

increasing the exposure to allow for the overall darkening effect that it has (2⅓ stops) will allow proportionately more of the hazy parts of the scene through to the film. A paler blue no. 38 filter will have a milder effect. Remember, when printing, to allow the horizon and other distant parts of the scene to remain pale – overexposing these helps give the impression of distance.

Coloured filters such as these have no use in colour photography, but haze can still be reduced by means of a filter that cuts ultraviolet wavelengths (this has a similar effect on black-and-white film). A colourless ultraviolet (UV) filter reduces haze, while skylight filters, which have a slightly warm tint (available in different strengths), reduce the blue cast as well as cutting the ultraviolet. A polarizing filter also has a UV-cutting effect by virtue of its glass, and in addition gives an apparent extra benefit by improving colour saturation and cutting some of the light that has been scattered by the atmosphere on a clear day.

Aerial perspective – the increasing of haziness with distance – is obvious in most long views like this one over Death Valley in California. It is controlled quite noticeably by polarizing filters, provided the view is not directly towards or away from the sun. The view *far left* is with a 400mm telephoto lens without a filter, that *near left* with a polarizing filter.

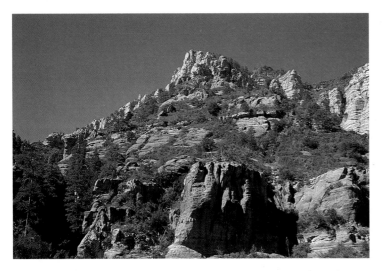

A clear blue sky over cliffs at Sedona, Arizona, is the tone most obviously affected by the use of filters on black-and-white film, and this affects the aerial perspective. The two extremes are the use of a red filter, which darkens the sky (paler in the negatives *right*) and reduces haze, and a blue filter, which makes the sky pale and increases the aerial perspective. The filters used are, from the top: no filter, 11 yellow-green, 15 yellow, 25 red, 29 red, 47 blue and 58 green. Try a similar exercise yourself.

The focal length of lens can also affect the sense of depth in a landscape. Both the 20mm wide-angle view *left* and 400mm telephoto view *right* were taken from the same place at the same time – the telephoto scene can just be made out in the top right corner of the wide-angle photograph. The telephoto version looks hazier, and so has more feeling of distance, because the entire scene is shot through about 1 mile (1.6 km) of salt spray.

Diffusing and Effects Filters

The filters that we have looked at on the last few pages are all basically functional. Used in the ways described, they improve the performance of the film in different areas. Colour correction filters control colour fidelity, neutral graduated filters can reduce the overall contrast range, polarizing filters improve colour saturation, and so on. Beyond this, however, are a large number of filters that distort or add to the image in a way that could be described as non-essential.

One class of filters degrades the image deliberately by making it less sharp, another adds colours for effect rather than for correction, while some filters add elements such as repeated images or starbursts. The acceptability of images photographed with effects filters such as these is largely a matter of personal taste and public fashion, and is in any case an aesthetic rather than a technical judgement. The effects from this kind of filtration are usually striking and definite, which alone accounts for a large part of their popularity. By the same token, they can also be overwhelming and predictable.

Diffusing filters of different types lessen sharpness, but in a specific way. A soft-focus image is not the same as one that is out of focus. The prime lens remains focused, but the detail of the image is softened and the highlights spread. Different designs of filter produce different styles of diffusion. One construction features tightly spaced engraved concentric rings, another has a relief pattern of small bumps in the glass, a third has an overall etched surface similar to a ground-glass screen, and a fourth has a slightly milky translucency dyed into the plastic.

Prism lenses are made of thick glass or plastic that has been faceted so that overlapping ghosted images of the subject appear. The pattern of the faceting determines the number and arrangement of these multiple images.

Diffraction filters contain gratings of finely spaced parallel etched grooves that have the effect of splitting the light from highlights in the image into the colours of the spectrum. A similar construction produces a starburst effect surrounding point sources of light in a photograph.

A step prism filter used on the upper part of this image produced a repetitive ghosting of the coin.

Soft-focus filters, used with the kind of backlighting that produces highlights, give a halo effect, evident in this negative as the dark shadow above the girl's hair.

In this double-exposed photograph, the hand, made of lights, was exposed through a crossed-diffraction filter to give a starlike effect.

In another double-exposed photograph of a security camera outside a bank, a step prism filter was used to produce several images of an eye.

FILM CARE

Although modern film is made as robust as possible, with a tough, stable base and hardened coatings to protect it against physical damage, it is still a delicate commodity, and sensitive to more than just the light entering the lens to form the image. Until it has been processed film is extremely vulnerable to mishandling, and this can include what many people might think only small neglect, such as warm temperatures and moist air. While these may have little effect if the film is subjected to them only for a short time, in the long term they will cause noticeable deterioration. In their recommendations about using and processing, film manufacturers assume that their products will be kept at what amounts to normal room termperature and humidity. Light, naturally, affects film, and if sufficiently bright can find its way through even the seemingly light-proof 35mm cassette. Hence the warnings against loading and unloading films in sunlight, and the need for such detailed precautions as not removing some motor-drives in strong light with a film in the camera (light can enter the camera if the coupling on the baseplate is left open). In addition to light, however, there are other wavelengths to which photographic emulsion will react. X-rays in particular will fog the film if they are sufficiently strong. Heat, humidity, and the fumes given off by volatile substances – including the apparently innocuous brown paper, glue and mothballs – are all inimical to film. Sensible storage until it has been developed is a high priority.

Even after processing, the film is not so stable that it can be treated carelessly and survive. Apart from common-sense protection against physical damage like scratches and dust, you should also keep it cool, dry and in the dark to prolong the life of the image. This is particularly important with colour dyes, and colour negative film is the most susceptible of all the three main groups of film to fading with age.

A good photograph represents time, effort and creative energy, and it is no surprise that many photographers feel personally attached to their growing stock of images. The exact conditions under which even a controlled still-life shot were taken can hardly ever be repeated, and a photograph lost through accident or premature fading is gone for good. Given the energy and imagination that you are likely to invest in your photographs, they are worth the care needed to ensure that they continue to give pleasure.

Selecting and Storing Film

Unexposed film ages, and as it does so its characteristics, and thus its performance, change. In most ways the change is not for the better: it becomes less sensitive to light, produces images with less contrast, and colour emulsions may acquire an overall colour cast. For these reasons, the best advice is to buy fresh film, use it and have it processed promptly, and as long as it remains unprocessed keep it cool and dry. There is a proviso to this, however, when using colour transparency film, which is that factory-fresh film is often not exactly neutral in its balance because the overall colour inevitably shifts over a few months in normal room conditions. Manufacturers anticipate that most films will have to wait for something in the order of three months before being used, first sitting on a dealer's shelf and then in the photographer's home. To optimize the colour balance, film is usually made to have a slight bias, which will age into neutrality at about the time most photographers will come to use it.

The expiry date on the film pack gives only limited clues as to how old the film is, however, and the storage conditions in many shops are not necessarily the best. So, to be certain of the balance, the best method is to buy a quantity at once, all from the same batch, having tested one roll first. As long as the colour balance looks acceptable, you can halt the ageing process by cold storage (see below). Professional films differ in that the manufacturer has tested the colour balance and selected film known to give a neutral colour rendition. This is then stored under refrigeration by the dealer, and should be kept under the same conditions by the photographer.

What is considered normal ageing varies between types of film. Black-and-white films age more slowly than colour, and the expiry date marked on the film pack is calculated by the manufacturer on the assumption of "normal" temperature and humidity. These are 75°F (24°C) and about 40 per cent relative humidity (some manufacturers assume as low as 40 per cent,

The month and year stamp assume that, with a non-professional film like this, it is stored under "normal" conditions – that is, no more than 75°F (24°C) and no more than 40 per cent relative humidity. This date does not, however, indicate when the film was manufactured, but if you buy from a good dealer with a high turnover, it will be fresh.

The batch number is important only if you need colour consistency between rolls, as, for instance, in a series of studio photographs with the same background. However, if this is the case, it is better to buy professional film.

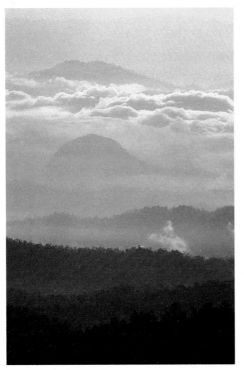

Film manufacturing tolerances are not always as close as they ought to be. This same landscape was photographed on two rolls of Kodachrome 64, stored and handled identically but from different batches. The green cast in the second shot (*right*) is all the more noticeable for being on neutral mid-tones.

some as high as 60 per cent). If the film is stored at higher temperatures and humidity than this, it will deteriorate more rapidly, but if it is kept cooler and drier, the ageing process can be slowed down.

One certain method of keeping the humidity low is to leave the film in its original packaging. This does not mean the boxes – they contribute nothing to its keeping properties – but do not open the snap-cover plastic can of 35mm film until you are about to use it, and leave rollfilm and sheet film in their heat-sealed foil pouches as long as possible. The film has been packed under dry, dust-free conditions.

Professional films are intended to be stored at about 50°F (10°C) or lower, and this is good advice for any film. Certainly,

when you are travelling and shooting this is usually not possible, but you have a long period of grace before there will be any noticeable effects to the image (provided that the film is not submitted to very high temperatures and moist air). Film manufacturers are generally conservative in their recommendations, but in practice you can expect colour films to be useable (without noticeable loss in image quality) for up to about six months beyond the expiry date, if they have been kept in normal room conditions. If you store them in a domestic refrigerator, they should last a year beyond the expiry date, and if in a freezer at about 0°F (−18°C), two years or more beyond. So, if you buy one batch of film in quantity, keeping it in a freezer will effectively halt

ageing for the time it will probably take to use. Cold storage runs the risk of condensation if you open the film in room temperature immediately after taking it out of the freezer; you should allow a warming-up period of one or two hours before you open the sealed can or packet.

There is rather more urgency once the film has been exposed. At this point it is carrying a latent image, and should be processed as quickly as possible. This is not, of course, always possible, but if the holdover time runs into several days, keep the film as cool and dry as you can. Refrigeration is a little dangerous because of condensation, but if you feel that it is necessary, pack the film in a sealed container with a desiccant under dry conditions.

X-rays

X-rays fog film just as surely as light will. Both are a kind of radiation, and although our eyes are sensitive only to light, film reacts much more. What makes X-rays such an important problem is their nearly universal use in airports for security checks. The effect of a strong dose of X-rays is overall, but most noticeable as a weakening of the density in the shadow areas. Also, if there is anything lying in the path of the X-rays that can slow them down (part of the metal cassette, for example, or a camera), that can leave a "shadow".

Unlike exposure to light, where there is a threshold below which the silver halides cannot be developed into silver, any X-ray dose has an effect. This alone, however, is no reason to panic, because you will not be able to see any difference from low doses.

The important question is: what dose has a visible effect? This depends very much on the film, and is not necessarily in proportion to the film speed rating. Kodak's Tri-X, for example, is a fast black-and-white emulsion with a rating of ISO 400, but is much less sensitive to X-rays than are most slow colour negative and transparency films. One reason is that X-ray damage depends on the speed of the most sensitive layer of emulsion in a film, wherever it lies. In a tri-pack colour film, the bottom layer needs to be much more sensitive than the top, because the light reaching it has already been filtered through the upper emulsion layers. X-rays, being very short wavelengths, pass straight through without hindrance. Nevertheless, the films most liable to damage are the relatively new generation of high-speed

colour. ISO 400 films are noticeably more susceptible than Kodachrome 64, for example, and those rated at ISO 1000 and over even more so.

X-ray dosage is measured in roentgens, and in the kind of inspection machine used in airports, doses are on the scale of milliroentgens, abbreviated to mr. Taking fairly fast colour films of around ISO 400 as a standard, professional opinion holds that some trace of fogging can be noticed with a dose of about five milliroentgens. So, how does this compare with the output of a typical X-ray inspection machine? In the United States, the law administered by the FAA actually specifies what the dose can be: one milliroentgen. Hence, unless you are carrying superfast colour film, there is nothing to worry about from one inspection.

An airport X-ray machine operator's view of a camera bag. The image is actually a frozen "snapshot" of a short burst of X-rays, not the result of a continuous bombardment. Nevertheless, although the dose is limited and a single inspection has no visible effect on most films, the X-rays do penetrate, as the view inside the telephoto lens amply demonstrates.

This is not the end of the story by any means, however, because X-ray exposure is cumulative. Pass the film through five times, and the dose will reach five milliroentgens – the danger level from the point of view of visible damage. One or two changes of aircraft and the return trip may be too much. In addition, outside the United States it is often difficult to be sure about the dosage. Many of the older machines have a much higher output.

Avoiding X-ray inspection

The safest answer is not to have any film submitted to X-ray inspection, but avoiding this means knowing something of the security systems at airports. These differ from place to place, and also change according to new technological developments and to the state of the world's terrorist attacks. In the United States, under the FAA regulations, you are entitled to a hand-inspection and can legally refuse to put the films through the X-ray machine (but it still helps to be pleasant rather than antagonistic). Elsewhere there is unfortunately no certain method of avoiding the problem. Common advice used to be to put the film in checked baggage, on the grounds that only Soviet and East European countries regularly inspected this with X-rays. Now, however, some other airports follow this practice also, and often with high doses (repeated if something appears to block the X-rays). The best recommendations for avoiding inspection at airports are as follows.

- Carry film with you in your hand baggage and ask for hand inspection.
- Pack it in clear plastic bags to make hand inspection easier.
- Be diplomatic when dealing with airport security personnel.
- Avoid airports that are known to insist on X-ray checks, such as Zurich and Paris Charles de Gaulle.
- In an emergency, you can carry a number of films in your pockets. A few will not trigger a typical magnetometer (and this does film no harm); if necessary, you will probably be asked to put them in a tray and walk through again.
- If an X-ray inspection is unavoidable, a lead-lined film pouch *may* help. Most films will survive one encounter.

Proprietary X-ray bags like this offer some protection, being lead-lined, but are still vulnerable to an increased dose. They are probably best used as a back-up in case a request for hand-inspection is refused.

Packing film like this, visibly in clear plastic bags, makes inspection easier, and may help to overcome resistance to a hand-inspection by security personnel. Transparent film cans, such as those used by Fuji, are even more helpful.

Preserving the Image

No image is completely permanent, but if reasonable, common-sense precautions are taken, there is no reason why black-and-white negatives should not last a lifetime, and colour film give acceptable results for perhaps 20 years. Putting a precise figure on the survivability of films is virtually impossible: much depends on the conditions of storage, and the deterioration of the image can ultimately only be judged on its visual effect, and this varies from viewer to viewer.

The most stable materials of all that are used in film are the silver deposits that form black-and-white images. Dyes, which replace the initial silver in colour film and in black-and-white chromogenic films such as Ilford's XP1 400, are less stable, and fade with time. However, although this means that in theory colour negatives will age faster than any other film, they also tend to be used less often than slides. Whereas a colour slide may spend a cumulative total of a few hours in a slide projector, a colour negative may only ever be used for minutes, and then only with the weaker light from an enlarger lamp.

There are measurements that can be made, but it is dangerous to pay literal attention to them. One starting point is the loss of dye density that is actually noticeable, and 10 per cent is normally considered a reasonable minimum (this means a 0.1 density loss from 1.0 if measured with a densitometer). Average conditions in a modern house are a room temperature of 70°F (21°C) and relative humidity between 40 and 50 per cent, and under these conditions, you could expect ordinary black-and-white negatives to take between 50 and 100 years to show a 10 per cent loss in density, provided they were kept in the dark. Chromogenic black-and-white films would begin to show the same loss in about 20 years. Colour transparencies are next on the scale of permanence, taking somewhere between 10 and 20 years, and colour negatives last, at between 5 and 10 years.

These figures are only guidelines, and as film technology improves, the keeping qualities also become better. There is also a difference among transparency films between non-substantive and substantive; in essence, this means between Kodachromes and the rest, with the Kodachromes lasting longer, provided they are stored in darkness (Kodachromes do not stand exposure to light so well).

The shortest good advice for keeping processed film is "cool, dry and dark". High temperatures, high humidity and light all cause the image to fade. In colour films, the three layers will not necessarily fade at equal rates, causing a colour shift towards the colour layer that fades the slowest. If all layers faded at the same rate, the result would be less noticeable. The ideal storage conditions are 0°F (−19°C) and a relative humidity of between 25 and 30 per cent. As the table on this page shows, even the normal loss of density at room temperature can be improved dramatically by lowering the temperature.

However, before immediately packing your films in the refrigerator, think about how often you will want access to them. The combination of low temperature and low humidity is difficult to achieve; most refrigerators are fairly damp, and the effect of a power loss is condensation. You may do more harm than good unless you first condition the films for at least an hour in very dry conditions (20 to 30 per cent relative humidity) and room temperature, and then store them in sealed containers with a desiccant. Under most circumstances there is no need to be so elaborate.

Dye fading at different temperatures (at 40 per cent relative humidity)

Temperature	Time taken for 10 per cent loss of dye density
70°F(21°C)	Normal
55°F(13°C)	Normal×4
39°F(4°C)	Normal×16
0°F(−18°C)	Normal×340

The ultimate method of safely preserving a colour record, such as from a colour transparency, is to make a set of three separation negatives, each through a primary filter. Here, Kodak Separation Negative Film 4133 was used, with a step wedge placed alongside the transparency to give an accurate measure of the density. Separation negatives have all the permanence of a silver image, and can be used to make dye transfer prints.

A copy negative is one method of preserving a valued original from the risk of physical damage through repeated printing. A black-and-white reversal film is needed, like the Kodak Professional Duplicating Film shown here. This particular film is available only in sheet sizes, from 4×5 inch to 8×10 inch, and the developer recommended by Kodak is Dektol. Enlargement at this stage means less optical loss of quality later, when printing, and any print controls, such as shading, can be done now. As it is a reversal film, more exposure gives less density.

Specific precautions

Apart from these basic storage conditions, there are a few specific precautions for the three major kinds of film.

● **Black-and-white negatives** Although these are the least demanding of all, still take reasonable care. To begin with, if you process the film yourself, make sure that you follow the procedures exactly, particularly the fixing and the final wash. Insufficient fixing, and failure to remove all traces of the fixer from the emulsion, are the principal dangers. Either will considerably shorten the film's life. Then, keep the film clean – in particular, hold it only by the edges; fingerprints and dirt can contain harmful chemicals and fungus spores.

Store the negatives in the acid-free sleeves made specially for the purpose. Avoid non-photographic paper or synthetic materials; these may contain acid compounds and other chemicals that can attack the emulsion. Once the negatives are in their sleeves, do not put them in wooden or cardboard boxes, for the same reason.

● **Colour negatives** Treat these as recommended for black-and-white negatives, but with rather more stringency. In particular, avoid exposing them to any more light than is absolutely necessary. If you have the opportunity, take more than one exposure of a shot that you expect to print many times; use one negative for printing, and store the other.

● **Colour transparencies** Unless you only ever intend to make prints from transparencies, individual mounts are the normal method. As long as you use commercially made slide mounts from photographic dealers, these will be of reasonable archival quality, which is important. Glass mounts may seem a good idea in some ways, but they carry two dangers that make most photographers avoid them: they can accumulate dust and then press this into the film, and they are liable to break, which may completely ruin the slide.

A better alternative for protecting the surfaces of the film in a mount are to slide the entire mount into an acetate slip cover, as shown on page 171. These covers must, however, be removed before projecting, as

Instant film prints are quite moist when freshly processed, and for permanence should be allowed to dry thoroughly for a week or two. Laying the prints out separately and including some silica gel desiccant speeds up the drying.

Even the hardened coating on peel-apart instant prints and the tough plastic window on integral prints will scratch if handled frequently. A normal 4 × 5 inch sheet film negative bag gives good protection for storage.

here, can be used in normal light. Although any camera can be used, most machines are designed for 35mm; this restricts the choice of films slightly, but as the main demand is for same-size copies that are as similar to the original as possible, this suits most people fairly well.

Typically, a slide duplicating machine has a controlled light source (if flash, there is a tungsten modelling lamp for focusing), a filter drawer or built-in dichroic filtration, an exposure meter and a means of fogging the film very slightly to reduce contrast (more about this in a moment). Adjustable bellows allow selective enlargement. Extras include a set of filters and a good lens. Even though a macro lens is adjusted for close distances and will be extremely sharp, it suffers from one major disadvantage: it does not project a perfectly flat image. At same-size copying

with a fairly wide aperture, this means that the edges of the image are likely to be a little unsharp. What you must have for top quality duplicating is an enlarging lens – and the best you can buy. A can that squirts compressed air is also useful for cleaning originals before duplicating them.

The inexpensive system is a slide-holding mount with a translucent screen that can be used with a macro lens and extension tubes or bellows. You then need to provide a flash or tungsten light source in a calibrated position. Although this seems straightforward, by the time you have tested the arrangement of camera, bellows, mount and light and worked out a method for re-assembling them exactly, you will probably begin to see the advantages of a slide duplicating machine. The procedures, nevertheless, are basically the same.

First adjust the bellows at the top, where the camera is mounted, and at the bottom, where the lens is attached, until the slide to be copied just fills the frame and is in focus.

Adjust the brightness control until the meter reading is as its normal setting (in the model shown here, the sensor is swung over the slide to make the brightness reading).

A common make of slide duplicating machine is here set up in two configurations for copying different sizes of film. In the normal set-up *left*, a 35mm SLR is attached to the machine's bellows, and a 60mm enlarging lens fitted. The white screen below the lens is part of the fogging device for reducing contrast. For larger films, the upper section is replaced with a box on top of which is an opal perspex screen large enough for a 4×5 inch sheet (*right*); the camera is mounted separately.

If necessary, set the fogging control to reduce contrast by lightening the shadows.

Duplicating film

The choice is between regular camera film and special emulsions designed specifically for duplicating. First, a word about why special duplicating film should be necessary. As just mentioned, the dyes in a normal transparency film can behave peculiarly when used to photograph another piece of film. For instance, there may be a "crossover" effect, in which the colour balance in the shadows is not the same as it is in the highlights: the darker areas might be greenish, while the light tones have a touch of magenta. Under these circumstances there is not very much that you can do, as the filter needed to correct one will simply exaggerate the other.

Another problem is that the overall contrast tends to increase when duplicating with normal film, and while this is useful for enlivening flat transparencies, it can produce terrible results if the original already has strong shadows and bright highlights. There are ways of overcoming this, but special duplicating film has a deliberately low contrast. Most duplicating films, like Kodak's Ektachrome 6121 (sheets only), Ektachrome 5071 (bulk rolls of 35mm, 46mm and 70mm and pre-packed rolls of 35mm) and Fuji's CDU (sheets and 35mm bulk) are balanced for tungsten lighting, but can be used with a flash source if you filter accordingly (you can expect to need to filter extensively in any case, so this is not intrinsically a disadvantage). Kodak also make a more convenient film: 35mm Ektachrome SO-366, packed in 36-exposure cassettes and balanced for flash.

Why then consider using regular transparency film? One reason is that there is a wider choice of films, both formats and types. If you want to make duplicates onto rollfilm, you are out of luck if you also insist on using duplicating film. (70mm is an alternative, but first you need a camera or magazine to take it, and then try finding a laboratory that will process cut lengths!) Also, the least grainy 35mm film is still Kodachrome 25, and as grain enhancement is a distinct problem in duplicating, some photographers prefer to put up with the contrast problems in return for Kodachrome image quality. Finally, stock photographers and libraries do not always like to draw attention to the fact that they are supplying potential clients with duplicates, and the rebates on duplicating film identify it as just that.

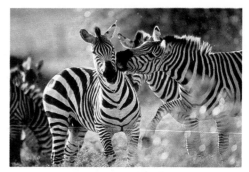

One of the most difficult problems to deal with is a crossover of colours between highlights and shadows. In this example, the filtration was chosen to balance the brighter parts of this image, but the shadows have acquired a blue cast.

Correcting these with more yellow filtration would adversely affect the highlights. In a case like this, the answer would normally be a compromise, relying on the fact that the duplicate will hardly ever be seen next to the original.

Using a regular film instead of a slide duplicating film, an increase in contrast is noticeable in this example, particularly in the sky. The original was Ektachrome 4×5 inch daylight-balanced film, the duplicate on Fujichrome daylight-balanced film, cut 1 stop in the processing to reduce contrast (although this was still insufficient, and some fogging should have been added). Note that Fujichrome's natural tendency towards vivid blues has also appeared.

Original

Duplicate

Using the same original transparency, another mistake when using a duplicating machine is over-use of the fogging device. With the Bowens Illumitran used here, fogging to lighten shadows is accomplished by means of a sheet of glass at 45° and a second, weak light source. Any fogging to reduce contrast should be minimal. Here, at f 14, even a ND0.9 neutral density filter passed too much light.

When setting up with a new system, or even with a new batch of film, choose an original transparency that has normal density and contains enough neutral tones to judge any colour shift. In this example, the original was a Kodachrome 64 35mm transparency, and the film chosen for duplicating Fujichrome 50D 120 rollfilm. A standard emulsion was chosen rather than slide duplicating film because in this instance a 6×9 cm duplicate was wanted. The original is shown *top left*, and two examples from a series of tests *left* and *below*. It is important to keep a note on each test duplicate of the settings used, as shown. They show, left to right, the brightness setting on the machine, the aperture, filters, and special processing. Following these tests, the settings chosen for this film batch were: Max *f* 13×2 2B, 81A Cut 1.

Max *f* 11 2E, 10B Cut 1

Max *f* 13×2 2E, 30R Cut 1

The ideal duplicate

Before you start, it is important to know what you can expect from a duplicate. One thing is certain: it will not be exactly the same as the original.

• **Sharpness** To get the sharpest results, use a fine-grain film with high resolution, the best affordable enlarging lens (a Schneider Componon-S, for example), an ultraviolet filter and the optimum aperture setting for the lens (2 or 3 stops down from the maximum). In addition, consider the light source. A condenser system will be sharper than a diffused light, but will also enhance grain and blemishes. Take extreme care over focusing.

• **Colour fidelity** Always use an ultraviolet filter – a Kodak 2B is the standard recommendation. With duplicating film, make a test with the filters suggested in the instructions packed with the film; with regular film make a test with a range of filters, such as these: no filter, CC10 red, CC10 green, CC10 blue, CC10 yellow, CC10 magenta, CC10 cyan, 81A, 82A. Choose as your test original a transparency that is normally exposed and has some neutral grey. Compare the processed film with the original on a colour-corrected light box, using gelatin filters as necessary to find the closest match. It can take several such tests before you arrive at the right filtration, and this is likely to be different for originals shot on other makes of film. Keep notes as you go along.

One thing you may notice with regular film is that the increase in contrast applies to colours as well as tones; with identical filters, the colour balance in duplicates of different originals drifts in opposite directions. For instance, a warm-coloured picture may go hotter, whereas an image that is a little cool may become distinctly blue.

If you notice some cross-over, in which the shadows have an opposite cast to the highlights, try using the fogging method described below with a filter that is comple-

▲ Original ▶ Duplicate

Attempts at contrast control can have an adverse effect on bright highlights, if they are an obvious and important part of the photograph. In this example, the whites of the pills are a key part of the image. Using regular Fujichrome for

the duplicate, cutting the processing by 1 stop had the effect of dirtying these whites and giving them a cool cast (see also pages 146–7 for the colour shifts). The answer here would be an 81A filter and a ½ stop more exposure.

mentary to the shadow cast. For example, if the shadows are greenish but the light tones reddish, you can correct the colour casts overall with a mild green filter over the light source but a stronger red filter over the fogging light.

● **Contrast** Unattended, duplicates on regular film will be more contrasty. Duplicating film has low contrast to begin with, although this can sometimes be too low (push-processing, described on pages 146–7, can be used to correct this). There are two principal ways of reducing contrast if you are duplicating with regular film. One is to reduce the development, the other to fog the film slightly. Pull-processing (see pages 146–7) reduces contrast, but also alters the colour balance slightly. Most E-6 films

appear cooler in colour when pull-processed, so that you should choose your filters for a specific reduction in development. Kodachromes, however, cannot normally be pull-processed.

Fogging works on the basis of a very small dose of light being leaked evenly onto the entire film frame. Too much will make the image look pale and washed out, but just the right amount will have the effect of lightening the shadows without having a noticeable effect on the light tones. Some slide duplicating machines have a special contrast control device, such as a semi-reflecting mirror or sheet of thin glass that directs light from a second source into the lens at the same time as the basic exposure is being made.

Even without this, you can do the same

thing by making two exposures on the same frame. First shoot the original slide. Then remove the slide and, using the same light source, make a second exposure through a strong neutral density filter (you will need to experiment to find the best strength, but start with a ND 2.0, which allows only 1 per cent of the light through. It helps if your camera has a double exposure lever, otherwise depress the rewind release catch between the exposures. Slight fogging also gives you the opportunity to alter the colour of just the shadows, by fitting a filter only for the second, fogging exposure. In practice, fogging works best when the shadow areas in a picture are fairly small. If the image is mainly dark, the effect can unfortunately appear just weak, as if the film had been improperly developed.

Lens quality
The difference between a normal camera lens and a good enlarging lens is noticeable under a loupe. In the duplicate *left*, a 150mm Symmar was used (this is the standard lens for a 4×5 inch view

camera); while this Schneider lens is one of the best made, it cannot perform as well in close-up as a flat-field enlarging lens – in the example *right*, a 100 mm Componon-S from the same manufacturer.

Glossary

18 per cent grey *See* **Mid-grey**

Acetic acid Stop-bath solution used to halt development. The acidity neutralizes the alkali in the developer, but is used in a weak solution: between 2 and 5 per cent.

Acutance The objective measurement of how well an edge is recorded in a photographic image.

Antihalation layer A light-absorbing material in photographic film, usually applied to the back surface, which reduces the reflection of light back into the photosensitive layer.

ASA Speed rating for film and other photographic emulsions devised by the American Standards Association. It is arithmetically progressive; a film that has twice the value of another is twice as sensitive to light. It is now incorporated in the universally accepted ISO system. *See also* ISO.

Average reading An exposure reading made by measuring all the light from the scene, so giving an average of all the values.

Bulk loader Device for loading empty cassettes with film in daylight. A light trap ensures that only a few inches of film are lost to fogging each time a cassette is loaded. Bulk loading is more economical than buying pre-packed film.

Cassette Metal or plastic film container in which the film is wound on a spool, unwinding from a slit when loaded in the camera. Used for 35mm film and some rollfilm formats.

Cellulose triacetate A chemical substance derived from wood pulp, etc., used for making film base. This cellulose ester is the most common film base, often called safety film because it is dimensionally stable, insoluble in processing chemicals and virtually inflammable.

Changing bag A light-tight bag, double lined and of black fabric, for changing films in normal lighting. Sleeves allow the photographer's hands inside without admitting light.

Characteristic curve Curve plotted on a graph from exposure and density used to describe the characteristics and performance of sensitive emulsions.

Clip test A short strip of film that is processed before the rest to determine whether any adjustment is needed in processing. It is useful when the exposure conditions are uncertain.

Colour balance The adjustment of any part of the photographic process to ensure that neutral greys will have no colour bias in the final image.

Colour bias/cast Overall tinting of the image towards one hue.

Colour coupler A chemical compound that combines with the oxidizing elements of a developer to form a coloured dye. It is an integral part of most colour film processing.

Colour shift *See* **Colour bias/cast**

Complementary colours The colours which, when each is mixed equally with a primary colour, give a neutral hue. Hence, the complementaries for the primaries red, yellow and blue are, respectively, green, violet and orange. On the colour circle, each complementary colour lies opposite its primary. Complementary colours are derived from the mixture of two of the three pure primaries.

Contrast The subjective difference in brightness between adjacent areas of tone. In photographic emulsions, it is also the rate in increase in density measured against exposure. Colour contrast is the subjective impression of the difference in intensity between two close or adjacent colours.

Dark slide A lightproof sheet used to protect film from exposure until it is mounted in the camera. It is used with sheet film and certain rollfilm systems.

Daylight film Colour film that is balanced for exposure with daylight or some other source with a colour temperature of 5400K, such as electronic flash.

Developer Solution of a chemical compound that converts silver halide crystals into black metallic silver. The main component is the developing agent, to which is added alkali, preservative and other ingredients.

DIN German speed rating for film (Deutsche Industrie Norm), being logarithmically progressive. *See also* ISO.

Direct reading Common term for reflected light measurement.

D-Max (maximum density) The maximum possible density that a photographic material can have: black.

DX coding Type of bar code on a film cassette that can be read electronically via contacts inside an automatic camera. It provides information about the film, including its ISO speed, that the camera can use to set certain controls.

ED glass Extra-dispersion glass.

Emulsion Light-sensitive substance composed of halides suspended in gelatin, used for photographic film and paper.

Exposure In photography, the amount of light reaching an emulsion, being the product of intensity and time.

Exposure latitude For film, the increase in exposure that can be made from the minimum necessary to record shadow detail, while still preserving highlight detail.

Exposure value (EV) A notation of exposure settings for cameras that links aperture and shutter speed. A single EV number can, for example, represent both $\frac{1}{60}$ second at $f\,8$ *and* $\frac{1}{250}$ at $f\,4$.

f-number Notation for relative aperture which is the ratio of the focal length to the diameter of the aperture. The light-gathering power of lenses is usually described by their widest (that is, lowest) f-number. Lens aperture rings are calibrated in a standard series: $f\,1$, $f\,1.4$, $f\,2$, $f\,2.8$, $f\,4$, $f\,5.6$, $f\,8$, $f\,11$, $f\,22$, $f\,32$, $f\,45$, $f\,64$.

Fast film Film that is more sensitive than average to light.

Film speed The sensitivity of film to light, now measured as its ISO rating.

Filter factor The number by which the exposure must be multiplied in order to compensate for the loss of light due to absorption by a filter.

Fixer A solution of sodium thiosulphate or other silver halide solvent which removes the silver halides in film that have not been exposed to light. It converts them to soluble salts, which are then removed by the washing stage of processing. Fixing halts any further darkening in the image.

Fog Darkening of the negative or print unrelated to the image. Caused either by exposure to light or to certain chemicals.

Format The shape and size of picture, frame of film, or sheet of printing paper.

Gamma Measure of the steepness of an emulsion's characteristic curve, and is the tangent of the acute angle made by extending the straight line position of the curve downwards until it meets the horizontal axis. Average emulsions averagely developed have a gamma of about 0.8, while high contrast films have a gamma greater than 1.0.

Gelatin Substance used to hold halide particles in suspension in order to construct an emulsion. This is deposited on a backing.

Gelatin filter Thin coloured filters made from

dyed gelatin that have no significant effect on the optical quality of the image passed.

Generation One of a series of image stages when film is being copied successively. The first generation copy is that made directly from the original image; the second generation copy is that made from the first, and so on.

Graduate Measuring container marked with a volume scale used for preparing solutions.

Graduated filter Clear glass or plastic filter, half of which is toned, either coloured or neutral, reducing in density towards the center, leaving the rest of the filter clear. It can be used to darken a bright sky, or for special effects.

Grain An individual light sensitive crystal, normally of silver bromide.

Graininess Subjective impression of granularity in a photograph, when viewed under normal conditions. The impression is created by clumps of grains seen, not of individual grains.

Granularity The measurement of the size and distribution of grains in an emulsion.

Hypo An alternative name for sodium thiosulphate, a fixing solution.

Incident light reading Exposure measurement of incident light, made with a translucent attachment to the exposure meter. This reading is independent of the subject reading.

Infra-red radiation Electromagnetic radiation from 730 nanometers to 1mm ($\frac{1}{32}$ inch), longer in wavelength than light. It is emitted by hot bodies.

Integral (instant) film A type of instant film which is processed within a sealed packet containing the necessary developing chemicals and materials.

Integral masking The addition of dyes to colour negative film at the manufacturing stage to compensate for deficiencies in the image-forming dyes.

ISO (International Standards Organization) Current, internationally accepted film speed rating made up of the ASA/DIN ratings (commonly abbreviated everywhere except Germany to the ASA rating).

Key reading Exposure reading of the key tone only.

Latent image The invisible image formed by exposing an emulsion to light. Development renders it visible.

Latitude The variation in exposure that an emulsion can tolerate and still give an acceptable image.

LED Light-Emitting Diode. In a camera, a small battery-powered light used in the viewfinder display.

Line conversion Copy of a normal, continuous-tone image on film onto line (lith) film. Produces a high-contrast image.

Line film Extremely high-contrast film, which can be developed so that there are no intermediate tones, only black and clear. Also known as lith film.

Lith film *see* **Line film**

Loupe Magnifying glass of high optical quality used for viewing transparencies and negatives on a light box to examine fine image details.

M-Q developer The most commonly used type of developer, a combination of metol and hydroquinone (also known as quinol).

Mask Derived image, often opaque and made on line film, that is registered with the full-tone transparency or negative to hold back a part of that image. Used extensively in photo-competition.

Maximum density *See* **D-Max**

Memory colour A hue that is so familiar that it can be judged quite accurately from memory alone. An example is skin colour.

Mid-grey Grey tone halfway between black and white, which reflects 18 per cent of the light falling on it.

Mid-tone An average level of brightness, halfway between the brightest and darkest areas of a scene or image (that is, between the highlight and shadow areas).

Mired value (*Micro Reciprocal Degree*) A measurement of colour temperature that facilitates the comparison of different light sources, calculated by dividing 1,000,000 by the colour temperature of the light source in kelvin.

Nanometer 10^{-9} meter or $\frac{1}{1,000,000,000}$ meter.

Neutral density Density of tone that is equal across all wavelengths, resulting in an absence of colour. Neutral density filters are used for reducing exposure by specific amounts, without altering the colour balance.

Neutral density filter Grey filter that reduces exposure to the film when placed over the lens, without any alteration to the colour.

Non-substantive film Colour film in which the colour-forming dyes are not present in the film

as manufactured, but added during processing. Kodachrome is the best known example.

Opaque Impermeable to light.

Orthochromatic film Photographic films that are insensitive to red. They can be worked with under a red safelight.

Overexposure Exposure of a film emulsion to more than the optimum amount of light, resulting in loss of highlight detail and contrast.

Oxidation The chemical reaction caused by prolonged exposure to air or to chemicals that add oxygen, remove hydrogen or remove electrons. In development, the exhaustion of the solution.

Panchromatic Photographic materials that are sensitive to all colours of the spectrum.

Photomechanical reproduction The combining of photography and mechanical printing processes to make copies in ink of an original. For photographs, it involves converting the image into a screen or half-tone dots, and for colour images requires separate colour plates.

Polarization The action of reducing the random vibration of light waves to a single plane.

Polyethylene Polyethylene terephthalate, an alternative material to cellulose triacetate for film bases. It is stronger and less sensitive to moisture than cellulose triacetate, but the manufacture is more demanding.

Push-processing Over-rating the speed rating of a film and then over-processing to compensate.

Rebate The margin surrounding the image area on film; dark on a developed transparency, clear on a developed negative.

Reciprocity failure At very short and very long exposures, the increasing loss of sensitivity of photographic emulsion means that the reciprocity law fails to hold true, and an extra exposure is needed. With colour film, the three dye layers are affected differently, causing a colour cast.

Reciprocity law Exposure=intensity×time. Alternatively, the amount of light reaching the film is the product of the size of the aperture opening and the length of exposure.

Reflected light reading Exposure measurement taken directly from a subject of the light reflected from it. The normal method of TTL metering systems.

Relative humidity A measure of the amount of water vapour in the air. Expressed as a percentage of complete saturation at the same tempera-

ture (air can carry more water vapour when warmer).

Resolution The ability of a lens to distinguish between closely spaced objects, also known as resolving power.

RMS (Root Mean Square) The square root of the average of the squares of a set of values. In measuring granularity in film, RMS is used as a measurement of the amount that density varies in a small area of the film.

Rollfilm Film rolled on a spool with a dark paper backing. The most common format is 120.

Shadow detail The darkest visible detail in a subject or in the positive image. Often sets the lower limit for exposure.

Sharpness The subjective impression of acutance when viewing a photograph.

Sheet film Film used in the form of flat sheets rather than rolls or strips. The most common formats are 4×5 inch and 8×10 inch. They are normally loaded individually into film holders.

Shoulder The part of the characteristic curve (q.v.) where the exposure and density are greatest. It usually represents overexposure in an image.

Silver halide Light-sensitive compound of silver and bromine, chlorine, iodine or other halogen. Silver halide crystals are the main active component of photographic emulsions, and following exposure to light and adequate development convert to black metallic silver.

Slow Film that is less sensitive than average.

Spectrum Range of frequencies. The spectrum of light is the range of visible radiation, and is itself part of the electro-magnetic spectrum.

Spiral reel The reel, made of metal or plastic, onto which is wound a roll of film prior to processing. It supports the film in such a way that the surfaces are kept separate.

Spot reading Exposure reading of a very small angle of view, usually about 1°.

Spotting Small-scale retouching on the surface of a print to conceal dust marks and other small blemishes.

Stop bath Chemical that neutralizes the action of the developer on the emulsion, effectively stopping development.

Straight-line section The central part of the characteristic curve, in which the differences in density in the film correspond to the differences in brightness in the scene. Roughly speaking, it is

the well-exposed area of the film.

Toe The part of the characteristic curve that represents the least exposure: close to the threshold. It is usually a region of underexposure.

Tonal gradation The scale of tones in a photograph between dark and light. In particular, the shading from one to the other.

Tungsten light Artificial light created by heating a filament of tungsten wire electrically to a temperature at which it glows.

Underexposure Exposure of an emulsion to less than the optimum amount of light, resulting in the loss of shadow detail and contrast, and an image that is considered too dark in a print, and too weak and thin in a negative.

Wetting agent Chemical that weakens the surface tension of water, and so reduces the risk of drying marks on film.

Zone system Method of measuring exposure and using the results in making a print that assigns all the tones to a stepped scale, usually 0–IX (see pages 140–1).

Bibliography

Adams, Ansel, *The Negative: Exposure and Development*, Morgan & Morgan, 1968.

Focal Encyclopaedia of Photography, Focal Press Ltd, 1978.

Freeman, Michael, *Collins Concise Guide to Photography*, Collins, 1984.

Freeman, Michael, *Instant Film Photography*, Macdonald & Co, 1985.

Freeman, Michael, *The Photographer's Studio Manual*, Collins, London, 1984; Amphoto, New York, 1984.

Freeman, Michael, *The 35mm Handbook*, Windward Books, 1980.

Kodak, *Basic Developing and Printing in Black-and-White*, Eastman Kodak, 1987.

Kodak, *Basic Developing, Printing, Enlarging in Colour*, Eastman Kodak, 1984.

Kodak, *Black-and-White Darkroom Techniques*, Eastman Kodak, 1981.

Kodak, *Creative Darkroom Techniques*, Eastman Kodak, 1973.

Langford, Michael, *The Complete Encyclopaedia of Photography*, Ebury Press, 1982.

Life Library of Photography, Time-Life Books, 1970–3.

The Manual of Photography, Focal Press, 1971.

The Techniques of Photography, Time-Life Books, 1976.

Vestal, David, *The Craft of Photography*, Harper & Row, 1975.

Wall & Jordan, *Photographic Facts and Formulas*, Amphoto, 1976.

White, Zakia, Lorenz, *The New Zone System Manual*, Morgan & Morgan, New York, 1976.

Magazines
American Photographer
Modern Photography
Popular Photography
Zoom

Index